HARPER'S BAZAAR

HARPER'S BAZAAR
FIRST IN FASHION

Edited by Éric Pujalet-Plaà and Marianne le Galliard

New York · Paris · London · Milan

Harper's Bazaar. Transatlantic Tales

Olivier Gabet
Director of the Musée des Arts Décoratifs

The history of fashion, shaped by the lives of its creators, is conveyed by survey exhibitions, sensitive retrospectives or blockbuster shows, and elucidated by anthropological research on key moments, art movements, periods of transition, the pulse of each new age… Sometimes a proper name serves to define a chapter in this age-old story; sometimes an item of clothing or accessory encapsulates the zeitgeist of an era, its preferences and passions. Historians can draw on a vast array of resources: fashion house archives, designers' biographies, serious multidisciplinary studies sprinkled with (occasionally unverified) anecdotes… and the clothes themselves, of course, with all the work that goes before them (drawings, sketches, patterns) and the records that come after them (photographs, films, fashion show videos). Our contemporary era tends to sanctify fashion for its glamour, impressed by whispered rumors of influence and inspiration, but seems to ignore (or indeed forget) that fashion history was, is, and will be written in the pages of its dedicated magazines. Roland Barthes's apt description of *The Fashion System* oversimplifies at times, presupposing the self-evidence of the nature of fashion with its collections and creations. Although the image-hungry social media have changed things in recent years, fashion has been displayed in magazines for over a century; double-page spreads, illustrated with prints then photographs, have shown the clothes and launched the trends—and this is still largely true in 2020. Fashion shows are attended (and perhaps soon forgotten) by only a few hundred people, treated to dozens of new designs in a matter of moments, while fashion magazines display them on glossy paper for all eternity—or at least for the time it takes to study and enjoy them. Magazines and exhibitions have this in common: a page layout is like an exhibition design, the former prioritizing certain designs, the latter using its *mise-en-scène* to infer subtle hierarchies. In both cases, choices must be made… and similarities abound between the work of a magazine editor and that of an exhibition curator.

To mark the reopening of the museum's fashion galleries after their long-awaited renovation (made possible by the gracious generosity of Christine and Stephen A. Schwarzman), the Musée des Arts Décoratifs and *Harper's Bazaar* decided to take up the challenge of creating a bona fide exhibition on a fashion magazine—not just a selection of photos from back issues, but a historical, artistic, cultural, intellectual and poetic exploration of the history of America's first fashion magazine, founded in New York in November 1867: *Harper's Bazar: A Repository of Fashion, Pleasure and Instruction*. The magazine's subtitle was full of new promise: a woman could be beautiful, elegant, intelligent, literary, cultured and fun-loving—and the magazine has evolved around that fundamental premise ever since. This exhibition was also a first for the Musée des Arts Décoratifs. Our renovated galleries had to host an event that would be far more than a linear series of prints and pictures, no matter how enchanting; instead, the exhibition had to convey the living heart and soul of *Harper's Bazaar*, show how fashion blossomed in its pages, and reveal the many inspirational connections between the magazine's history and the museum's collections. It is fascinating to observe the constant interplay between the editorial line at *Harper's Bazaar* and its showcasing of creations by Charles Frederick Worth, Gabrielle Chanel, Jeanne Lanvin, Madeleine Vionnet, Elsa Schiaparelli, Cristóbal Balenciaga, Christian Dior, Courrèges, Yves Saint Laurent, Karl Lagerfeld, and Alber Elbaz, to name but a few. The legendary expression "The New Look," famously coined by Carmel Snow in February 1947, comes into focus in the exhibition, which also features the translator and writer Mary Louise Booth (*Harper's Bazar*'s first editor in chief), the legendary photographer Richard Avedon, the fabulous covers by Erté and Cassandre, and the flair and

impudence of Diana Vreeland with her "Why Don't You...?" column. From dramatic Hollywood poses to pure Parisian chic, style is of the essence in these transatlantic tales of elegance, epitomized by the likes of Daisy Fellowes, Jacqueline de Ribes, Babe Paley and Marella Agnelli. The exhibition had to do justice to the vital forces represented in the magazine: early works by Andy Warhol, texts by Salvador Dalí and Truman Capote, iconic photographs by Hiro and Peter Lindbergh, gowns which once graced the pages of the magazine before being entrusted to our care by the Union Française des Arts du Costume. And as our museum is also dedicated to graphic design, it was only natural to showcase the genius of Alexey Brodovitch—hailed for his pioneering audacity in a 1930 article by Philippe Soupault, co-founder of the surrealist movement—or the creativity of Fabien Baron in the 1990s.

 Like a magazine, an exhibition and a catalogue need to be edited: some choices are obvious, others more subjective. Additions, improvements, deletions and cuts must be made, requiring determination on the one hand and causing frustration on the other. This delicate task fell to Éric Pujalet-Plaà, assistant fashion and textile curator at the Musée des Arts Décoratifs, and to historian Marianne le Galliard, an eminent specialist on the work of Richard Avedon. The resulting exhibition, recounting over 152 years of history in 1,400 square meters, strikes a perfect balance between the works on display and the various representations of *Harper's Bazaar* (copies of the magazine, double-page spreads, enlarged photos), without succumbing to the fetishism of all things "vintage." Grateful thanks to the exhibition curators, to all the museum teams involved in this unique project, and to Adrien Gardère, who designed the exhibition layout after completing the renovation of the galleries in association with the Bien Urbain architecture agency. Thanks also to design duo André Baldinger and Toan Vu-Huu, responsible for the graphics of the exhibition and the art direction of this catalogue, which could not be a mere replica of *Harper's Bazaar* but had to keep the right distance in order to be a book *on* the magazine rather than a glorified new issue.

 At the Musée des Arts Décoratifs, there can be no ambitious exhibition projects without the generous support of our committed patrons. Once again, I would like to extend my warmest thanks to Regina and Gregory Annenberg Weingarten and the GRoW @ Annenberg Foundation, and to our new patrons Silas and Veronica Chou in New York. Thanks are also due to American Express, who decided to partner with the museum for this project. We are indebted to Marina French Kellen and Andrew Gundlach, and to the Anna-Maria and Stephen Kellen Foundation whose commitment to supporting the museum's fashion collections in the coming years will help ensure their conservation and restoration. The American Friends of the Musée des Arts Décoratifs has been a precious partner for many years, thanks to the unfailing support of Hélène David-Weill and Maggie Bult.

 Last but not least, we are deeply indebted to Glenda Bailey, editor in chief of *Harper's Bazaar* since 2001, for her crucial and enlightening contribution. An expert in the magazine's history and geography, she tactfully and generously shared her immense knowledge of fashion and of *Harper's Bazaar*. Her precious advice, time, and energy not only helped make this project possible, but also reestablished the vital legacy of her predecessors, from Mary Louise Booth to Liz Tilberis. Recalling our first unexpected meeting somewhere in New York, I remembered her passion for Elsie de Wolfe, whose famous quote—"I am going to make everything around me beautiful—that will be my life"—seems to echo Glenda's work for the magazine.

Our *Bazaar*

Glenda Bailey

Dame Glenda Bailey has served as the editor in chief of *Harper's Bazaar* since 2001. She was awarded the French Legion of Honour prize in 2012 and was named Dame Commander of the British Empire by Queen Elizabeth II in 2019.

When I look back on the history of *Harper's Bazaar*, I'm always astounded by the number of "firsts" that involved the magazine. *Bazaar's* first tagline back in 1867 was "A repository of fashion, pleasure, and instruction," and while the world has changed, our mission today remains very much the same: to delight, inform, and inspire women to explore and embrace the possibilities of fashion.

Bazaar—or *Bazar*, as it was spelled in the early days—was the first American magazine to dedicate itself to exploring the lives of women through the lens of fashion. *Bazaar's* first editor, Mary Louise Booth, was involved in the women's suffrage movement in the United States, and it was one of the first mainstream publications to advocate for voting rights for women. Thomas Hardy's *Tess of the D'Urbervilles* and Anita Loos's *Gentlemen Prefer Blondes* were both first published in *Bazaar*, and the magazine was the first to look at fashion in the context of culture and art. *Bazaar* was the first fashion magazine to show real life, environments and movement in its photography, to pry fashion out of the studio and bring it out into the world. *Bazaar* was the first fashion magazine to do a location shoot, the first to commission Richard Avedon, and the first to feature bikinis and denim. It was also the first to celebrate Dior's New Look, the first women's fashion magazine to put a man on its cover (Steve McQueen), and the first to introduce America to Kate Moss and Rihanna to the concept of swimming with sharks. (For that last one, I must claim responsibility!)

I remember my own *Bazaar* "firsts" vividly.

On my first day at work in the *Bazaar* offices in the late spring of 2001, the magazine's new creative director, Stephen Gan, arranged for me to meet with Richard Avedon. It was the thrill of a lifetime. Of course, Dick was responsible for some of the best-known images ever to appear in *Bazaar*—including his 1955 picture of the model Dovima in a sashed Dior dress flanked by a pair of elephants at the Cirque d'Hiver in Paris, one of the most famous fashion images of all time. But Dick was also a product of one of the great, golden eras of *Bazaar*, the 1940s and 1950s, when *Bazaar's* legendary editor Carmel Snow, art director Alexey Brodovitch, and fashion editor Diana Vreeland were revolutionizing fashion and fashion magazines. I felt that being able to have that kind of direct contact with that history was important as we worked to move the magazine forward.

Dick later agreed to give us some engraver's prints from a couture session he shot for *Bazaar* in the 1950s for the November 2001 issue, which was slated to be my first. I was planning a more complete redesign of the magazine for spring, but I did make one immediate change: I brought back *Bazaar's* iconic Didot logo, first introduced by Brodovitch in the 1930s, which had been replaced a couple of years earlier with a chunkier, sans serif one. But to me, that Didot logo was about much more than branding—it represented the spirit at the heart of *Bazaar*, which I wanted to tap into as we moved the magazine into the twenty-first century.

The November 2001 issue, with Gwyneth Paltrow on the cover, was set to go to press in early September. As we were shipping the remaining pages to the printer on the morning of September 11, airplanes struck the World Trade Center and the Pentagon. The terror attacks that day transformed the world as we knew it, causing a clear rupture between

what came before and all that was to come after. I'd been scheduled to present the issue to Hearst executives the following day, but I immediately knew that the magazine we'd made, which virtually no one outside our offices had seen, was already of another age.

As I went to change my editor's letter to acknowledge the attacks, I quickly found myself having to answer a question I suspect that every editor of *Bazaar* has had to confront at one juncture or another: in times like these, why does fashion matter?

The conclusion I came to in that moment was a simple one that helped crystallize my vision for *Bazaar*. In an instant, we'd been thrust into a reality where optimism, imagination, and joy were very quickly being displaced by fear, anxiety, and sadness. But we couldn't let that happen. Even when things seem to be at their darkest, there is something necessary about retaining your ability to dream of a better life and a better future. Without it, you can never move forward—which is what we, at *Bazaar*, and so many of those around us, so desperately needed to do.

Why did fashion matter? It mattered then, as it matters now, as it mattered in the mid-nineteenth century, because, at its best, fashion has the capacity to inspire.

In many ways, going through that experience inspired me—and continues to inspire me—to make a magazine that celebrates life.

I've also always liked to think of *Bazaar* as a party where everyone is invited, and this exhibition is one on an epic scale. As the editor of *Bazaar*, you're not only standing on the shoulders of giants, but giants upon giants. Over the past 153 years, *Bazaar* has not been one magazine but a series of many different ones, all of them shaped by and shaping their own decades and eras. To this day, the groundbreaking work of Booth, Snow, Brodovitch, Vreeland, Nancy White, Henry Wolf, Tony Mazzola, Liz Tilberis, Fabien Baron and so many other editors, art directors, photographers, stylists and writers, who have contributed to *Bazaar*, continues to influence not just the magazine, but the way we look at, think about, and talk about fashion.

Then there are the greats of tomorrow—the members of *Bazaar*'s current team who have not just taken on the mantle of its history, but who have made it their own during a revolutionary period for both magazines and fashion. Their place in this exhibition is well-earned and well-deserved.

I'd also like to personally acknowledge Elizabeth Hummer, *Bazaar*'s design director of the past 15 years. Elizabeth has both built upon *Bazaar*'s great visual legacy and taken it to new creative and innovative heights, and her work on this exhibition has been integral to its success.

I've always loved history, but as an editor, too much looking back can be an occupational hazard. In many ways, the job of an editor is the polar opposite to that of a historian: to do it well, you have to commit to living fully in the moment, with one eye cast ahead. Maybe that's what makes magazines—and in particular fashion magazines like *Bazaar*—so compelling as artifacts: they are forever of a time, and the best of them don't simply chronicle history but capture the sights and the smells and the air unlike any other medium.

In that way, this exhibition is its own "first": a one-of-a-kind journey through the past that not only tells the story of fashion and *Bazaar*, but also brings it all to life.

Contents

- 10 READING *HARPER'S BAZAAR*
- 12 MARY LOUISE BOOTH
- 18 CHARLES FREDERICK WORTH
- 24 ART NOUVEAU
- 30 ROMAIN DE TIRTOFF, AKA ERTÉ
- 38 ADOLPHE DE MEYER
- 46 CARMEL SNOW
- 54 ALEXEY BRODOVITCH
- 64 MADELEINE VIONNET
- 72 DIANA VREELAND
- 82 SURREALISM
- 90 VICTORY

- 96 NEW LOOK
- 106 RICHARD AVEDON
- 118 PARIS – NEW YORK
- 124 FICTION
- 130 NUDES
- 140 POP
- 150 HIRO
- 158 PORTRAIT
- 166 LIZ TILBERIS – FABIEN BARON
- 174 BAILEY'S *BAZAAR*
- 186 SPHERES
- 192 BIBLIOGRAPHY
- 196 INDEX

READING
HARPER'S BAZAAR

Éric Pujalet-Plaà

1. Christian Dior, *Dior by Dior*, V&A Publishing, 2012, p. 14.
2. Philippe Jullian, *Les Styles*, Paris, Plon, 1961.

From the time of its launch in New York in 1867, the women's magazine *Harper's Bazaar* has always covered literary and society news and feature stories, but is best known for the quality of its fashion illustrations and photographs. As a hotbed of talent, it also played host to a graphic design revolution: pioneering designer Alexey Brodovitch honed his skills there from the 1930s to the 1950s, influencing a new generation of artists most famously represented by photographer Richard Avedon.

The exhibition "*Harper's Bazaar*. First in Fashion" presents the different facets of the magazine and charts its evolution. Fashion items, photographs, drawings, prints and art objects recreate the context in which its critical essays and perceptive art and literature reviews were composed; they also evoke its pivotal contribution to raising the profile of French fashion and underscore its role in the emergence of fashion museums. The columns published in *Bazaar*, like so many chapters in a day-by-day fashion history, often set the tone for museum curators. Today's fashion culture continues to reflect the opinions of *Bazaar*'s most famous editors—Carmel Snow, Diana Vreeland, Liz Tilberis… Most of the fashion items in the exhibition were featured in the magazine; now hailed among the museum's masterpieces, they owe their historical importance to their initial appearance in *Bazaar*.

As the flagship for transatlantic and cosmopolitan luxury, *Harper's Bazaar* found itself at the heart of the nascent fashion culture. Primarily a trendsetter, the magazine also set the standard for museum displays showcasing outfits in visual compositions—vitrines or catalogues—with a dynamic use of text. But *Bazaar*'s influence made little difference to the way fashion magazines (tone, vision, format, style, and composition) are perceived; they are generally considered by museums to be useful documentary resources while textile creations are classified as artworks. Nonetheless, the inclusion of these artworks in a collection is often determined by their appearance in the press: when photographed, captioned, pasted up and printed on glossy paper, a dress becomes an icon.

Since 1897, *Bazaar* has been a space where women are regularly transformed: constructed, animated, colored, undressed, diffracted, retouched, reconstructed and idealized by turn, according to the inspiration of couturiers and creators, the opinions and decisions of fashion editors, and the artistic orientations of fashion designers, photographers and graphic artists.

To certify the magazine's status as a work of art, we needed to take a detailed look at this long-established publication dedicated to the female form.

It is important to remember that the fashion figure so significantly reinvented by *Bazaar* did not come into being in 1867. Fashion plates, widely circulated in the nineteenth century, stem from a long tradition of representation that probably dates back to the early days of printing. In addition to their mass production, fashion designs need to be associated with a season, period or cycle—a principle of rhythm shared by the first printed books in the fifteenth century. Although these incunabula, which aimed to summarize the universe in book form, had a priori nothing to do with fashion, they referred to the planetary cycles and explained their earthly, celestial, symbolic or prophetic significance.

The shepherd's almanacs of the sixteenth century—best sellers in their day—were based on the same principles and illustrated with the first plates depicting figures in civilian dress. The circulation of the almanacs influenced other iconographic media, such as the Bruges tapestry called *L'Astronomie*, dating from the 1510s, which had pride of place in Christian Dior's drawing room in the 1950s. Its figures personify the interpretation of the movement of the planets, and its presence in the couturier's home is a reminder that modern fashion sketches and figures are derived from the *gravures* in the early almanacs that inspired these tapestry characters. The term *gravure* is synonymous with fashion sketch, as the great couturier noted in 1956 in his reference to "the sketches of the freelance designers who went from house to house displaying the samples of their work which today are still called *gravures*."[1]

In the centuries between the incunabula and the fashion plates in the first issue of *Harper's Bazar* (spelt with one A until 1929), different kinds of images were tested on different media and at different frequencies. It was not until the eighteenth century that the fashion-plate format was defined: a full-length isolated figure, often lacking individuality, with a complete and detailed outfit evocative of fashionable elegance against a banal background. This figure was reproduced on a small scale in large numbers, with a (usually brief) text, in a periodical. Periodicity was an essential aspect of women's magazines, which were published on a weekly or monthly basis, sometimes according to the concept of season or, more broadly, of artistic era. In every period, the content of *Bazaar* reflected the new ideas and their impact—on fashion in particular.

Harper's Bazaar relayed the sensitivity of the Pre-Raphaelites, the daring of the Surrealists and the experimentations of Pop artists, thereby heightening the impact of each of these artistic revolutions, whose influence would have been less widespread without *Bazaar*'s appeal to the high-end audience.

The aim of this exhibition and book is not to present the results of research; rather, it is designed to provide some starting points for an appreciation of the magazine's creativity. Observing the shifts and developments in *Bazaar*'s history, the authors sought to identify recurrent elements and motifs, which are presented chronologically in a series of periods represented by key figures and personalities from the worlds of fashion, photography, and art. Each period gave rise to a different type of woman: good little girl, bluestocking, fin-de-siècle woman, Ophelia or Scheherazade, twenties vamp, neoclassical purist, woman soldier, *femme fleur*, elegant young lady, dolly bird, star, supermodel, artist's muse… a woman with a mind and desires of her own. This ideal female lineage recalls the 1961 satirical work on styles by French author Philippe Jullian, featuring "Madame Haugoult-Dujour" ("Madame Up-to-Date").[2] But these repertory-style characters did not spring out of thin air: it seems to us that they sprang from *Bazaar*'s original blend of various elements, based on a tried and true formula—the choice of a dress and its construction (cut and concept), the illustration and its quality (drawing or optical effects), the written text and its place (literature, page layout)… and, naturally, a "dash of daring"!

MARY LOUISE BOOTH

Éric Pujalet-Plaà

1. According to the conclusion of this book, New York was destined to become the capital not only of the Union, but also of the world.
2. Quote from a letter written by Mary L. Booth to the Duyckinck Brothers publishing house, reproduced in Tricia Foley, *Mary L. Booth, the Story of an Extraordinary 19th-Century Woman*, 2018, p. 66.
3. Editorial by Mary L. Booth, first issue of *Harper's Bazar*, vol. 1, no. 1 November 2, 1867.
4. Letter to the Reverend Antoinette Blackwell, in Tricia Foley, *op. cit.*, p. 132.
5. Posthumous tribute, *Harper's Bazar*, vol. 22, no. 14, April 6, 1889, p. 242.
6. *Ibid*.

Mary Louise Booth, the first editor in chief of *Harper's Bazar*, was born in 1831 in the state of New York and grew up in the Long Island countryside, where her ancestors had settled in the eighteenth century. She was an exceptionally gifted child whose early education focused on the scriptures and the classics, and from a young age she was able to earn her living as an editor, translator, and journalist.

Her translation work from 1856 onwards included a technical handbook on marble carving, classics of French literature (*Les Pensées* and *Les Provinciales* by Blaise Pascal), fashionable novels (Edmond About's *Le Roi des montagnes* and *Germaine*), a biography of the poet André Chénier, histories of France, and, above all, essays on the American nation and the question of slavery. She began to translate the writings of Édouard de Laboulaye in 1863, and remained in close contact with this French politician, regarded as the "father of the Statue of Liberty" because of his 1875 fundraising campaign for the construction of Auguste Bartholdi's famous monument inaugurated in 1884. The scholarly reputation Miss Booth acquired through these publications was further strengthened by her work as a researcher and historian; among other works, she published a clock and watchmakers' manual in 1857 and a history of New York in 1859.[1]

Her commitment to the cause of women is illustrated by her translation of works by French feminist writers: Jenny d'Héricourt's *La Femme affranchie* and an (unpublished) translation of George Sand's autobiography. In 1855, Miss Booth began to associate with the founders of the New England Women's Club in Boston and the Sorosis Club in New York, and she joined the Anti-Slavery Society the following year.

In addition to her activities as an abolitionist and supporter of women's suffrage, she also took a stance with regard to aesthetics, joining the Society for the Advancement of Truth in Art in 1857. This American Pre-Raphaelite group published a journal called *The New Path*, whose front page quoted a passage from the Revelation of St. John: "Write the things which thou hast seen, and the things which are, and the things which shall be hereafter."

In her early thirties, Miss Booth, who remained single and childless, moved to the Manhattan surgical offices (at 89 Madison Avenue) of renowned gynecologist Dr. James Marion Sims, whom she assisted with his writing—a collaboration that must have raised her awareness of women's health issues. After her meeting with Prussian-born physician Marie E. Zakrzewska, who worked in a women's free clinic in New York, she co-signed an 1862 appeal for subscriptions to a "Woman's Journal" founded on the principle of "equal rights for all." The American Civil War put paid to this project, however.

As a supporter of President Lincoln, Mary L. Booth turned her journalistic skills to the Union cause, contributing to the organization of charity events called "Sanitary Fairs" in aid of the war wounded.

In a letter dated 1865, she expressed her political beliefs as follows: "I believe that I have translated well nigh everything in France that has been written in French on the American question; and it will be my highest source of gratification through life if I have been able to contribute something, however humbly, to the cause of the country and of liberty."[2]

In 1867, the four Harper brothers—Fletcher, James, John, and Joseph—who published the popular *Harper's Weekly* and *Harper's New Monthly* magazines—contacted Miss Booth about a project for a women's weekly along the lines of the Berlin-based *Der Bazar* magazine. November of the same year saw the launch of *Harper's Bazar: A Repository of Fashion, Pleasure and Instruction*. With this first, sixteen-page issue, Mary L. Booth paved the way for the magazine's future success by promising features on fashion—"Our readers will thus be sure of obtaining the genuine Paris fashions simultaneously with the Parisians themselves" —and society—"Serials, novelettes, poems, literary and art miscellany, familiar science, esthetics, the current literature, new books, amusements, gardening, architecture, household literature—in short, all that is likely to interest the home circle will receive due notice."[3]

Mary L. Booth became one of the best paid women of her time and acquired considerable influence in her later career. The literary gatherings she hosted on Park Avenue with her companion Mrs. Anne W. Wright were attended by many famous artists and writers.

Miss Booth set an editorial line that corresponded to her views, with articles that pleaded the cause of women's suffrage

but, by her own admission, stopped short of militancy: "You know, I have always been a sort of guerrilla worker, doing my own work in my own way, and aiding others when and where I could without specially allying myself with them. I don't really think I have enough of the aggressive element in me ever to be a reformer; and I can only admire and marvel at those who are brave enough for the task."[4]

The *Harper's Bazar* style stemmed from Miss Booth's patriotism, pioneering feminism, and love of all things French. Rather than a political manifesto, it was a lifestyle magazine promoting luxury, literary and artistic expression, and the idea of social progress. "The journal she edited was her chosen means of usefulness. If those who read it were frivolous, she wished at least to make them refined and honest."[5]

With her literary leanings, Mary L. Booth invited contemporary authors to contribute to *Harper's Bazar*; in its first year of existence, these included Charles Dickens. In terms of both content and style, the weekly magazine was designed in the literary salon tradition: the latest artistic and intellectual news was represented and commented on, and *Harper's Bazar* acquired a dual trend-setting and consciousness-raising role that kept readers coming back for more.

The magazine's posthumous tribute to its first editor in chief on April 6, 1889 included references to French author Germaine de Staël and revolutionary heroine Madame Roland. "One of the traits that most won the respect of those who knew her was that she had her own individuality, her life, her opinions, quite apart from her functions as an editor. It seemed as if her whole life, like Madame Roland's, has been influenced by the early reading of Plutarch's Lives."[6]

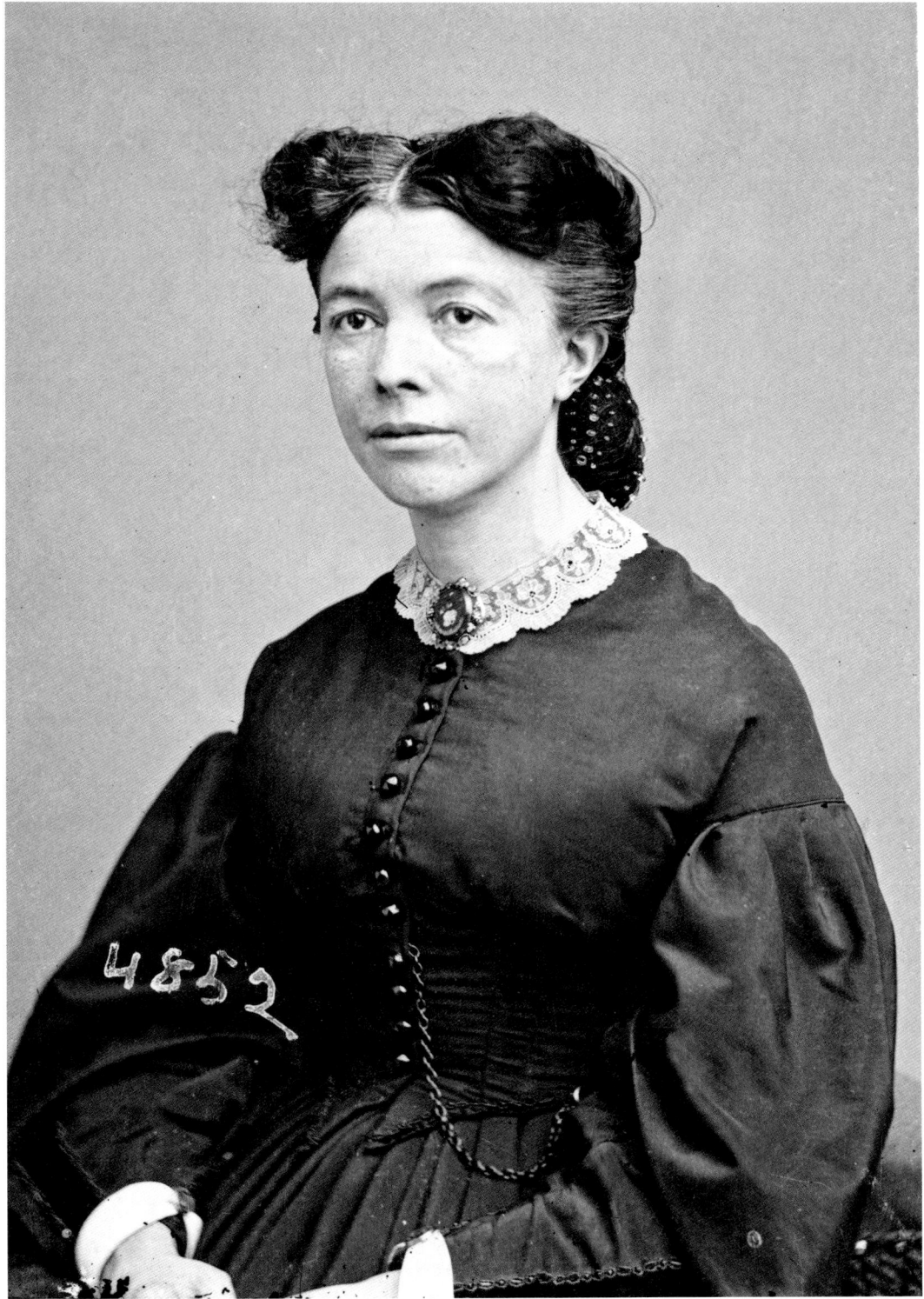

A Mathew B. Brady, portrait of Mary Louise Booth, c. 1860. Brady-Handy Collection, Library of Congress.

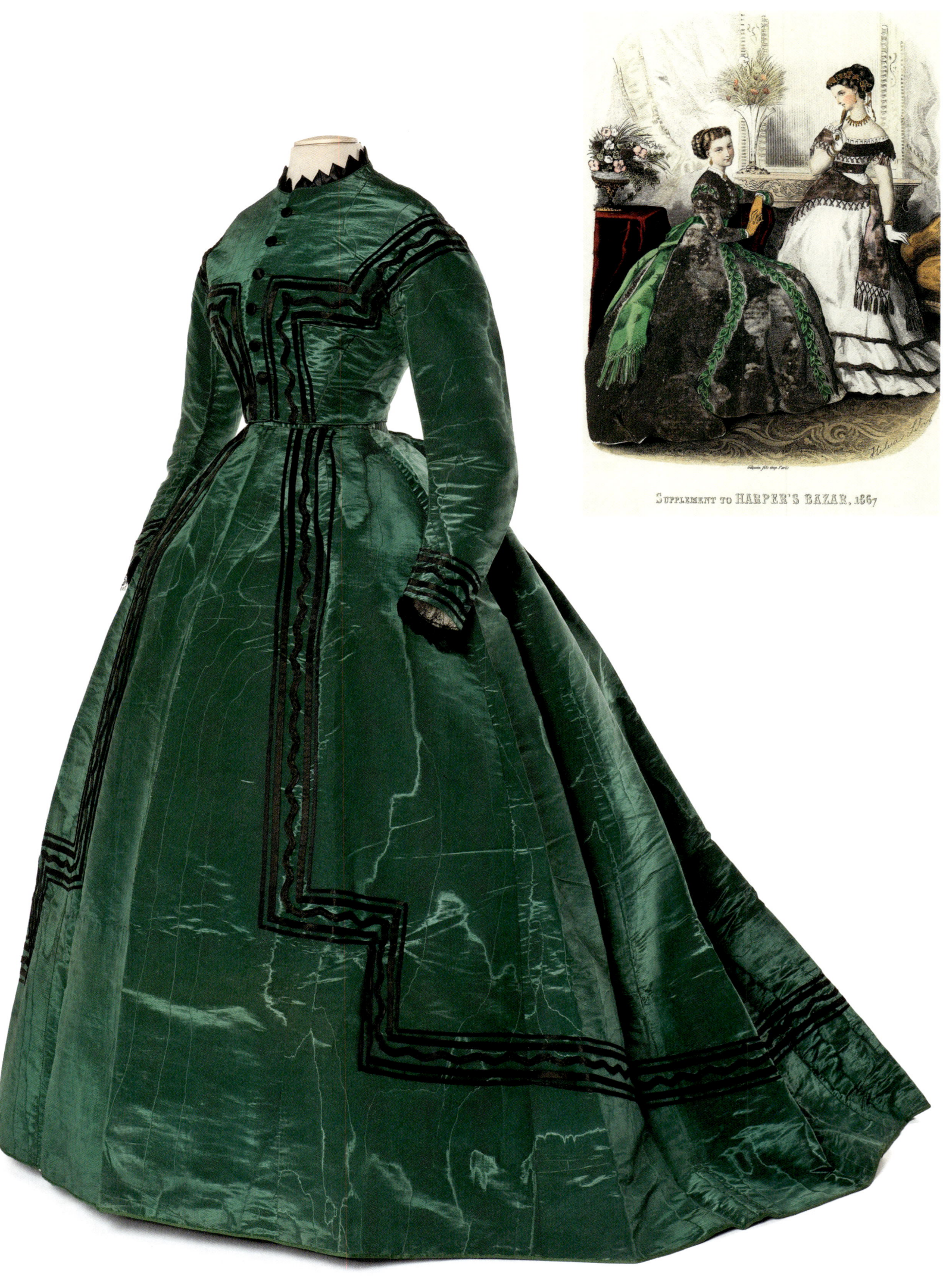

A B C

A Miette Landry, day dress, moiré antique, 1866–1868. Paris, Musée des Arts Décoratifs, purchased 1996, inv. 996.1.1.1-2.

B *Harper's Bazar*, printed as a supplement to the November 2, 1867 issue. Illustration by Héloïse Leloir.
The magazine took an international approach from the start, hiring the illustrator Héloïse Leloir, who also worked for *La Mode illustrée* and *Le Moniteur de la mode*.

C *Harper's Bazar*, November 2, 1867, cover. This was the debut issue of *Harper's Bazar*, with Mary L. Booth as editor in chief.

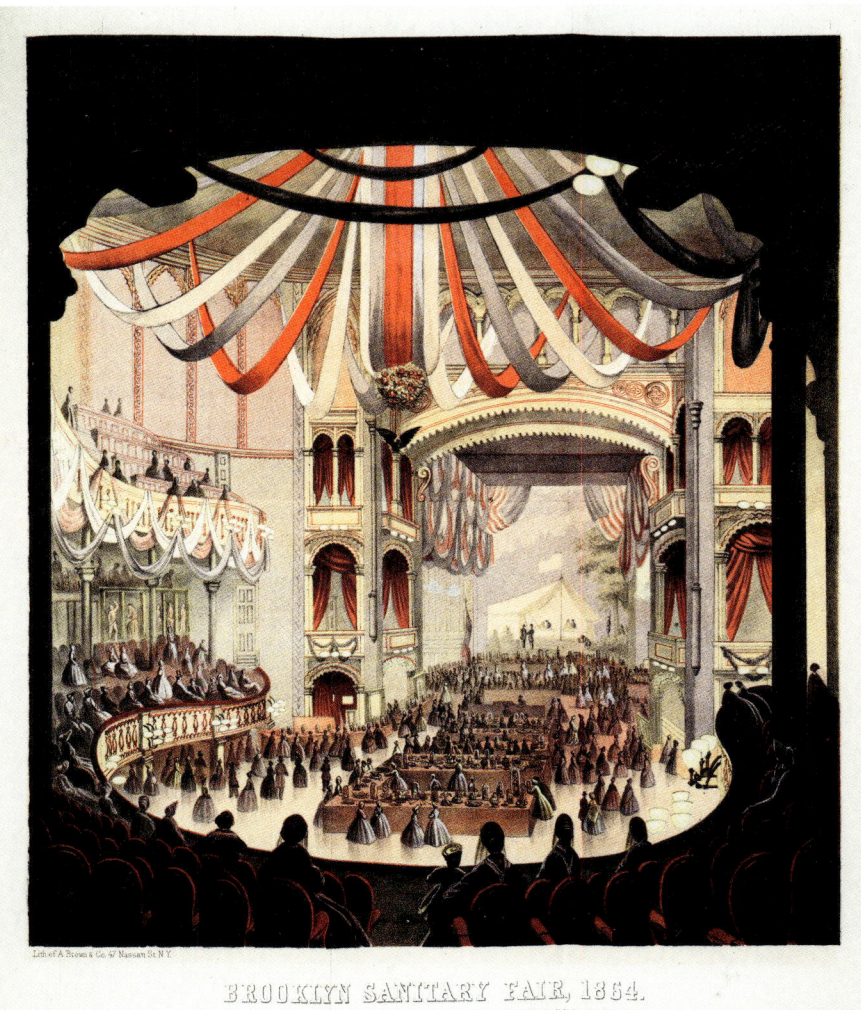

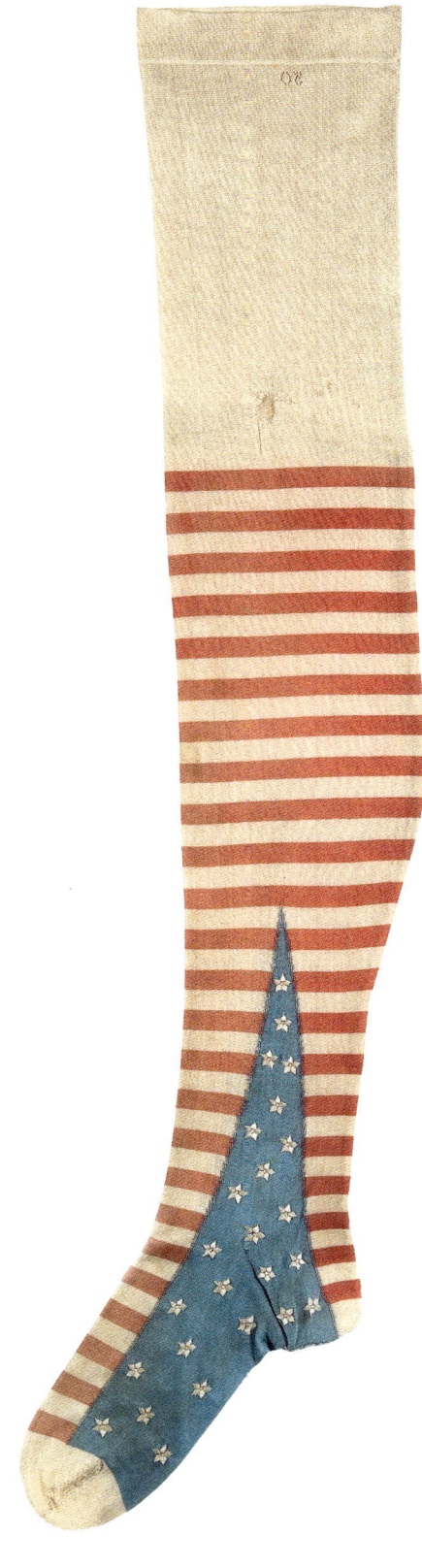

A	B	C
D	E	

A A. Brown & Co, *Brooklyn Sanitary Fair, 1864*, lithograph, 1864.
The charity events held in aid of the Union in New York, Brooklyn, Philadelphia, and Boston charged entrance fees to restaurants and art galleries.

B Milon Aîné, clocked stocking, embroidered silk jersey, c. 1875. Paris, Musée des Arts Décoratifs, purchased 1961, UFAC collection, inv. UF 61-41-28.
This stocking, which did not belong to Mary Louise Booth, evokes women's support for the Union cause.

C "Why Should We Not Vote?" *Harper's Bazar*, November 28, 1868, p. 909.
This image, printed *in plano* inside the magazine, folded out like a manifesto poster.

D Title page of Jenny P. d'Héricourt's *La Femme Affranchie*, translated by Mary L. Booth [1860].

E "The Champions of Woman's Suffrage," *Harper's Bazar*, June 12, 1869, p. 381.

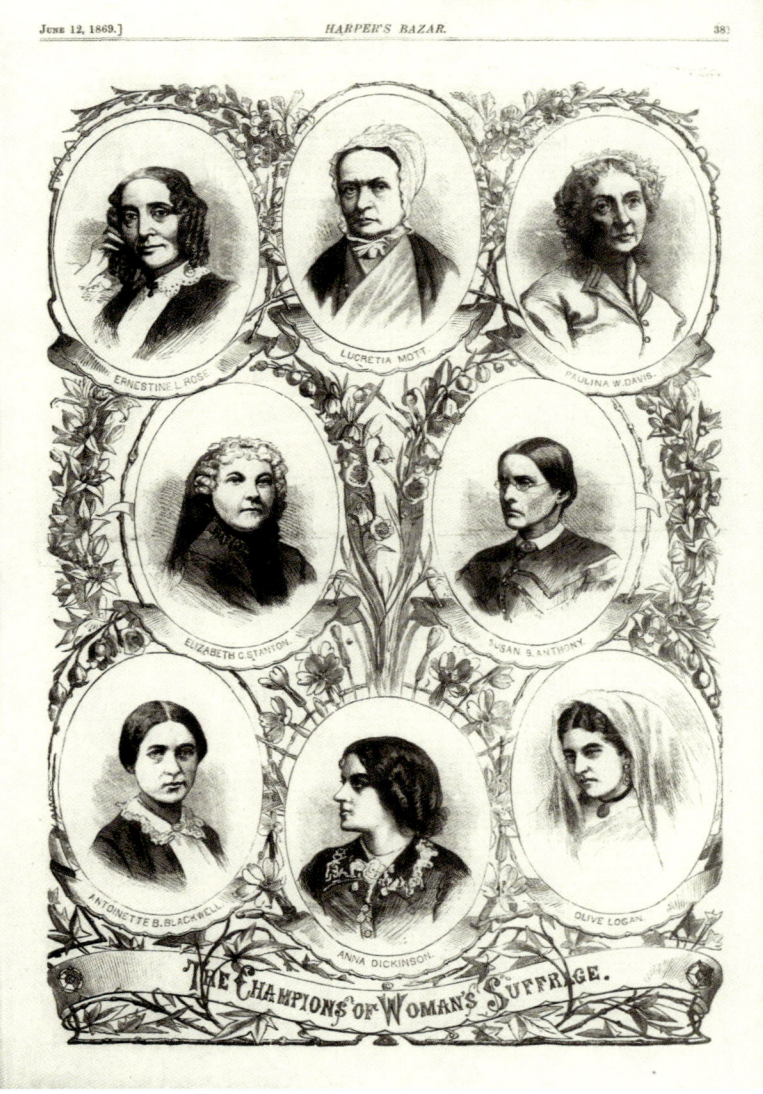

LA
FEMME AFFRANCHIE

RÉPONSE A MM. MICHELET, PROUDHON, É. DE GIRARDIN, A. COMTE

ET AUX AUTRES NOVATEURS MODERNES

PAR M^me JENNY P. D'HÉRICOURT

TOME II

BRUXELLES
A. LACROIX, VAN MEENEN ET C^ie, ÉDITEURS
RUE DE LA PUTTERIE, 33

PARIS
CHEZ TOUS LES LIBRAIRES

1860
Tous droits réservés.

CHARLES FREDERICK WORTH

Marie-Pierre Ribère

Harper's Bazar magazine was launched in New York on November 2, 1867. The following day saw the end of the Paris World's Fair, an ambitious event initiated by Emperor Napoleon III to showcase French fashion and textile production.[1] This coincidence of timing foreshadowed the link between the innovative lifestyle magazine and the aftermath of the French exhibition, which sparked emulation worldwide, particularly among American visitors and businessmen.[2]

Trade between France and America's key cities was boosted by the end of the American Civil War two years earlier and by improved transport conditions. Moreover, French fashions were already being exported or taken across the Atlantic by Americans fortunate enough to shop for clothes in the French capital, and Paris fashion had enjoyed a prestigious reputation in America for decades.

Meanwhile, the well-to-do were increasingly enthralled by the lifestyles of European royalty and high society. As dressmaker to those social categories, Charles Frederick Worth therefore attracted great interest in America. Regarded as the "father of modern couture," he founded his couture house in 1858 at 7, rue de la Paix in Paris, and his luxurious creations soon appeared in the pages of *Harper's Bazar*.

Readers were kept up to date with the latest Paris news and fashions[3] through articles by Paris correspondents,[4] in keeping with the editorial line set by the magazine's Francophile editor in chief, Mary Louise Booth. She boosted the great couturier's reputation with a series of portraits published from 1867 to 1874, celebrating "The Napoleon of Costumiers":[5] his dresses, his innovative production methods, his eccentricity, his château in Suresnes and his vast popularity with American clients. However, the associated extravagance and ostentation were criticized, the magazine's readership still upholding a certain Protestant ethic.[6]

Worth's outfits, frequently mentioned in the 1870s and 1880s, made regular front-page appearances in the 1890s in the form of carefully detailed engravings accompanied by descriptive articles; readers could sometimes order the sewing patterns for the featured outfits for twenty-five cents. Illustrator Adolf Sandoz drew young women with standardized faces, wearing the latest Worth fashions and hats by the milliner Madame Virot, and depicted outdoors or in indoor settings furnished in the historicist style favored by Americans and incarnated by Worth's creations.

The magazine's frequency of publication was justified by the need to change outfit several times a day depending on social circumstances. *Harper's Bazar* reported on the glamorous events attended by tycoons' wives, such as the Vanderbilt fancy dress ball of March 26, 1883, which established the Vanderbilts as members of New York's fashionable society. The extraordinary Worth gown worn on that occasion by Mrs. Cornelius Vanderbilt attests to the vital role of the Paris couture house in supporting its clients' social aspirations.[7]

Harper's Bazar confirmed the close ties between this new cosmopolitan society and Paris haute couture, whose figureheads and styles were so often featured in its pages in the late nineteenth century: Félix, Laferrière, Raudnitz, Rouff, Callot Sœurs, Paquin, and Doucet—who designed Consuelo Vanderbilt's gown for her wedding to the ninth Duke of Marlborough in 1895.[8]

But the special place occupied by Charles Frederick Worth is reflected in the many pieces held in American museums and the vibrant tribute paid by *Harper's Bazar* after his death in 1895: "Through the length and breadth of the civilized world no contemporary French name is better known than that of Worth; no painter, no sculptor, no poet, no actor, no novelist, of the past three decades, has achieved so widespread a fame as that of this dressmaker of the Rue de la Paix."[9]

1. Auguste Luchet, *L'Art industriel à l'Exposition universelle de 1867. Mobilier, vêtements, aliments*, Paris, Lacroix, 1868, p. 368; according to the author, exports of French silk garments reached the record sum of 400 million francs in 1865.
2. Stella Blum, *Victorian Fashions and Costumes from Harper's Bazar 1867–1898*, New York, Dover Publications, 1974, p. 5.
3. "Our Bazar," *Harper's Bazar*, vol. 1, no. 1, November 2, 1867, p. 2.
4. Notably Emmeline Raymond, editor in chief of the journal *La Mode pratique* and Lucy Hamilton Hooper, a writer, poet and journalist who penned many articles on fashion and the Paris art scene.
5. "Worth, the Paris Dressmaker," *Harper's Bazar*, vol. 7, no. 7, February 14, 1874, p. 116.
6. "Paris Gossip. Those Dreadful Americans," *Harper's Bazar*, vol. 5, no. 27, July 6, 1872, p. 450.
7. "The Vanderbilt Fancy Ball," *Harper's Bazar*, vol. 16, no. 16, April 21, 1883, p. 242: "Mrs. Cornelius Vanderbilt was very charming as the Electric Light, Fire was illustrated by a curious gleaming red substance which flamed up the skirt and around the neck." The dress in question is now in the New York City Museum.
8. "New York Fashions—Miss Vanderbilt's Wedding Gown," *Harper's Bazar*, vol. 28, no. 45, November 9, 1895, p. 903.
9. "The Arbiter of Fashion," *Harper's Bazar*, vol. 28, no. 12, March 23, 1895, p. 226.

A *Harper's Bazar*, May 21, 1892, cover. Illustration by Richard Caton Woodville.

The British illustrator rendered to perfection the richness of the Lyon silk fabrics so dear to the couturier, such as figured velvet and satin.

A *Harper's Bazar*, March 28, 1891, cover. Illustration by Adolf Sandoz.

B Charles Frederick Worth, dress, ottoman, shot taffeta and velvet, c. 1883. Paris, Musée des Arts Décoratifs, purchased with the support of Louis Vuitton, 2013, inv. 2013.3.9.1–2.

The shape and asymmetrical decoration of this dress reflect the late nineteenth-century taste for historicism, illustrated by the creations of Charles Frederick Worth.

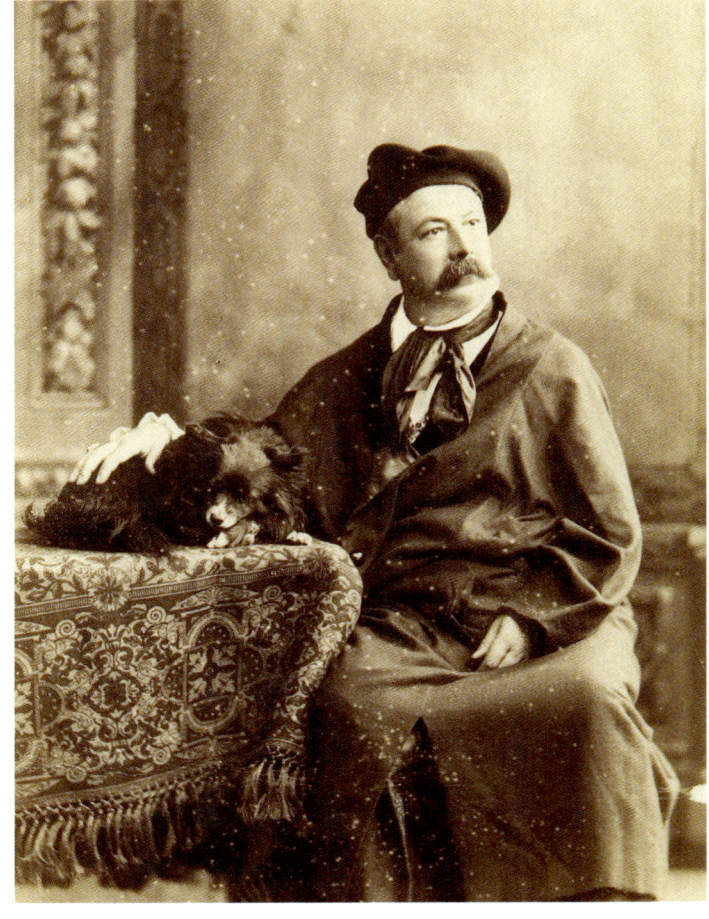

A B C

A Photograph of the Worth family on the terrace of their château in Suresnes, c. 1880.

B Charles Reutlinger, c. 1881, Photograph of Charles Frederick Worth with Scrubbs. Paris, Musée des Arts Décoratifs.
Charles Frederick Worth, who considered himself an artist, posed in the painter's smock he always wore when meeting clients and even in the presence of Empress Eugenie.

C José-Maria Mora, photograph of Alice Cornelius Vanderbilt II, 1883.
Alice Cornelius Vanderbilt II as "Electric Light"; gown by Worth, worn at the fancy dress ball held in New York on March 26, 1883. The torch could be lit by batteries concealed in the gown.

22

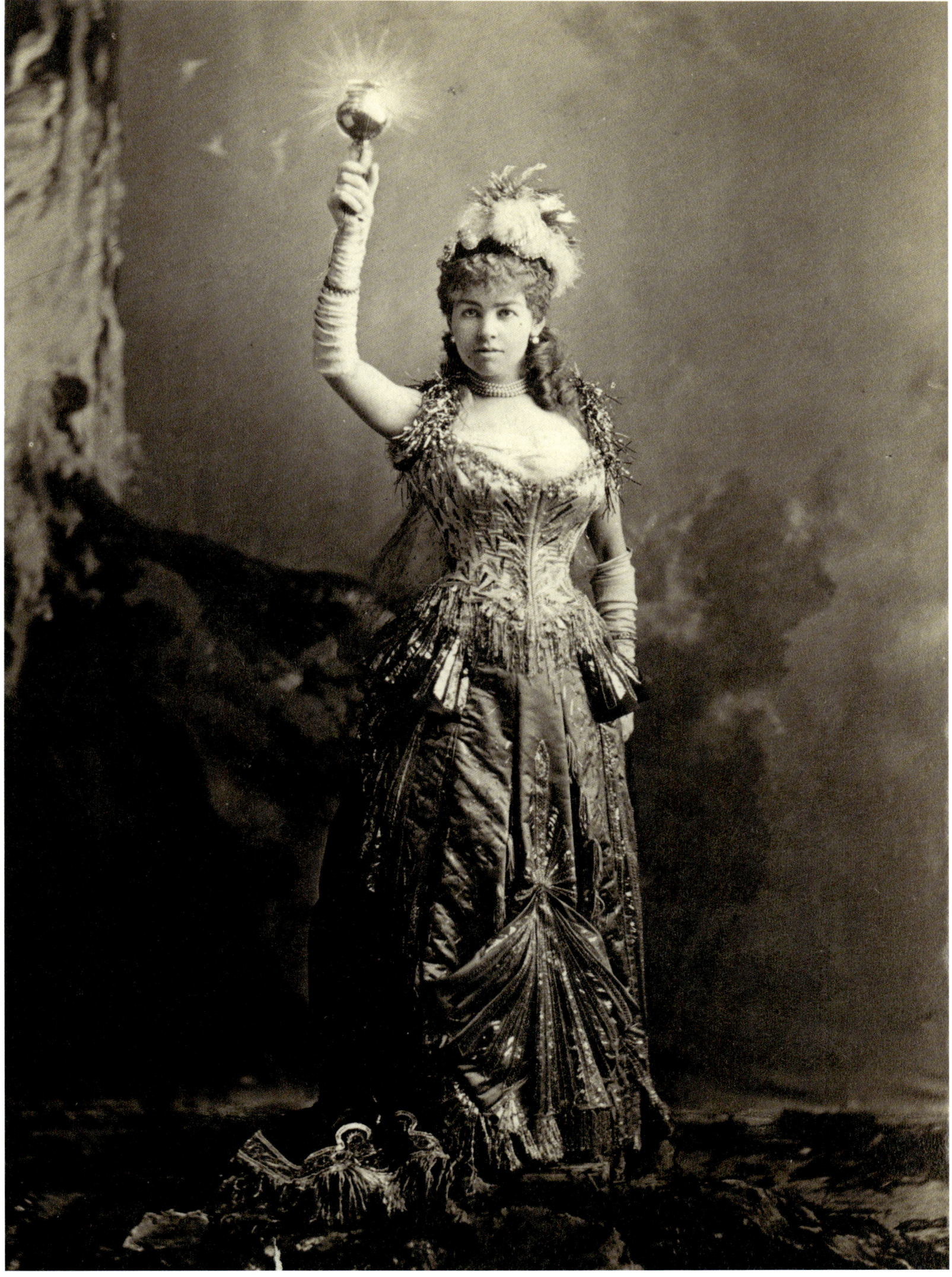

ART NOUVEAU

Éric Pujalet-Plaà

1. *Harper's Bazar*, vol. 39, no. 11, November 1905, pp. 979–981.
2. *Harper's Bazar*, vol. 23, no. 34, August 23, 1890, p. 651.

Mary L. Booth's influence on the artistic orientations of *Harper's Bazar* was perceptible well into the 1900s. The predominant Art Nouveau style of the period was, in a sense, an extension of the Pre-Raphaelite aesthetic upheld by the magazine's editor in chief. The ideology of Art Nouveau was rooted in the notion of artistic unity, encompassing sacred, secular, fine, and applied arts. Illustration and decoration were thus elevated to the status of art, and magazine covers and posters were seen as forms of artistic expression.

The covers of *Harper's Bazar* were peopled with silhouettes recalling the stately figures of Edward Burne-Jones, decorated with multitudes of flowers reminiscent of William Morris prints or adorned with neo-gothic lettering. The Easter, Thanksgiving, and Christmas issues tended to focus on sacred themes. Graphic compositions featuring lilies, yellow irises, and tuberoses were sprinkled with hollyhocks, angels' wings, and armor, according to a mystical symbolism influenced by heraldic culture and references to chivalry. Joan of Arc (whose canonization process began in 1897) was perceived as a heroine with contemporary relevance, a link between the histories of France, Britain, and the United States. Mark Twain—whose short story *A Helpless Situation* (illustrated by Clarence F. Underwood)[1] was published in *Harper's Bazar* in 1905—had written a serialized novel about the Maid of Orleans in 1895, published by Harper & Brothers and illustrated by Eugène Grasset. The latter's monogram, EG, often appeared on the covers of *Harper's Bazar* and the other *Harper's* magazines. Illustrators such as Louis Rhead and Luc-Olivier Merson drew inspiration from other female archetypes, with auburn-haired figures reminiscent of Dante Gabriel Rossetti's *Venus Verticordia* or undulating aquatic plants recalling Shakespeare's *Ophelia*.

The reference to Elizabethan theater is also perceptible in images of eerie, almost phantasmagorical female figures. The Art Nouveau woman—a sacred vessel able to hold a combination of medieval, floral, and fantasy references—was embodied to perfection by legendary actress Sarah Bernhardt, in whom *Harper's Bazar* took a keen interest. Bernhardt played Lady Macbeth in 1884, Joan of Arc in 1890, and Salome in 1892 in a version she commissioned from Oscar Wilde and which was published in English in 1894—with illustrations by Aubrey Beardsley that cast a distinctly erotic light on the "modern woman." Encouraged by French painter Pierre Puvis de Chavannes, Beardsley was a follower of Burne-Jones; he had an obvious influence on *Harper's Bazar* illustrators such as William H. Bradley and Rhead, who followed in the Pre-Raphaelite and Symbolist traditions.

Most of the magazine's illustrators took a holistic view of the arts and worked in a variety of fields ranging from illustration, poster design and easel painting to the decorative arts (jewelry and furniture). Eugène Grasset, for example, designed typefaces, furniture pieces, and postage stamps, while academic painter Luc-Olivier Merson created stained-glass windows for William K. Vanderbilt's New York residence and bank notes for the Banque de France.

In regard to fashion, the Art Nouveau style was mainly used for jewelry and ornaments. Waistless princess-line dresses provided neck-to-hemline canvasses for the creation of intertwining plant designs. The fashion of the period was greatly influenced by Irish or guipure lace. The increased production of these crocheted designs combining Celtic interlacing and floral decoration was a by-product of the Great Irish Famine of the 1850s, and massive Irish emigration to the United States probably boosted their popularity. Many dressmakers used Irish lace in conjunction with white embroidery, broderie anglaise, and antique lace. Even under the most concealing outfit, nudity could be suggested by the play of transparency in the openwork patterns of lace and guipures sprinkled with white flowers. "White shoes, white gloves, and white parasols are fashionable accessories of summer costumes, especially of toilettes for driving worn by guests in country houses... The immaculate gown is of white China silk or of crêpe de Chine, trimmed with insertions and frills of Valenciennes lace; or else large-patterned Irish lace forms a yoke or plastron and sleeves on the simple French waist, and a panel down the middle of the straight skirt."[2]

At the turn of the century, however, the covers of *Harper's Bazar* reflect a certain eclecticism. The ethereal aesthetic of illustrator Charles Louis Hinton, inspired by classical Greece, featured lyres and beribboned fasces from the neoclassical decorative repertoire that also appealed to couturier Jacques Doucet. In contrast, the illustrator Harry Whitney McVickar, a co-founder of *Vogue* in 1892 and author of an 1896 history of costume called *The Evolution of Woman*, designed a cover for the *Bicycle Number* of *Harper's Bazar* on March 14, 1896, depicting a woman in an unprecedentedly dynamic pose.

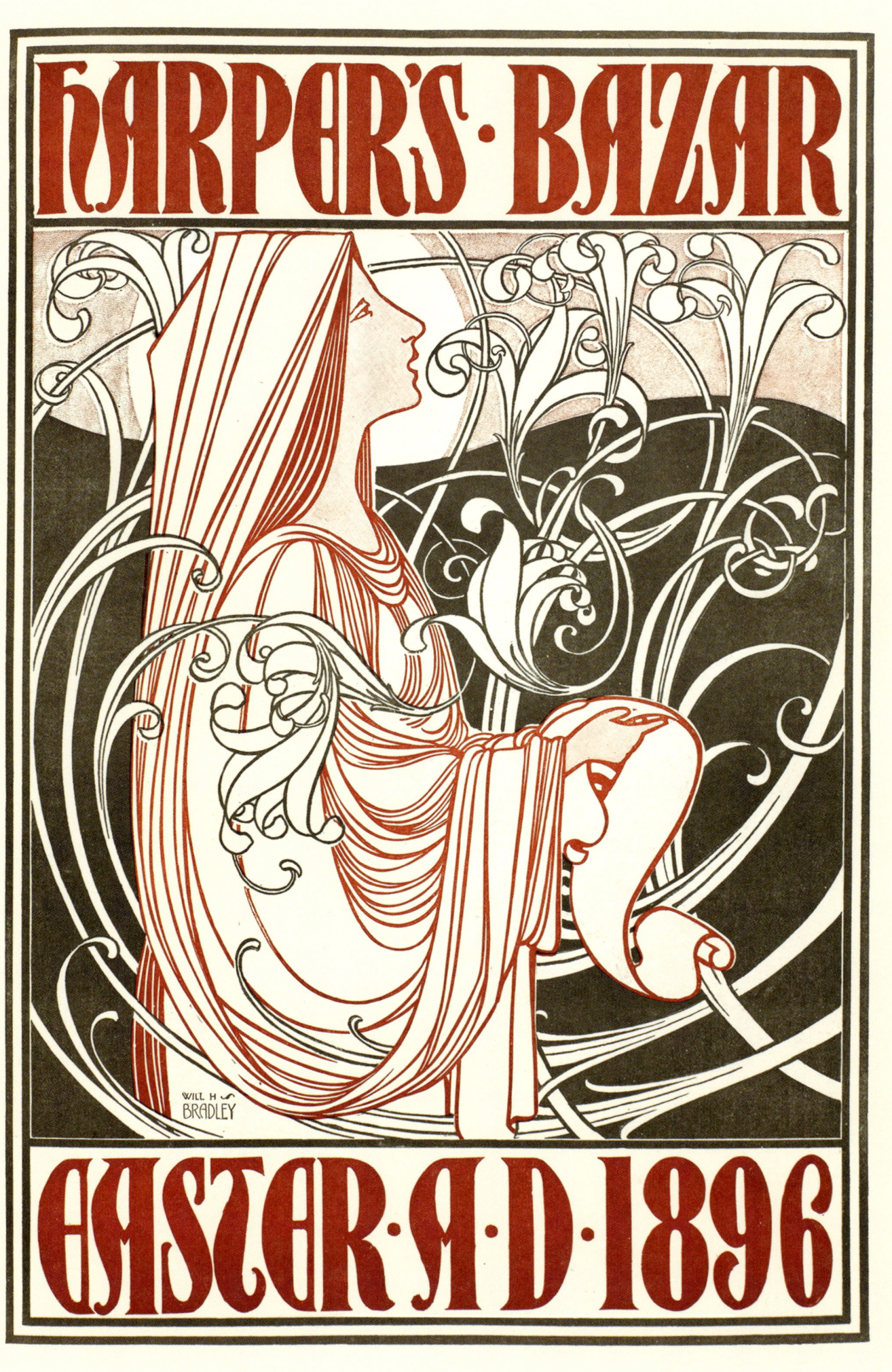

A *Harper's Bazar*, March 28, 1896, cover. Illustration by William H. Bradley.

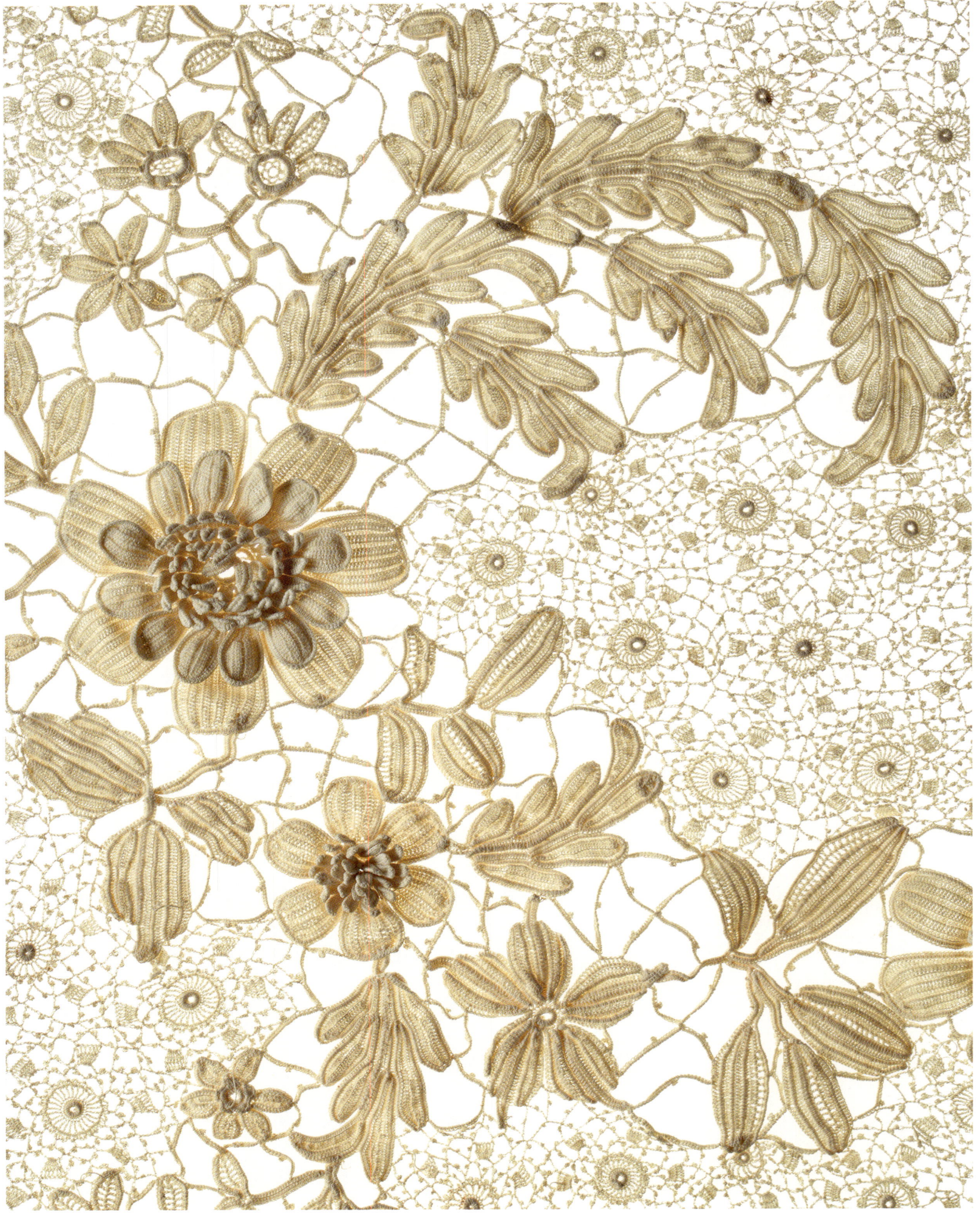

A Detail of a day dress, Irish crochet lace, c. 1905. Paris, Musée des Arts Déccratifs, gift of Mrs. Leegenhoek, UFAC collection, 1963, inv. UF 63-4-1.

B *Harper's Bazar*, November 21, 1896, cover. Illustration by Charles Louis Hinton.

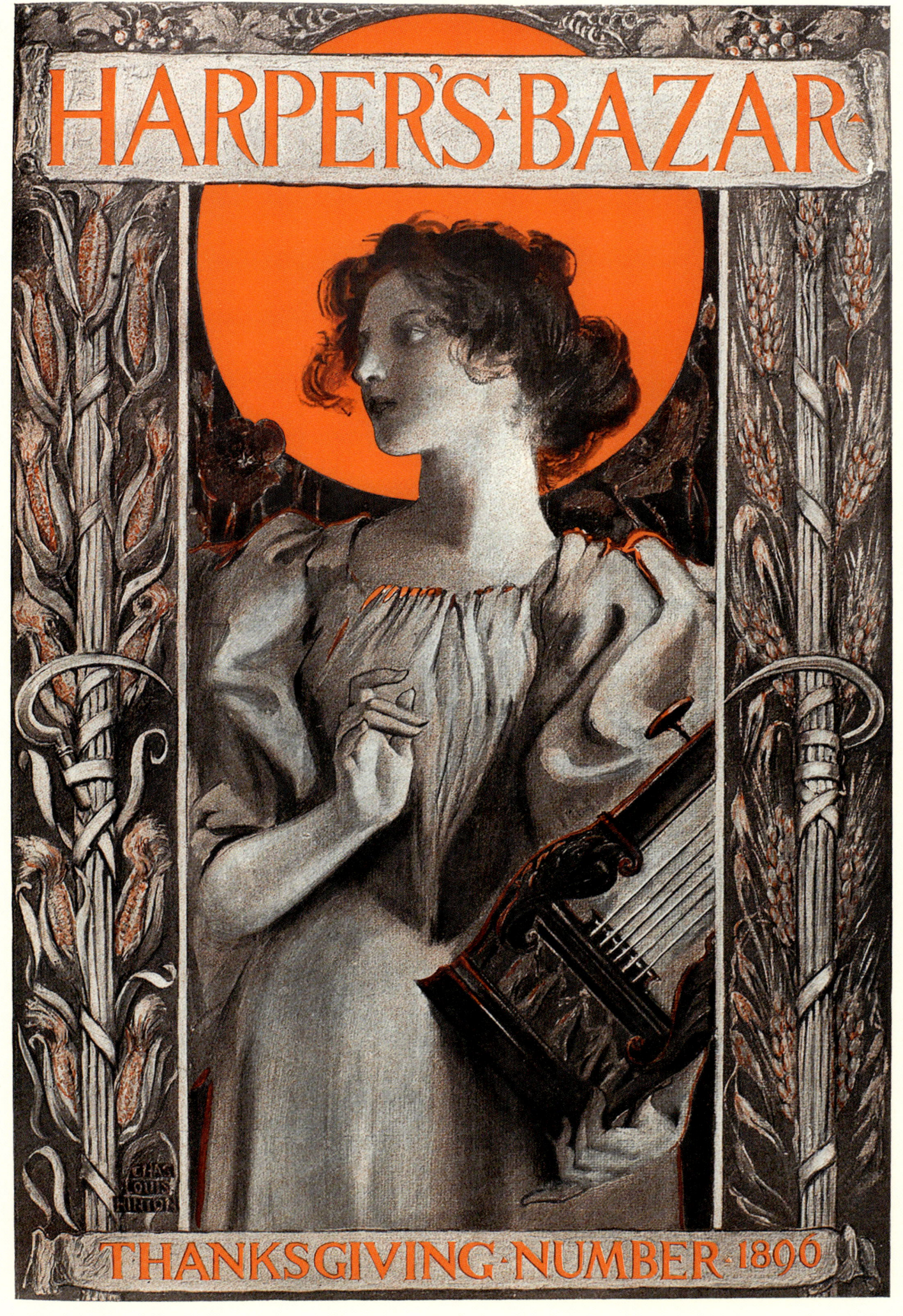

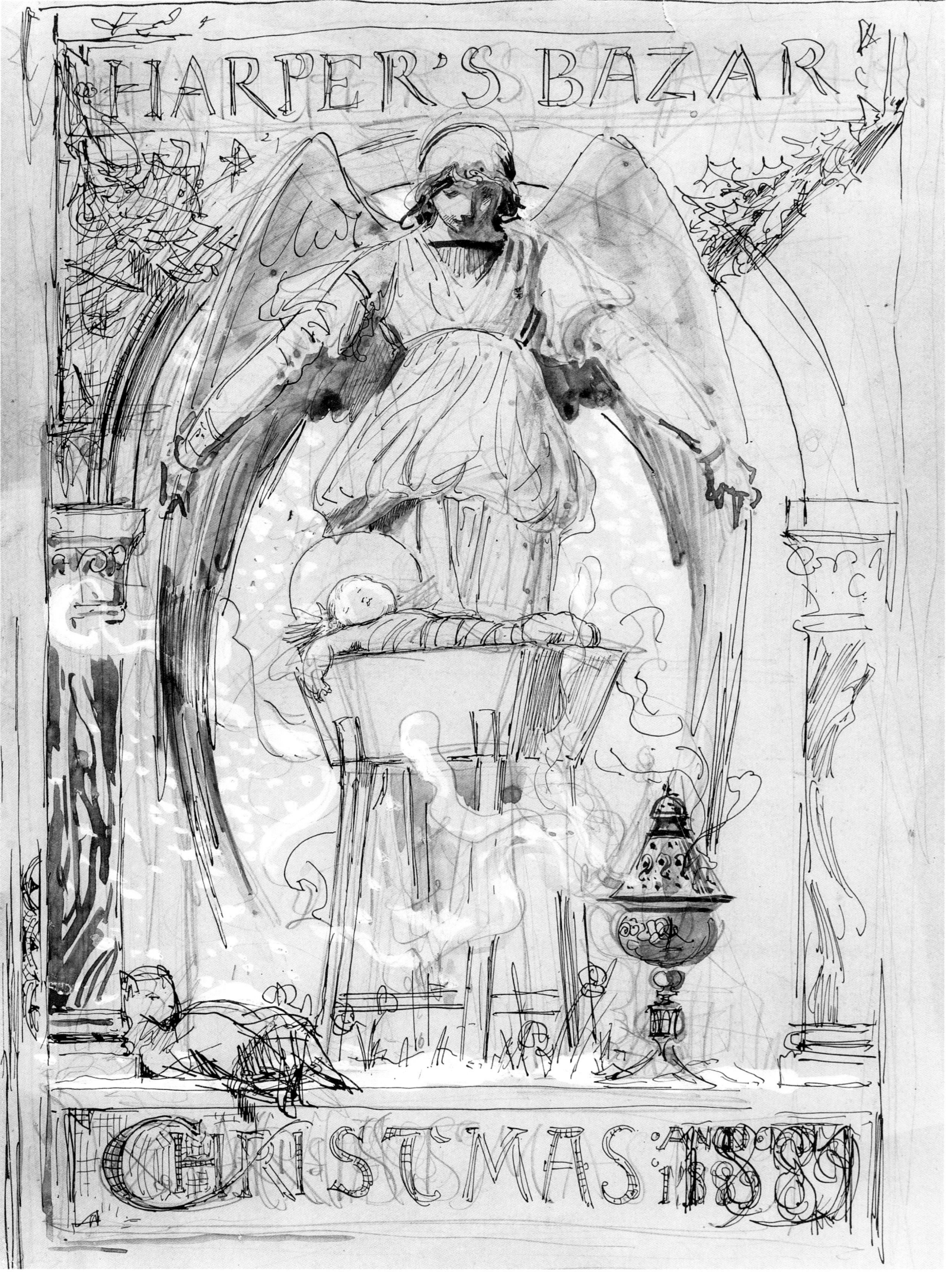

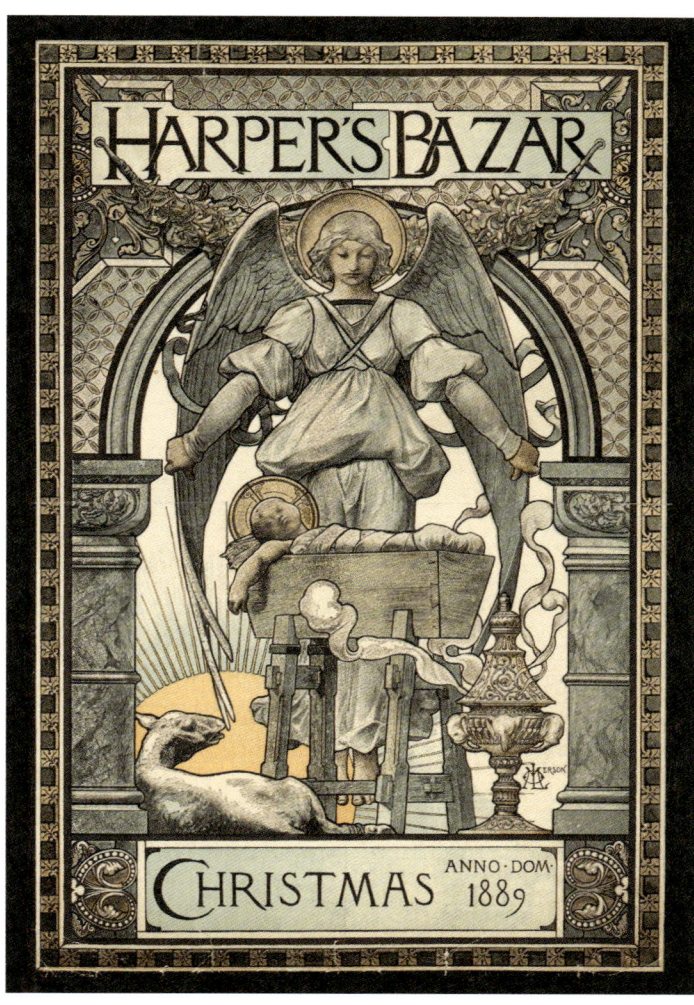
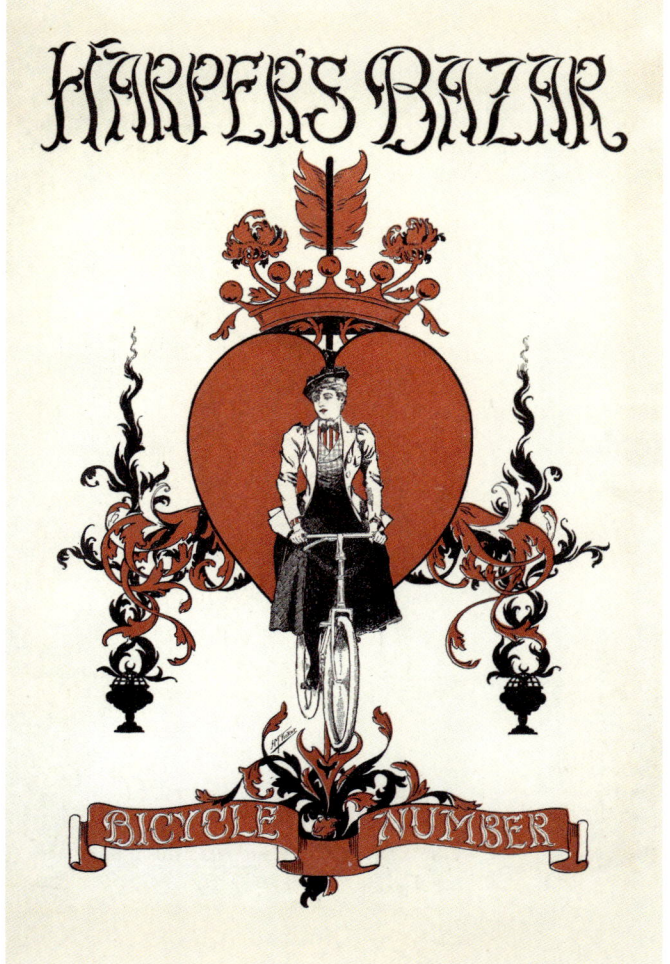
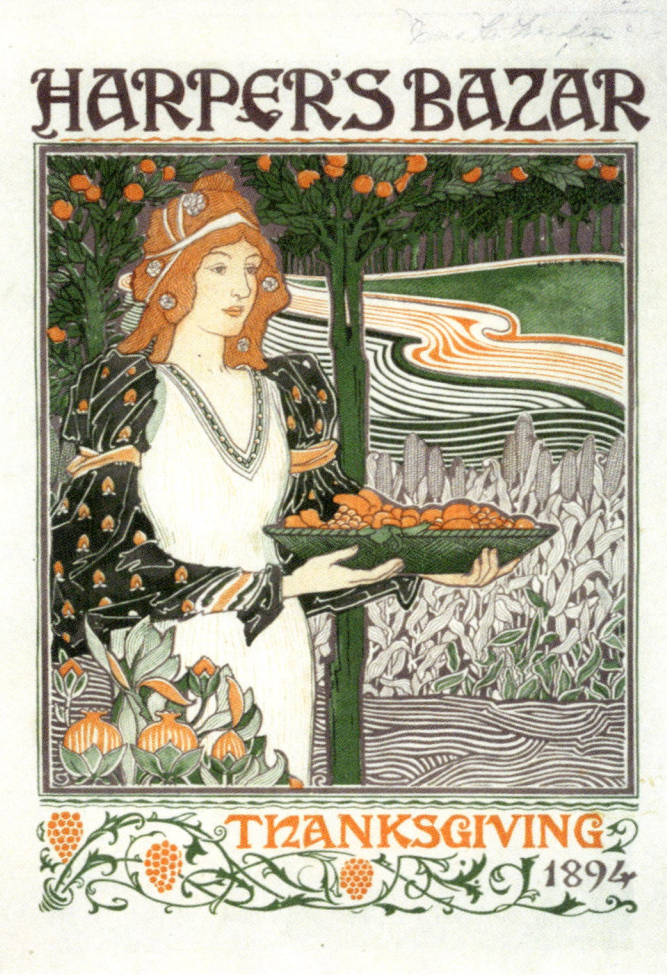
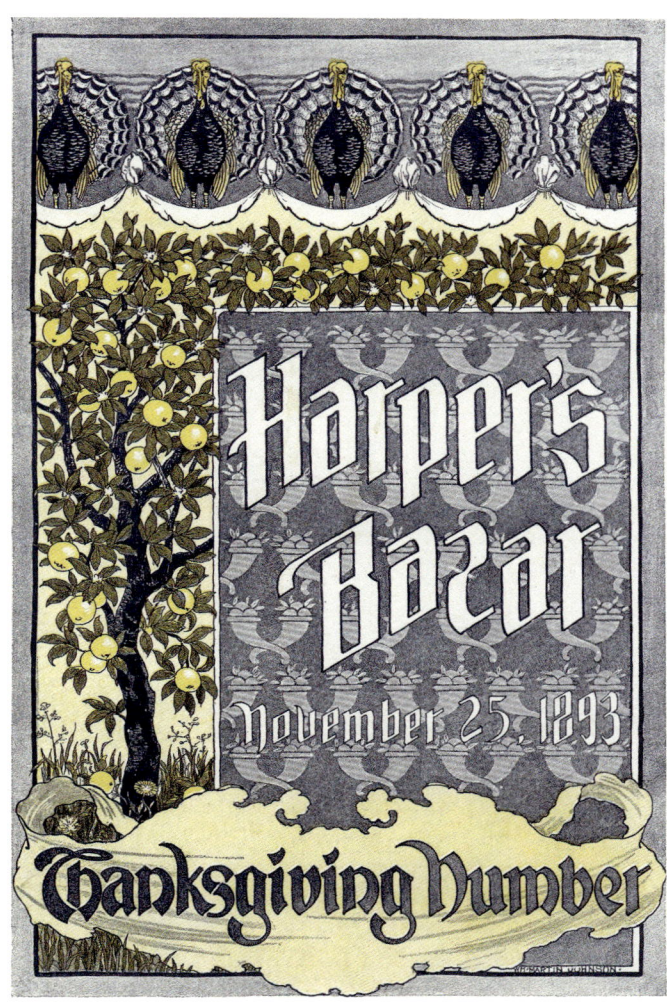

A Luc-Olivier Merson, "Harper's Bazar, Christmas 1889," pencil, ink, and gouache highlights on paper. Nantes, Musée d'Arts, inv. 983.21.110.D.

B *Harper's Bazar*, December 21, 1889, cover. Illustration by Luc-Olivier Merson.

C *Harper's Bazar*, March 14, 1896, cover. Illustration by Harry Whitney McVickar.

D *Harper's Bazar*, November 24, 1894, cover. Illustration by Louis Rhead.

E *Harper's Bazar*, November 25, 1893, cover. Illustration by William Martin Johnson.

ROMAIN DE TIRTOFF, AKA ERTÉ

Press magnate William Randolph Hearst bought *Harper's Bazar* in 1913. Two years later, he signed a contract with Russian-born artist Romain de Tirtoff, known as Erté, commissioning the latter for a monthly cover drawing and illustrations. As his contract was regularly renewed until 1936, Erté's drawings had a profound impact on the aesthetics of the magazine. In contrast with the black and white inside pages, his precious, exotic, dreamlike images were brightly colored. Erté, an illustrator, scenographer and costume designer for theater, opera and music hall, began his career as a fashion illustrator and designer in 1910 with Paris-based couturier Paul Poiret. The latter, at the peak of his fame, and Leon Bakst, costume designer for the Ballets Russes, staked rival claims to authorship of the Orientalist trend. Bakst made his name as a stage designer with the triumphant productions of *Cleopatra* (1909), *Scheherazade* (1910), *Le Spectre de la rose* (1911), and *Daphnis et Chloe* (1912). His collaboration with dancer and choreographer Vaslav Nijinsky culminated in the creation—and ensuing scandal—of *L'Après-midi d'un faune* in 1913.

Bakst designed a cover for *Harper's Bazar* in October 1913; Erté's first cover appeared in January 1915. William Randolph Hearst was probably following the example of *Comœdia illustré*, a French theater magazine which featured Ballets Russes programs decorated with Bakst's magnificent drawings. With drawings in the same vein, Erté's long-term contribution to *Harper's Bazar* ensured the aesthetic and social impact of the magazine. "His love of colour is the heritage of his race, and this combined with the inspiration he receives from his adopted country, France, makes him one of the most remarkable artistes of his day."[1]

The Orientalism, opulence, and choreographic inspiration characteristic of Erté's style were also de rigueur for other illustrators hired by Hearst. The magazine presented the work of George Barbier, who designed covers in 1914, as follows: "It was his association and intimate knowledge of early Etruscan paintings, Egyptian paintings, old Japanese prints and Persian miniatures that inspired him to apply and modernize these antique designs."[2] The artists Edmond Dulac, Léon Benigni, and André-Édouard Marty drew Egyptian, Byzantine, Persian, or Chinese-style figures, with the occasional playful inclusion of a shepherdess with doves.

Bakst's artwork was not the only aspect of the Ballets Russes that influenced fashion and its illustration in *Harper's Bazar*: each of the dance company's productions seems to have been a source of inspiration. The 1917 ballet *Parade* introduced a "new spirit," described by Guillaume Apollinaire as "a kind of surrealism";[3] it presented a fantasy repertoire of costumed circus performers —acrobats, horsewomen, a Chinese conjuror— and introduced the character of the "Little American Girl," representative of a nascent American identity.

The creative process used by the Ballets Russes involved constant experimentation with artists from various horizons, resulting in the intermingling of classical ballet with popular or ancient dance traditions. *Harper's Bazar* took a similar approach, creating cocktails of luxury products, art and society news, literature, and special features. Each article required an appropriate illustrative technique (oils, watercolor, pastel, wash, charcoal, etc.) according to its content: tasteful, society topic or lighter,[4] more frivolous subject. Étienne Drian,[5] dubbed "the greatest fashion draughtsman in the world," produced a beautiful etching depicting a theater box as a sort of extension of the literary salon; he was invited to draw for *Bazar*, as was Jean-Gabriel Domergue, an artist and celebrity portraitist whose sitters included Mrs. William Randolph Hearst. Bernard Boutet de Monvel, who demonstrated his exceptional skills at the *Gazette du bon ton*, also worked for *Harper's Bazar* before becoming the favorite portraitist of American Café Society.

In the 1920s, photography began to compete with illustration. Lucien Vogel launched the French photography magazine *Vu* in 1928. At *Harper's Bazar*, Baron Adolphe de Meyer's photos were gaining ground but color illustrations by Erté (or sometimes Benigni) continued to reign supreme on the covers. Erté's gouaches were becoming increasingly angular and Art Deco in style, with New York skyscrapers appearing in his *tondi*, reflecting the combination of Orientalist and machine-age aesthetics—like the Chrysler Building, whose diadem or kokoshnik-style crown recalls the tiers of platinum, diamond, and onyx palmettes and lotus flowers in Louis Cartier jewelry.

1. *Harper's Bazar*, vol. 50, no. 11, November 1915, p. 19.
2. J. H. Duval, "The Man who Drew the Cover," *Harper's Bazar*, vol. 49, no. 4, April 1914, p. 42.
3. Program for *Parade*, May 1917, Guillaume Apollinaire, *Œuvres en prose complète*, Paris, Gallimard, vol. II, 1991, pp. 865–867.
4. Ralph Barton, for example, added amusing illustrations to Anita Loos's novel *Gentlemen Prefer Blondes* from 1925 on accompanying his sketches with comical extracts: "Kissing your hand may make you feel very good but a diamond bracelet lasts forever." *Harper's Bazar*, vol. 58, no. 2552, June 1925, p. 92.
5. *Harper's Bazar*, vol. 49, no. 1, January 1914, p. 4.

A Erté, *Le Rêve… Le plus beau voyage…*, gouache on card stock, 1923. Paris, Musée des Arts Décoratifs, purchased with the support of the Friends of the Musée des Arts Décoratifs, 2019, inv. 2019.40.1.

A Paul Poiret, *Han Kéou* dress, trimmed figured satin, velvet and plush silk by Bianchini Férier, 1922. Paris, Musée des Arts Décoratifs, gift of Denise Boulet-Poiret, UFAC collection, 1963, inv. UF 63–18–9.
The silk is trimmed with Chinese medallions, while the flared hips of this "robe de style" evening dress recall the hoop skirt. This creation, from the wardrobe of Madame Paul Poiret, combines the Orientalism and historicism that infused the work of Erté and the Ballets Russes.

B *Harper's Bazar*, covers, May 1918 (B1), May 1926 (B2), September 1920 (B3), August 1922 (B4), June 1923 (B5), September 1919 (B6), November 1924 (B7), December 1922 (B8), October 1920 (B9). Illustrations by Erté.

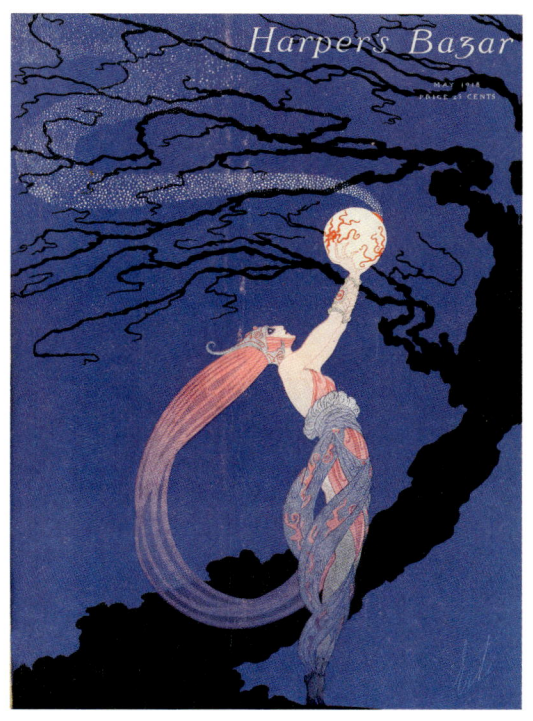
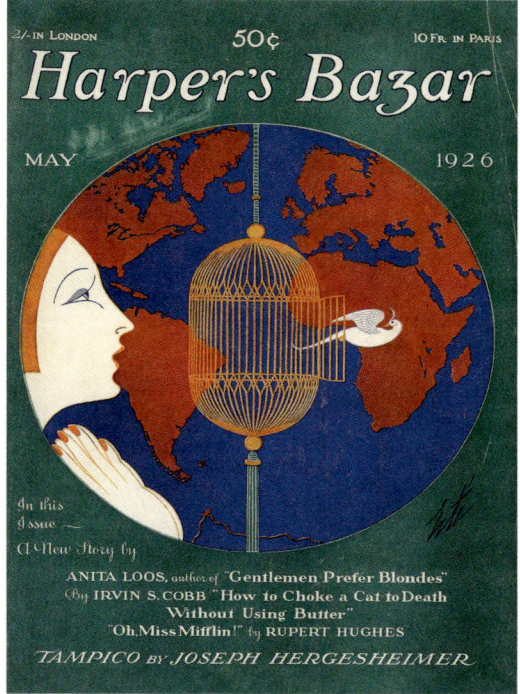
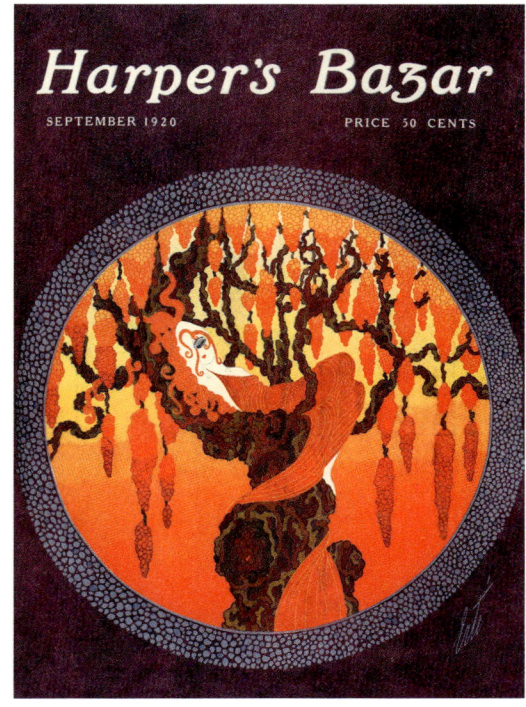
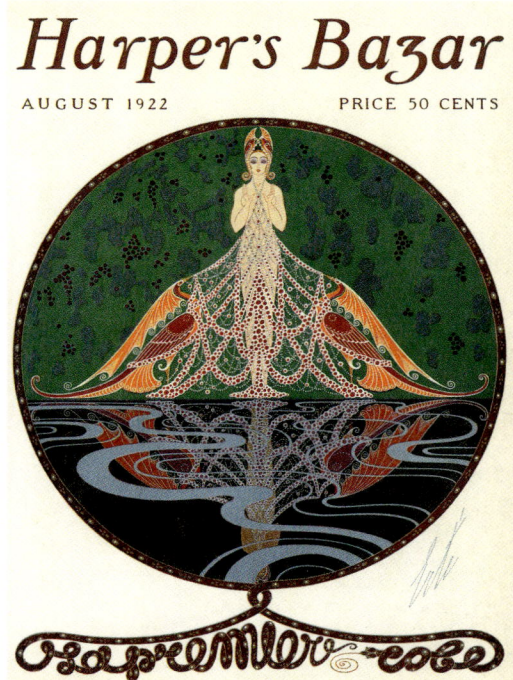
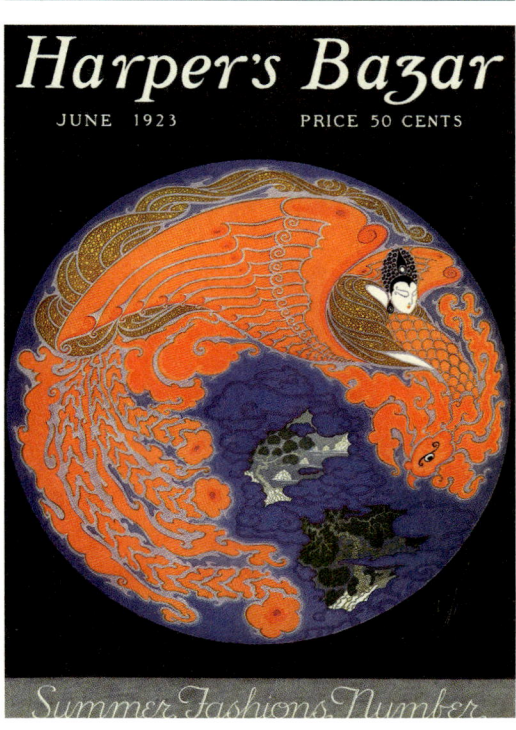
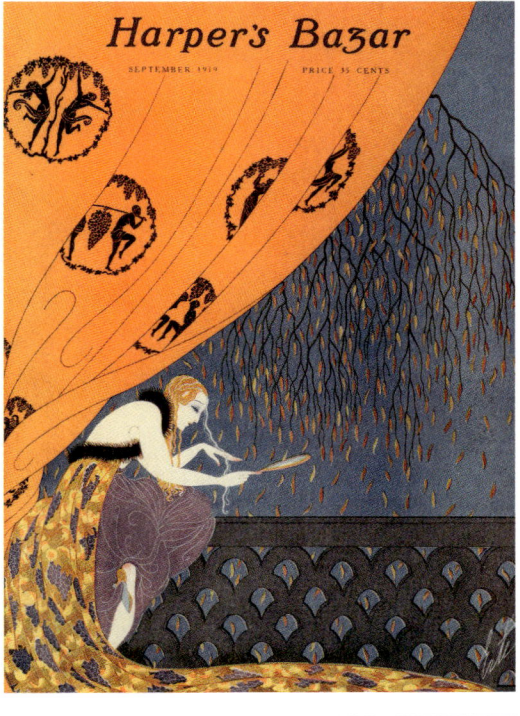
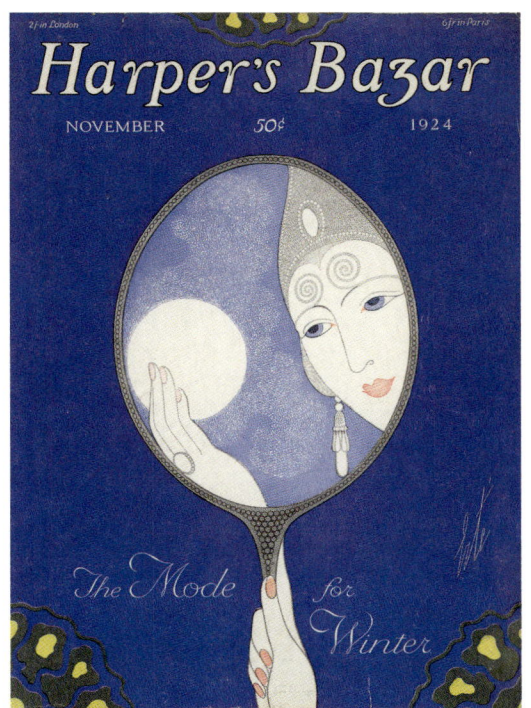
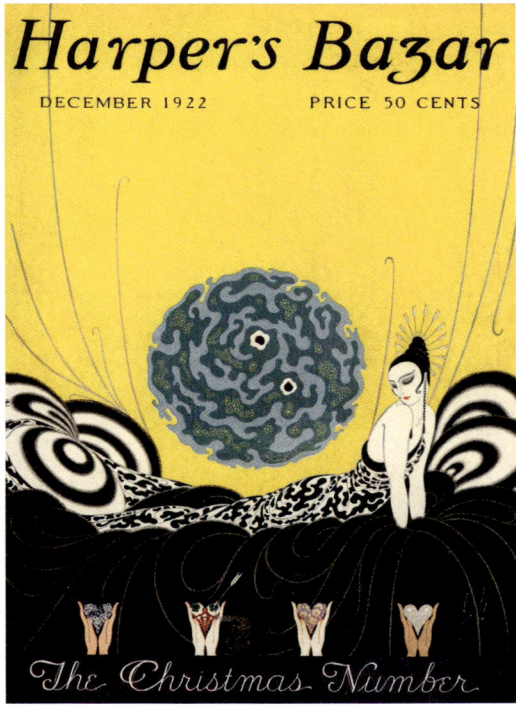
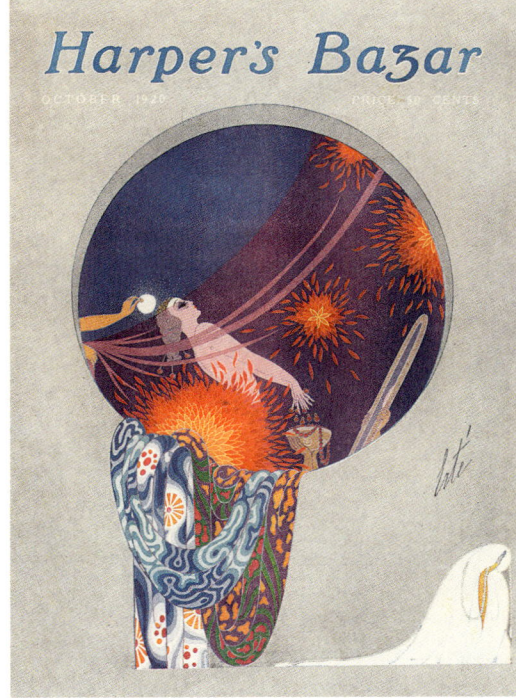

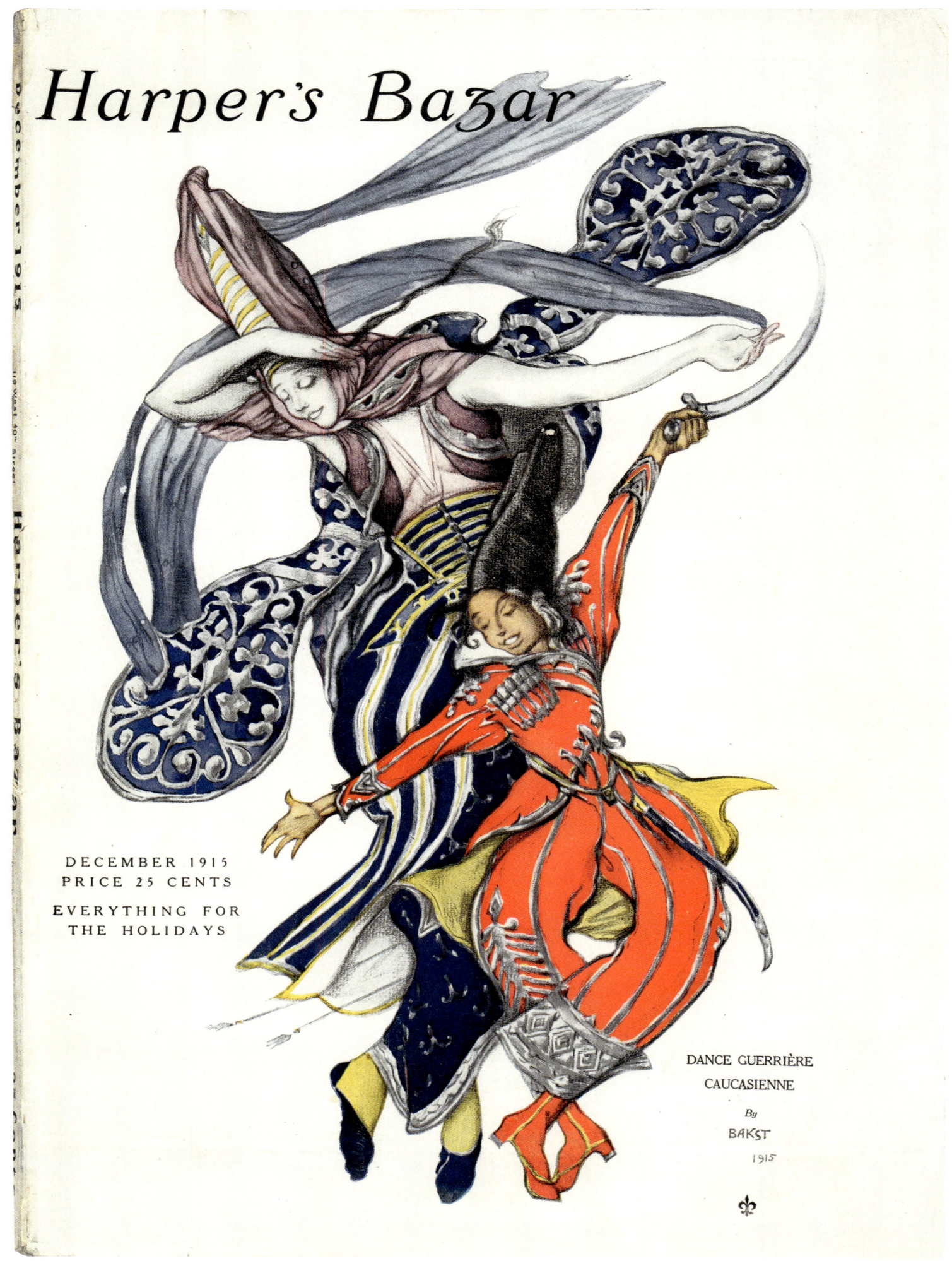

A *Harper's Bazar*, December 1915, cover. Illustration by Leon Bakst.

B "Nijinsky, Karsavina, Tchernichova," *Harper's Bazar*, December 1915, p. 46. Photographs by Emil Otto Hoppé. The costumes and background sets are from Leon Bakst's *Scheherazade*.

Nijinsky Karsavina Tchernichova

trained in the ballet schools and the imperial theatres of Russia.

The dancers appear in twelve or more ballets, each different in scenery and costume and all designed by Léon Bakst, the most distinguished artist in line and colour now known to the theatre. The sombre magnificence of his setting of *Scheherazade*, the fantastic detail of his India of *Le Dieu Bleu*, the endless opulence of evanescent light that floods *Narcisse*, his Egyptian temple of orange blocks, through the columns of which are glimpsed the deep ultramarine line of the Nile, make pictures such as our stage has rarely presented. M. Diaghileff has prevailed upon M. Bakst to come here this season to assist in the production.

It takes a master workman to bring together all the factors of the ballet and bend them to a common end. Such a master was found in the person of Michael Fokine, who has accomplished most marvelous results. He has planned the movements, the grouping, the gesture, now graceful and delicate, now savage and barbaric; he has synchronized the music

Harper's Bazar, December, 1915

with the moving figures, harmonized the colouring by lighting and by grouping until he has succeeded in bringing to the modern stage the most exotic pictures of which it can boast. The Russians have been liberated from the strict ballet technique by the Slav dances of the peasants and the Greek discoveries of Isadora Duncan. So Fokine has arrived at a freedom in his use of gesture and grouping hitherto undreamed of in the formal field of the ballet. In this director's scheme each *coryphée* plays her separate part. The Russian ballet addresses itself to the imagination and the emotions through the eye rather than through the ear. In some of its pieces it subordinates the music to the spectacle. Nevertheless the music plays a most important part.

Since Tchaikowsky wrote three ballets for the Imperial Opera Houses, no Russian musician has deemed it less than an honour to follow suit. Strawinsky, Glazunow and Tcherepnine have done so. The Ballet Russe has also inspired the genius of many of the great composers of other nationalities. Richard Strauss wrote *The Legend of Joseph* for the

47

Russians, Maurice Ravel, *Daphnis et Chloe*, Reynaldo Hahn, *Le Dieu Bleu* and Claude Debussy, *Jeux*.

The Russians will be seen here in several of the masterpieces of their *répertoire:* the curious and sensual *L'Après-Midi d'un Faune*, Debussy's prelude, with action devised by Nijinsky; the fragrant and prettily decorative *Papillons*, *Les Sylphides*, *Carnaval* and *Le Spectre de la Rose*, with music by Schumann, Weber and Chopin and with Bakst's fanciful variations of the conventional ballet skirt; Reynaldo Hahn's Hindoo extravaganza, *Le Dieu Bleu*, in which occurs an iridescently marvelous peacock dance; the wild and barbaric dances from Borodine's opera, *Prince Igor*, the most bloodstirring offering of the Russians; the Greek pantomime, *Narcisse*; the tragic and myriad-hued *Scheherazade*, Rimsky-Korsakof's familiar orchestral suite, transformed into a ballet with the story of the prologue of *The Thousand-and-One Nights* as its theme; and Strawinsky's vibrant story of the Russian carnival *Petrouchka*, told by puppets in action.

36

A B

A Jeanne Lanvin, *Inquiétude* evening gown, figured panne velvet, haute couture, Fall/Winter 1935. Paris, Musée des Arts Décoratifs, purchased 1991, inv. 991.91.

B *Harper's Bazaar*, May 1935, cover. Illustration by Erté.

ADOLPHE DE MEYER

1. The person who replaced de Meyer at *Vogue* was none other than Edward Steichen, who would be supported by Carmel Snow, fashion editor at the time.
2. Adolphe de Meyer and Man Ray both worked on the same commissions. For example, a beaded Chanel gown photographed by Adolphe de Meyer for *Bazar* in November 1928 was photographed by Man Ray in the 1930s (inventoried AM 1994–393 [271] in the Centre Georges-Pompidou collection).

Born in Paris in 1868, Adolphe de Meyer was made a baron after his marriage in 1899 to writer and socialite Olga Caracciolo, supposedly the illegitimate daughter of King Edward VII of England. De Meyer was a member of the early twentieth century's international intellectual elite and a supporter of the Photo-Secession movement launched by Alfred Stieglitz. He worked with the Ballets Russes in Paris in the 1910s and his book on the *Prélude à l'après-midi d'un faune* was published by Éditions Paul Iribe in 1914. His now famous photographs of Vaslav Nijinsky as a faun must have appealed to Condé Nast, who hired him at *Vogue* in 1913; de Meyer thus became the magazine's first chief photographer. Ten years later, at the request of Hearst himself (who also poached the illustrator Erté from *Vogue*), he was hired by *Harper's Bazar* for a ten-year contract.[1]

His contribution to the magazine was far more than photographic. Baron de Meyer wrote regular articles from Paris, visiting couturiers and recounting his impressions of the latest trends. His membership of the Paris smart set gained him easy access to the couture houses and their major clients.

De Meyer's photography of women is often of expressionistic character where his models appear as evanescent, diaphanous creatures, hovering between light and shade. His images captured the dazzle of beaded and sequined gowns, the transparency of layers of tulle, the glitter of high jewelry. They also set new fashion trends: couturiers probably began to anticipate de Meyer's photographs, or were inspired by them to create designs dominated by black and white. Jeanne Lanvin's *Pénombre* evening gown, seen through Baron de Meyer's lens, creates the illusion of a draped figure sculpted by lateral light. The photographic and cinematographic aesthetic of black and white thus influenced fashion design in the 1920s and 1930s, and may have been at the origin of the legendary "little black dress."

The rich graphic ornamentation in Adolphe de Meyer's work and the magnificent geometrically designed decors (often enhanced with mirror effects) framed the figures with bright facets of light. The use of a photographic chamber required lengthy posing sessions in the studio, carefully studied attitudes, and skillful lighting. As a result, the stately and sculptural female figure appears frozen, while her gown sparkles within a kaleidoscopic space. Such fashion photos with their careful layout, surrounded by a frame with the artist's handwritten signature below, served as society portraits—and in many cases, the fashion photographs of the period were portraits of celebrities. This enduring aristocratic bias, together with the predilection for the artificial lights of cinema, music hall, and magic shows, created an ideal woman who was enigmatic, aloof, sometimes almost supernatural. The imagery of cabarets of the 1930s made frequent use of this figure of the vamp.

Baron de Meyer's contract came to an end in 1934. *Harper's Bazaar* replaced him with new photographers such as Man Ray—another society portraitist.[2]

CHANEL

WHITE MOUSSELINE
embroidered in pearls, silver, and rhinestones

A *Harper's Bazar*, April 1925, p. 96.
Photograph by Adolphe de Meyer.

BARON DE MEYER VIEWS THE MODE

Seen Through Baron de Meyer's Analytical Eyes, The Mode Resolves Itself Into Easily Perceived Features

18 rue Vaneau, Paris.

DRESSMAKERS' collections always make a brave show on the day set for their formal openings. A festive atmosphere pervades the showrooms, which somehow disposes my brain to be more receptive. I therefore take advantage of my numerous invitations and try to attend all the openings.

I have acquired a number of pleasant memories, some of which I would not have missed for worlds. Among these is the beauty of the Vionnet collection, so full of invention—this creative artist at her best. I am grateful to Patou for giving me something new to write about, something people will like, dislike—anyway, discuss! His reverting to the normal waist-line, his having discarded black in his collection in favor of rainbow shades—*couleurs en folie*, as they are termed—proved him to be the season's boldest innovator.

I devote a pleasant and grateful memory to the lovely Chanel collection, pervaded by this designer's fragrant note of elegance; while the record-breaking crowd at Lelong's on the two opening days, when orders were still given and accepted at one A.M., is still vividly in my mind. Many more such notable facts are worth recording, but I notice I am wasting time on an introduction.

THE VIONNET INDIVIDUALITY

THE models of the Vionnet collection happen to be almost the first glimpses of the new spring fashions I was privileged to see. I shall therefore speak of them to start with. The style of the house is of such a decided character that one's first impression in coming across a new model, wherever it may be, is one of recognition. *Ah! C'est du Vionnet!* Its novelty, its detail, in fact, its beauty comes to one only later. This stamp of individuality is a great asset. Madeleine Vionnet's stock of new ideas seems inexhaustible, though she reverts in many instances to devices, almost classics, of the Vionnet traditions, such as circular ribbon roses, favorite cut-out effects, or, as just now, her famous fringes. She succeeds in giving these time-honored decorations a new twist and presents them in such a novel way as to make them more attractive, more delightful than before. Strange to say, this season's most sensational Vionnet models are those on which our old friend "the knotted fringe" figures prominently.

For sports and Southern wear fawn-colored homespun and butter-colored kasha, as well as white ratine or serge, are very popular. For town wear colored gabardines in violets or greens are a great novelty. These materials are made into plain tailored suits of an impeccable masculine cut. They are worn with printed neck scarfs, closely tied around the neck, an identical handkerchief hanging out of the pocket, reaching below the skirt hem.

Crêpe gowns are very numerous; some are gathered about the neck-line and have small godets for the sake of fulness around the hips. A red frock has elongated pieces of pink crêpe inserted in the material.

Many gowns are decorated with tucks all over them; tucks of fabulous workmanship. Some of these are shaped into squares, others into lines and circles. Another departure is a Georgette gown made of several horizontal bands stitched together. These bands are of shaded tones in *bois de rose* or green. Nothing, however, pleases me as much as the series of flounced *mousseline de soie* dresses in

The invitation card on the mirror

Crossing the bridge and the Place de la Concorde

Leaving 18 rue Vaneau

plain or printed materials with scalloped flounces sewn on in wavy lines. These are quite a feature of the collection. The skirts are dreams of billowy and floating flounces, which somehow this season have a way of billowing and floating in quite a novel way. Another of this season's novelties are tunics of *mousseline de soie*, almost shaped like coats, either plain or figured, to be worn over a different colored foundation. As I have already mentioned, fringes—which many people consider quite passé—have been revived by Madame Vionnet. She somehow seems to have given them a new lease of life.

VIONNET USES FRINGE

THEY look new to me, almost the most novel evening gowns I have seen, so far. There are several such models in black and in white, and one in red, covered in diagonal zigzag lines by graduated navy blue fringes. This gown in coloring, at least, seemed to me the most original of the series. One white crêpe gown, a clinging chemise, is hidden entirely by white fringes of different lengths, which form a bewildering maze of geometrical designs. Another white gown, a marvelous invention, has gleaming white fringes wound like a spiral around the figure, starting at the shoulder and ending on the skirt hem. A black model is shown with a long-fringed shawl, which has a winglike Watteau effect in fringe, truly wonderful. To close this series, I was shown a white satin gown with bands of black silk "knotted-in" fringes, which is very stunning.

Of course, there are any number of other evening gowns. One in flesh satin, for instance, has a design of Greek horses on a background of heliotrope tubes and beads. It looks very unusual. However, this is but one of a dozen others in a most fascinating collection brimful of inspiration.

PATOU HAS SUCCESS

PATOU'S opening caused a sensation. His collection was universally voted quite unsurpassable, which expression was heard on every side. It floated through a festive atmosphere, from a festively inclined assembly, composed of many Parisian and American notabilities.

The most striking feature of the Patou collection is the almost normal waist-line. In spite of its displacement, this new departure does not clash too violently with the line of previous seasons, though it is higher than it has been for many years. Both coats and skirts are fuller, jackets shorter, some almost of bolero length, unless on the contrary they are very long. Kasha, preferably beige, both plain and embroidered, figures extensively for sports purposes. A new washable material, suitable for summer gowns, is called "crêpe gigolo." Hyacinth, pervenche, lavender are tones very popular this season, especially when in combination with navy blue. With blues and pinks, and with a lovely shade of beige rose, almost apricot, they are the leading colors in the Patou collection.

His evening gowns this season are a riot of color. Prismatic rainbow shades are the outstanding novelty. Gowns fashioned out of these materials are unsurpassably rich, in fact bewilderingly so. Mr. Patou says himself, "Let us steer clear of excessive simplicity. Let us bear in mind that the fine point in all art is to give, beyond doubt, the impression of perfect simplicity, but let us obtain it by a research for detail and the most refined technique." He adds, "Fashion is again becoming rich." Somehow it is impossible to imagine how Mr. Patou next season can surpass his present gorgeousness. He seems to have achieved the maximum.

Every means of giving the impression of a higher waist-line is cleverly taken advantage of, be it by a line or a flounce placed higher up than hitherto, by a belt, or maybe only by a pinch in the material. The fabrics seem to cling much closer to the figure, while skirts in most instances are fuller, more flaring, producing a rippling movement, especially when made of light materials. A charming gown exemplifying this style is "Claridge." It is of beige rose Georgette crêpe.

There are almost no satin day gowns in the new Patou collection, in fact, black satin is used in very few instances. Patou now considers black too utilitarian. *Diamant rose* is one of the new shaded crêpe evening gowns. It is designed in cerise vanishing into pink, and is closely *clouté* with pink and red diamonds. The gown is slightly draped, excessively short in front, and hangs very low at the back. The series of rainbow gowns, bejeweled, befringed, and heavily embroidered in every known sparkling bead, is a revelation. Of these *tissues dégradés*—pink, blue, green, yellow, violet, et cetera—shades of which the great Loie Fuller dreamed but which she hardly ever realized, one can but say, "astounding." They cannot be described, they must be seen.

There are coats to harmonize with every one of these astounding gowns. They form an ensemble, for, as Patou says, "The ensemble is the summons of chic for the elegant woman; a long career is in store for it." Less riotous and therefore more distinguished is a really lovely white crêpe frock. It apparently has three waist-lines, produced by bands of diamonds embroidered on the clinging bodice part, while the very soft but full skirt is studded in a regular all-over design of sparkling diamonds. The model is called "*Vierge folle*."

Nothing can be more beautifully elegant than "Anthinéa," an ensemble produced by a liquid silver evening coat fashioned on the best Patou lines, trimmed with dark fur borders, lined in pink velvet, and worn over a rose and silver gown.

In speaking of the new Chanel collection I cannot express my own impressions better than in Mademoiselle Chanel's own words. Why, therefore, look for others? This is what she said to me on the opening day.

"In designing my new models I have neither labored nor broken my head in order to create sensational new departures. My clientele does not require this, in fact, it would be resented. Sensation and eccentricity are justified for those who have to make up by such methods for what comes to me naturally—good taste. I believe my collection to be comprehensive. It contains what every woman needs, now they have realized that in order to be well dressed they have to adopt the style of one house, be it mine or the style of some other first-class establishment, but have to remain faithful to it. Women who dress in half a dozen different houses hardly ever succeed in looking smart. Therefore, the ones who come to me come here expecting to see only Chanel gowns, no others. Chanel gowns are synonymous with elegance, so if I've labored—and believe me, I've worked hard over this collection—I've labored to create nothing but elegance. Have I succeeded?"

"Yes, you have," was my reply.

"Well, then, if you think my collection elegant it is sufficient. It contains a great many novelties, but requires the experience of a seasoned dresser to detect its subtleties."

THE ELEGANT CHANEL

FOR sports purposes thin jerseys and homespuns are used in a happy combination. Jersey alone is made into little daytime gowns worn under kasha and crêpella coats.

Crêpella, both for gowns and coats, is quite a feature of the house. Some of the coats of this material are unlined, therefore only possible for summer

Arriving at the maison de couture

léon bénigni

A Adolphe de Meyer, "Baron de Meyer Views the Mode," *Harper's Bazar*, April 1925, pp. 98–99. Illustrations by Léon Benigni.

42

for NOVEMBER 1928

CHANEL

Splendor is simplified by Chanel in this gown. The gold tissue is embroidered in lines of jewels, making a flexible, brilliant sheath. Only Chanel could weave jewels into subjection.

A B
 A Chanel, evening gown, embroidered organza over an underdress covered with pearls and rhinestones, haute couture, Fall/Winter 1928. Paris, Musée des Arts Décoratifs, gift of Madame Jean Larivière, UFAC collection, 1972, inv. UF 72–18–1 AB.

Adolphe de Meyer appreciated the photogenic quality of this jewel dress, as did his successor at *Harper's Bazar*—we know of seven contact prints by Man Ray featuring the same model.

B *Harper's Bazar*, November 1928, p. 99. Photograph by Adolphe de Meyer.

A B C
A Jeanne Lanvin, detail of the *Pénombre* evening gown, silk chiffon embroidered with tubes, haute couture, Spring/Summer 1929. Paris, Musée des Arts Décoratifs, gift of Madame Lebel-Stapfer, UFAC collection, 1951, inv. UF 51-2-1. The contrasting embroidery creates a bold, music-hall lighting effect. This piece entered the museum's collections together with a wavy flapper-style wig in black horsehair by Jeanne Le Monnier.

B *Harper's Bazar*, April 1929, p. 74. Photograph by Adolphe de Meyer.
C Jeanne Lanvin, collection drawing, gouache on paper, *Pénombre* gown, Spring/Summer 1929. Patrimoine Lanvin collection, Paris.

CARMEL SNOW

After a stint as fashion editor at *Harper's Bazaar* (reporting to top editor Arthur Samuels), Carmel Snow became editor in chief in 1934 —a landmark event in the history of the magazine and one which set it on the path to modernity.

Snow had trained at *Vogue* in the 1920s, acquiring a critical eye and clear-cut views on editorial content; she remained grateful to Condé Nast all her life. After being hired at *Bazaar* by William Randolph Hearst, she wasted no time in restructuring the magazine, which had previously focused on fiction,[1] organizing it into two main sections: fashion and "fiction and features" (literary texts and articles on fashion, beauty, and art). As editor in chief, she worked hand-in-hand with the fashion, fiction, and art directors,[2] but it was Snow who had the last word. Her clear sight and snappy decision-making have since remained legendary.

With her love of all things French, Carmel Snow surrounded herself with new contributors from the Paris smart set: poet and illustrator Jean Cocteau, set designer Christian "Bébé" Bérard, journalist Janet Flanner (correspondent for *The New Yorker* with her *Letter from Paris*, written under her pen name "Genêt"), and Marie-Louise Bousquet, who held a salon on Place du Palais-Bourbon. She also enlisted the painter Marcel Vertès (who designed advertisements for Schiaparelli's *Shocking* perfume), designers/illustrators Jean and Valentine Hugo, and designer/painter Jean-Michel Frank. These various contributors all knew each other, collaborating on set design, fashion and advertising projects and organizing lavish fancy-dress balls (at the homes of the Noailles family and Étienne de Beaumont). By bringing them together, *Harper's Bazaar* became a kind of salon where artists could express their creativity. By appointing Mrs. Reginald "Daisy" Fellowes Paris editor of *Bazaar* in 1933, Carmel Snow associated herself with one of the fashion world's most influential and stylish women, described by Snow in her memoirs as the "fashion leader of Paris." So the Paris *Bazaar*[3] was in good hands!

Carmel Snow was quick to create a new image of women—sporty, outdoorsy, spontaneous, and fun-loving. She gave photography pride of place and persuaded Hearst to hire Hungarian photojournalist Martin Munkácsi, specialized in reporting for illustrated magazines, including the *Berlin Illustrirte Zeitung*. So the fashion models began to run and move naturally, hair blowing in the wind. The snapshot made its debut in the magazine—a revolution that put paid to Baron de Meyer's "still life" style by capturing reality without artifice or preparation.

With her skill as a talent spotter, Carmel Snow gradually managed to intensify the magazine's innovative dimension. By appointing Alexey Brodovitch art director in 1934, she intended to adapt this idea in the magazine, so as to make it an interesting and entertaining whole. She regarded Brodovitch as an ally, someone who shared her views of the magazine's advertising and artistic role and her bid for excellence in graphic design, editing, and pictorial and literary content. Over the next twenty years, they would succeed in reinventing *Harper's Bazaar*.

Carmel Snow's humanism and empathy appealed to influential collaborators and artists from the modern avant-gardes. *Harper's Bazaar* commissioned drawings from artists like Marc Chagall, Raoul Dufy, Pavel Tchelitchew, Leonor Fini, and André Derain, and promoted personalities such as Gertrude Stein, Colette, and Tériade (founder of the French art magazine *Verve*). By opening up to European culture, with Pablo Picasso, Henri Matisse, Constantin Brancusi, and Alberto Giacometti,[4] the magazine acquired a new intellectual and visual identity, enhanced by a greater focus on photography. A firm believer in the power of the photographic image, Carmel Snow recruited George Hoyningen-Huene (who left *Vogue*), Jean Moral, François Kollar, Brassaï, and Walker Evans in 1935, Louise Dahl-Wolfe in 1936, and Henri Cartier-Bresson, Richard Avedon, Lillian Bassman, Bill Brandt, Robert Frank, and Hans Namuth[5] after the war. Her goal was to create a synergy, engage reflection and critical thinking, and educate the tastes and perceptions of the magazine's readership.

Carmel Snow also took a political stance, especially with regard to women's place in the world of work (November 1934),[6] the condition of African-American artists (Marian Anderson, September 1937),[7] and housing in poor neighborhoods (report by Walker Evans, August 1939).[8] These articles, ingeniously included in the magazine, appear surprisingly modern even today.

Richard Avedon described Snow's style as follows: "She was the first to create this blend of arts and the best of photographs, the best of class and quality. The idea is not of an aristocratic life, but a life devoted to quality where everything mattered."[9]

Her working method consisted of reading the press first thing in the morning, and collecting articles on high-profile authors and celebrities and reviews of the latest plays, parties, and restaurants. The scrapbook design of *Harper's Bazaar* allowed for a mix of the latest fashion news and predictions of changes to come. As Snow often said, success depended on "having a finger on the pulse of the times."[10]

1. Fiction was promoted by *Harper's Bazaar* editors in chief, Charles Hanson Towne (1926–1929) and Arthur Samuels (1929–1934), authors in their own right and staunch defenders of contemporary authors such as Anita Loos, Virginia Woolf, D. H. Lawrence, and Somerset Maugham.
2. The prewar team comprised four members: Frances McFadden (managing editor, who followed Carmel Snow from *Vogue*), Alexey Brodovitch (art director), Diana Vreeland (fashion editor), and George Davis (fiction editor).
3. The Paris office of *Harper's Bazaar* was located at 15, rue de la Paix. It served a dual purpose: a propagator of Paris fashions and an information office for wealthy Americans staying in the French capital.
4. Alexey Brodovitch played an active role in opening the magazine up to the Paris modern art scene and was personally acquainted with artists such as Picasso, Chagall, and Dufy.
5. Robert Frank and Hans Namuth took numerous fashion photographs for *Harper's Bazaar*, especially for the "Accessories" section. Robert Frank would gain recognition in 1958 with his legendary book *The Americans*, first published by Robert Delpire. Namuth's photographs of painters of the New York School and, above all, his 1951 film showing the painter Jackson Pollock at work, had a major impact on the evolution of the new American abstraction.
6. "Working Girl" and "Girl against Wall Street," *Harper's Bazaar*, vol. 68, no. 2665, November 1934, pp. 64–67.
7. "Marian Anderson Sings," *Harper's Bazaar*, vol. 70, no. 2699, September 1937, pp. 98–99.
8. Katharine Hamill and Walker Evans, "2,196 families are living in the Williamsburg and Harlem River Housing Projects," *Harper's Bazaar*, vol. 72, no. 2726, August 1939, pp. 100–103.
9. Richard Avedon, interview with Calvin Tomkins, Calvin Tomkins Papers, New York, MoMA archives.
10. "Balenciaga and Dior are not in ivory towers. They are as sensitive as radar to everything that goes on in the world. For success in fashion rests on much more than a knack with scissors and fabrics. It means having a finger on the pulse of the times." Carmel Snow and Mary Louise Aswell, *The World of Carmel Snow*, New York, McGraw Hill, 1962, p. 196.
11. Carmel Snow and Mary Louise Aswell, *op. cit.*, p. 195.

Carmel Snow's personal fashion taste was reputedly impeccable. Her outfits came from Vionnet and Molyneux in the 1930s, and from Dior and Balenciaga after the war. She never missed the twice-yearly Paris fashion shows, where she was given pride of place—her sphere of influence, and her moment of glory.

Snow's keen eye could determine the future of the Paris creations, which were inevitably put to the ruthless test of time: "It is fascinating to see the birth of a new idea in the spring collection, and then to spot the same notion in the autumn line, matured and polished, maybe a little modified, like a fruit that has ripened during the summer. Sometimes the reporters miss the prophetic dress—the biggest fashion is not always the most obvious. Often a buyer will see it, and then deliberately skip it, knowing that her customers would find it too extreme. A magazine can and should take chances that a merchant can't. If I think a dress is important I don't care if it has been bought or not. I mark down the number in my little red book and give it to Avedon or Louise Dahl-Wolfe. The photography usually evokes both praise and criticism. But I just sit back and wait. For I know that six months, maybe a year, later the public will be ready for it and the fruit will be plucked."[11]

A Carmel Snow, editor in chief of *Harper's Bazaar*, May 11, 1951. Photograph by Richard Avedon (contact print).

A BLACK and WHITE PORTFOLIO
by Martin Munkacsi

Costume for a dryad—for a wraith in the summer dawn—for Miss Greta Garbo in her next divine moment: a voile nightgown, white as a cobweb, pleated all over like a Fortuny, in tiny box pleats—and over this, a trailing white voile wrapper, with full sleeves that end at the wrist in long pleated cuffs. It comes from Bergdorf Goodman.

A "A Black and White Portfolio," *Harper's Bazaar*, June 1936, pp. 56–57. Photograph by Martin Munkácsi.

A B

C D

E F

A Carmel Snow, "What this country needs is–" *Harper's Bazaar*, July 1936, pp. 52–53. Photographs by Man Ray.

B "The Colors That Go With Red Hair," *Harper's Bazaar*, December 1934, pp. 46–47. Illustrations by Christian Bérard and Jean-Michel Frank.

C "Pure Color and Perfect Form," *Harper's Bazaar*, November 1935, pp. 82–83. Illustrations by Pierre Pagès.

D "Plaisances et Rocailles," *Harper's Bazaar*, April 1936, pp. 74–75. Illustrations by Jean Hugo.

E "Suspense," *Harper's Bazaar*, September 15, 1939, pp. 50–51. Painting by Leonor Fini.

F *Harper's Bazaar*, July 1937, pp. 30–31. Illustrations by Jean Cocteau.

50

G	H	
I	J	
K	L	

G "Rhinestone Pyrotechnics," *Harper's Bazaar*, September 1946, pp. 252–253. Photograph by Leslie Gill.

H "Women are the Fashion," *Harper's Bazaar*, November 1945, pp. 80–81. Painting by Jean-Auguste-Dominique Ingres.

I "Care Gives Wings to the Feet... and Eloquence to the Hands," *Harper's Bazaar*, April 1942, pp. 66–67. Photographs by Erwin Blumenfeld.

J *Harper's Bazaar*, April 1948, pp. 158–159. Reproduction of a double page from the book *Jazz* on Henri Matisse's gouache cut-outs.

K "Your beauty horoscope," *Harper's Bazaar*, March 1935, pp. 78–79. Illustration by Jean Lurçat.

L "Black, White, Blond–and Blued," *Harper's Bazaar*, March 1945, pp. 82–83. Photograph by George Hoyningen-Huene.

51

A	B	C
D		

A *Harper's Bazaar*, September 15, 1937, p. 73. Illustration by Jean Hugo.

B Paquin, evening gown, silk velvet, haute couture, Fall/Winter 1937. Paris, Musée des Arts Décoratifs, gift of the Marquise de Paris, UFAC collection, 1970, inv. UF 71-27-9 AB.

C *Harper's Bazaar*, December 1939, cover. Illustration by A. M. Cassandre.

D Elsa Schiaparelli, collection drawing, gouache and ink on paper, Fall/Winter 1939. Paris, Musée des Arts Décoratifs, gift of Elsa Schiaparelli, UFAC collection, 1973, inv. UF-D-73-21-2524.

53

ALEXEY BRODOVITCH

Marianne le Galliard

"In my view, this artist represents a much-needed force and audacity and, above all, exactly the kind of spirit that can spark a momentum today, in 1930, and lead to a string of new discoveries in the visual arts." This is how journalist Philippe Soupault, a co-founder of the surrealist movement, described Alexey Brodovitch in the magazine *Arts et métiers graphiques* in 1930.[1] The article, in which the far-sighted Soupault predicted Brodovitch's influence within and beyond the field of graphic arts, is key to understanding the impact of the artist's research on the nascent discipline of graphic design. Brodovitch used *Harper's Bazaar* as a laboratory space in which he could develop his own language, reach a wide audience and build key contacts with photographers, art directors and admen. A whole new movement grew up around his work.

When Carmel Snow discovered Brodovitch at an exhibition in 1934 at the Art Directors Club of New York,[2] the Russian-born artist already enjoyed a certain renown. After arriving in Paris in the 1920s, he frequented the artistic community of Montparnasse (Pablo Picasso, André Derain, Anna Pavlova, Igor Stravinsky, Vaslav Nijinski, Alexandre Alexeïeff). He painted stage sets for Sergei Diaghilev's Ballets Russes and designed jewelry, objects, and textiles for Poiret, Cartier, and Bianchini. In 1924, he won a poster competition for the Bal Banal[3] and he became art director at the Aux Trois Quartiers department store in 1928, where he learned to work with photographers, decorators, and advertisers—an experience that would stand him in good stead. Brodovitch adhered to Diaghilev's view of the synthesis of the arts; like other artists of the time (Léon Bakst, Erté, Georges Lepape, Paul Iribe, George Barbier), he took an eclectic approach, producing stage sets, posters, ads, magazine covers, book illustrations and furniture pieces. In 1930, he left Paris to direct the advertising art department at the Philadelphia Museum and School of Industrial Art.

True to his credo "Publicity is born of life and life is learned through publicity,"[4] he shared Carmel Snow's vision of giving the magazine a distinctive identity.[5] Inspired by the ideas of the European avant-gardes (Bauhaus, Dadaism, constructivism, New Typography) and the language of cinema with its cuts and splices, Brodovitch's page layouts conveyed the dynamism of modern life, drawing the reader into its dance. Through surprise effects, the art of perspective and symmetry, close-ups followed by panoramas, blurred or distinct images, and dramatic scenes alternating with calmer ones, the vitality of layouts created a precise balance, and the distinctive dynamics of *Harper's Bazaar* in the 1930s attained an overall harmony.

However, this was not an easy task. A tremendous amount of very diverse content (fashion, fiction, celebrities, special features, shopping) had to be contained within a coherent whole. On top of that, each of the magazine's three pre-war fashion photographers had a distinctive personal style: Martin Munkácsi was spontaneous, Louise Dahl-Wolfe followed the pictorial tradition, and George Hoyningen-Huene showed a neoclassical influence. To manage such aesthetic diversity, in his first years at *Bazaar*, Brodovitch treated the magazine as a stylistic exercise in which page layout took precedence over pictures and the idea of a photograph as a finished image was abandoned.[6] He often asked photographers to propose their work in several different formats: "A layout designer has a simple task when the photos are good. He has to perform acrobatics when they're bad."[7] With Richard Avedon's arrival in the 1950s, the magazine's content tended toward greater simplicity and structural purity, befitting the designs of Christian Dior and Cristóbal Balenciaga.

The spontaneous style of the magazine might suggest considerable improvisation on the part of editor in chief Carmel Snow and layout designer Brodovitch. Nothing could be further from the truth! Together, they designed the magazine methodologically and seriously, spreading it out on the floor. Blank pages gradually gave way to editorial pages, like a flipbook: "The magazine was always on the floor of her office. Normal size. The month started with the floor covered in white. Blank pages. Maybe the well of the magazine was sixty pages. And you'd see everything as it came in go down on the floor. Carmel and Brodovitch would shift it and change it. They would walk right on it and across it. It was a magical thing."[8]

A good many photographers and art directors were trained in Brodovitch's Design Laboratory Classes at Philadelphia, then at the New School for Social Research in New York from 1941 onwards;[9] many of them were published in *Harper's Bazaar* before going on to enjoy an international career: Irving Penn, Richard Avedon, Robert Frank, Leslie Gill, Lisette Model, Lillian Bassman, Bill Brandt, Louis Faurer, Marvin Israel, Saul Leiter, Hiro, James Moore, Karen Radkai, Ben Rose, Francesco Scavullo, Diane Arbus …

1. Philippe Soupault, "Alexey Brodovitch," *Arts et métiers graphiques*, no. 18, July 15, 1930, p. 1015.
2. The Art Directors Club of New York (ADC), founded in 1920, launched a number of exhibitions and awards.
3. The *Bal Banal* was held in 1924 by the Union of Russian Artists in the Salle Bullier on Avenue de l'Observatoire in Paris.
4. Alexey Brodovitch, "What pleases the modern man," *Commercial Art and Industry*, August 1930.
5. Mehemed Fehmy Agha, who worked at *Vogue* from 1929 to 1943, was another revolutionary art director whose style often recalled Brodovitch's graphic designs (double-page photographs, dynamic compositions) but whose room for maneuver was limited by editor in chief Edna Woolman Chase.
6. The bizarre graphic compositions of the 1930s corresponded to fashion designs such as those of Schiaparelli.
7. *Alexey Brodovitch*, Paris, Ministry of Culture, 1982, p. 32 (exhibition at the Grand Palais, Paris, October 27–November 29, 1982, curated by Georges Tourdjman).
8. Richard Avedon, interview with Calvin Tomkins, Calvin Tomkins Papers, New York, MoMA archives.
9. Alexey Brodovitch also taught at the Yale School of Design and the American Institute of Graphic Arts.

Red and pink roses on white—a new warp-printed taffeta for a new gown by Bergdorf Goodman. Miss Betty Wyman poses.

THE PULSE OF FASHION

SKIRT LENGTHS: A shade shorter by day, and at night our prophecy of shorter-in-front evening skirts and uneven hemlines is coming true. They may be ankle length all round by June.

FEELING: Getting softer and more lyric every minute.

FABRICS: A tremendous moment for tweeds, and in the evening for diaphanous fabrics like chiffon, net, lace, tulle, and Indian gauzes. Checks and plaids rampant. Prints will be as universal as they were back in the Twenties.

HAIR: Bangs being slowly banished in favor of tightly curled Greek coiffures, aureole effects, or longer hair drawn up into a top-knot of curls, à la little girl in the bath-tub.

LINGERIE: More delicate, often trimmed with Malines and tulley laces, and the novelty now is not blue, but a delicious tea-rose pink with velvet ribbons of a very dark brown.

COLORS: We are going to go under an inevitable tidal wave of navy blue, then natural linen shades and grays or tan-bark brown. In the evening all the pastels, especially mauve.

A "The Pulse of Fashion," *Harper's Bazaar*, February 1935, p. 37. Photograph by Martin Munkácsi.

LIP SERVICE

by Carola de Peyster Kip

True red for vague faces, orange for suntanned skin, burnt orange for hair with red in it and for brown clothes, pastels with the dreamlike freshness of gouache to make old mouths young, more and more crimson for the blue-reds and purples everyone is wearing. (Continued on page 120)

by Elinor Guthrie Neff

TIPS ON YOUR FINGERS

Now is the time to bring your finger tips to life... not with the greens or blues (these are just for fun) but with wild, light, lively pinks and rose-reds. Put away those deep-dyed winter polishes: the blackberry, raven-wing, dried-blood colors-- they belong in mothballs now!
• Above: Rhubarb and next down, Fire Weed, both by Peggy Sage. To the left: La Cross's Lobster and, at the bottom, Sea Wheat.

Don't get set about your fingernails. Experiment with new shades, and switch them about as easily as you do your hats—for the color of your polish can change the expression of your hands as a lipstick changes the expression of your face. Try, for instance: At the top, Revlon's Cherry Coke, to its right, Revlon's Hot Dog. And below this, Chen Yu's Flowering Plum, and Celestial Pink.

HERBERT MATTER

A C
B D

A Carola de Peyster Kip, "Lip Service," *Harper's Bazaar*, January 1937, pp. 68–69.

B Elinor Guthrie Neff, "Tips on Your Fingers," *Harper's Bazaar*, April 1941, pp. 84–85. Illustration by Herbert Matter.

C "One of These Statements is True…," *Harper's Bazaar*, October 1938, pp. 70–71. Illustration by Alexey Brodovitch.

D "Nylons," *Harper's Bazaar*, November 1945, pp. 120–121. Photograph by Leslie Gill.

MAINBOCHER

MAN RAY

BROADCLOTH APPEARS FOR EVENING IN BRICK-DUST AND PALE CHAMPAGNE — AND NOTE HOW STRAIGHT AND SLIM THE SILHOUETTE — HOW CAREFULLY MOLDED THE BODICE — HOW PERFECT THIS WOULD BE FOR A LITTLE DINNER AND THE THEATRE

HATTIE CARNEGIE. MARTHA WEATHERED, CHICAGO. COIFFURE, GUILLAUME, ELIZABETH ARDEN

RUG BY MYBOR

A B

A *Harper's Bazaar*, September 15, 1937, pp. 55–56. Photographs by Man Ray. On the right, the dress, whose skirt is cut in a huge circle, is presented on a circular rug that also suggests the texture and softness of the silky fabric.

This model, surrounded by astrological signs, illustrates the fashion of Winter 1937 and heralds the corolla skirts of the postwar period.

B Madeleine Vionnet, evening gown, shaved silk velvet, haute couture, Fall/Winter 1937. Paris, Musée des Arts Décoratifs, gift of Madeleine Vionnet, UFAC collection, 1952, inv. UF 52-18-106.

OU DON'T LIKE　　　ROYAL PURPLE FAÇONNÉ VELVET, CUT TO LAY BARE A WOMAN'S SHOULDERS

THE MOLDED DRESS

VIONNET

SALON DE COUTURE, BONWIT TELLER. I. MAGNIN, CALIFORNIA

57

THE NEW SPIRIT
by Dorothy Hay Thompson

• The fashion in beauty, as in dress, can never be taken at face value. There is always something behind it—you might call it the *spirit of appearance*. And whatever that spirit is, it moves in step with the needs and dreams of society. The woman who catches that spirit is never old—she is new every day. The woman who misses it may follow fashion to the letter—she will still manage to look set in the mold of the last time she waltzed.

• Today there is a new way to be beautiful (and at once it becomes the only way), animated by a new spirit, and born of a new need. The woman of this country is neither a man's competitor, nor his comrade—but his complement, his *completement*. He has come out of the war with a heightened sense of himself as a man, and a disquieting sense that the American dream girl isn't altogether a dream. In his mind, the girl who is one of the boys is a dead duck; the girl who is out to out-smart the next fellow is a dead pigeon; and the "busy-signal" girl, with so many appointments that during one she is already halfway to the next, is the deadest of all. He wants a woman to be the beautiful, desirable, leisurely creature who restores him and gives him peace. She must look it. The new spirit of appearance is *beauty with the man in view*. (Continued on the next page)

IF YOU don't like full skirts, turn your eyes to the left.
ALIX is making these graceful dinner dresses with square necks and
TIGHT DRAPERY pulled over the form and held firmly with
A TWIST of the material. They are not always dead black but often
CHALK WHITE, which looks much newer for little dinners.
LONG SLEEVES replace the done-to-death jacket and
WHITE SANDALS emphasize the whiteness of the white.
SOME have no apparent fulness but cling to the body like
WET CLOTH, flat in front with the new tight drapery behind.
CHANEL also provides for those who hate bouffant skirts by her
STRAIGHT STRAPLESS black dresses with naked tops like
SARGENT'S portrait of Madame X, the line of the decolletage
CUT HEART-SHAPED and the skirts flowing out toward the hem.
MOLYNEUX does slinky black dresses with little
POINTED TRAINS and a series of princesse dresses that are
PLAIN OR PRINTED, and very easy to wear.
MAINBOCHER gives you a new silhouette, with a simple
MOLDED TOP and a slim skirt with a gathered flounce like a
LAMPSHADE put on just below the crucial point of the derrière.
SCHIAPARELLI also makes long-sleeved dinner dresses, but
JACKETS STILL APPEAR in the Schiaparelli collection, and these are
WOOLEN JACKETS embroidered in gold and beads or else
SATIN JACKETS with large embroidered silk motifs. They are worn over
SIMPLE MOLDED DRESSES with brassiere tops. Fresher for spring are
SCHIAPARELLI'S printed evening dresses with their variously
SHAPED HOODS that slip down like capes over the shoulders.
FUR BOLEROS are shown over all these molded
DINNER DRESSES and the smartest are black fox or
SILVER FOX mounted on black crepe de Chine
SKINTIGHT to the figure, stopping short,
TO MAKE YOU THINK that hips are thin as air.

A Dorothy Kay Thompson, "The New Spirit," *Harper's Bazaar*, April 1946, pp. 122–123. Photograph by Leslie Gill.

B *Harper's Bazaar*, March 15, 1938, pp. 60–61. Photograph by George Hoyningen-Huene.

C Dorothy Kay Thompson, "The New Spirit," *Harper's Bazaar*, April 1946, pp. 126–127. Photograph by Leslie Gill.

D *Harper's Bazaar*, July 1950, pp. 54–55. Photographs by Richard Avedon.

Fashion thrusts the neck and shoulders wholly into view. Except for sporadic summer sunnings, our necks and shoulders have been covered up by built-up necklines, and hidden away by down-hanging manes of hair. Now, suddenly, they are unwrapped. With dresses cut all off one shoulder, or all off both; with hair either done up completely off the neck, or cut shorter than it has been in years, the neck and shoulders become the focal point of the silhouette. And we are faced anew with all their implications... the extraordinary expressiveness of shoulders in their least curve and shadow, in their most fleeting motion; and the remarkable way in which the neck, by the way it is carried, gives to the whole woman an air of pride and poise if it is held high, or of caution and withdrawal if it is sunk down between the shoulder blades.

• And other things become apparent, too: that neck and shoulders, as much as any temporal thing, are subject to the havoc of neglect. They must be exercised to suppleness, massaged to subtle contours, and creamed to a new softness. The scrawny neck can be improved, the bony shoulder can take on more roundness, and the empty hollows at the collarbones almost vanish. But you have to care, you have to work at it, you must take time. Have your neck and shoulders creamed and molded by expert hands—and do it yourself every time you open your cream jars. Make up your neck and shoulders as immaculately as your face—and make them up to match it. Exercise your neck and shoulders in accordance with the simple exercises on page 216. And never underestimate the power of suggestion. Think of your neck as a column, think of your shoulders as a crossbeam— on which depends the whole expressiveness of your body.

A MINK COAT CUT ON THE ROUND *AND A CALF PUMP INLAID WITH FUR*

• Above: The coat with the beautiful curves, a magnificent wrap-around designed by Jacques Fath and executed by Bernham-Stein in dark, lustrous Umpa ranch mink. The skins are worked horizontally in a series of half circles, with a final, low, devastating dip in back. There's a curve, too, in the rise of the collar, in the rolled-back cuffs of the three-quarter sleeves. The little black velvet crown, veiled with fish netting, by Mr. John. The black velvet shoe, by Julianelli. The diamond earrings, by Harry Winston.
• Opposite: Two textures—the high patina of black calf and the special gloss of silky black baby fur calf—combined in a pump with a low-curved vamp. About $24. I. Miller; Carson Pirie Scott; Stix, Baer and Fuller.

62

A B D
C

A *Harper's Bazaar*, June 1940, cover.
Photograph by Herbert Matter.

B *Harper's Bazaar*, April 1946, cover.
Photograph by Ernst Beadle.

C *Harper's Bazaar*, October 1947, cover.
Photograph by Ernst Beadle.

D *Harper's Bazaar*, August 1940, cover.
Photograph by Herbert Bayer.

MADELEINE VIONNET

Éric Pujalet-Plaà

1. Thayaht worked with Vionnet from 1919 to 1924. In 1921, he made a study trip to Harvard University where he attended the classes of art professor Denman Waldo Ross, a disciple of Jay Hambidge and his design theory of "dynamic symmetry."
2. Jacques-Louis David, *Les Sabines*, 1799, Paris, Musée du Louvre, inv. 3691.
3. The article Carmel Snow wrote to accompany the opposite picture stressed the classical style of Vionnet's creations: "Her most notable new gown is not only antique and Grecian in inspiration but caused an up-to-date sensation among sophisticated Parisians and the more blasé American buyers.[...] It's a gown that archeologists, sculptors and smart hostesses could all get together—for once," "What they did best," *Harper's Bazaar*, vol. 68, no. 2676, October 1935, pp. 58–59.

Madeleine Vionnet founded her fashion house at 220, rue de Rivoli in Paris just after the armistice of 1918. Her creations, inspired by classical Greek drapery for women with Juno-like figures, seem to reflect the victory of France and the return of peace. Vionnet was often featured in *Harper's Bazar* from the 1920s onwards, perhaps because of the contacts she had made with the magazine when she worked at the Callot Sœurs fashion house in the 1910s. Readers became familiar not only with her designs but also with her persona, famously caricatured by the illustrator Sem. Madeleine Vionnet built up a loyal American clientele including Natalie Clifford Barney, a Paris-based American writer whose salon was frequented by such key figures of the American expat crowd as Gertrude Stein and Romaine Brooks.

Vionnet's approach entailed experimentation on a small wooden doll, combining fabric pieces cut into simple geometric shapes to compose gowns held at the shoulders and belted like Greek chiton tunics. Rectangles, squares, triangles, strips, whole circles, and circle segments, placed on the straight grain or on the bias, were systematically combined to create draperies, falling randomly or rhythmically, curving around the female figure like a flowing shell. The *couturière* rediscovered the art of classical drapery and invented the lines of the 1920s, then those of the 1930s (at least for evening gowns).

In the early 1920s, Thayaht's contribution to Vionnet's collections confirmed that her ancient Greek references were derived from an academic theory of neoclassical aesthetics.[1] No drawings by Madeleine Vionnet have survived, but in the 1920s she took a keen interest in the work of this American-born Florentine futurist artist, and she never abandoned the logo he designed for her. Thayaht was a graphic artist, ornamentalist, designer, and illustrator for Vionnet; his work includes examples of graphic continuity, from the initial sketch of a dress design to the press illustration of the finished item. Several dresses designed by Thayaht were later illustrated by him in the *Gazette du bon ton*—the dress itself was just a transitory, intermediary stage between two drawings. A dress was essentially, and (unless conserved in a museum) enduringly, *una cosa mentale*, a mental thing.

Vionnet had all her dresses photographed (in front, back, and side views) to patent her designs. Graphic continuity, and the transfer of the dressmaker's work to the realm of the image, was extended by the use of photography, required by the copyright law to which Vionnet rigorously adhered. In the course of her twenty-eight-year career, she produced some 10,000 models—250 models per season, twice a year. The photographs of her creations were classified into albums, the drawings kept in notebooks in the form of mimeographed sketches. These records, sometimes including samples with indications of atelier, were categorized according to season and type of garment (day dress, evening gown, négligé, sportswear, etc.) with detailed accounts of sales to clients and purchasers.

Each illustration in *Harper's Bazaar* of a Vionnet dress was the result of a lengthy, inventory-like process of objective representation. The magazine's illustrators and fashion photographers interpreted the chosen dresses according to their own imaginations. Adolphe de Meyer, Harry Meerson, George Hoyningen-Huene, and Man Ray attempted this exercise, coming up against the challenging contrast between the highly sensual nature of Vionnet's creations and the classical aloofness conveyed by their sculptural construction. A remarkable color photograph from November 1936 by Hoyningen-Huene synthesizes these two aspects by bringing together a live model and a mannequin, each wearing a Vionnet dress (in white and red respectively); the composition recalls Hersilia and her companion in the center of Jacques-Louis David's monumental painting *The Intervention of the Sabine Women*.[2] Whether deliberately or by chance, Hoyningen-Huene's color photo has an ambivalent impact, also evoking the strange charm of images of women by the Roman School of the 1930s.

Vionnet dresses, inspired by geometric and neoclassical principles, were showcased in style in *Harper's Bazaar*. Alexey Brodovitch, who attached great importance to proportionality, used Latin letters, numbers and symbols; the classical inspiration behind his graphic compositions intensified the classicism of the photographs and of the dresses themselves, contributing to the image of an ideal Greco-Roman woman imbued with unprecedented sensuality.[3]

A *Harper's Bazaar*, October 1935, p. 58. Photograph by George Hoyningen-Huene.

A C
B

A Madeleine Vionnet's trademark registration, July 30, 1928.
B Madeleine Vionnet's business card, designed by Thayaht.
C *Harper's Bazaar*, March 1, 1939, cover. Illustration by A. M. Cassandre.

66

A	B	C
D		

A *Harper's Bazaar*, November 1936, p. 74. Photograph by George Hoyningen-Huene.

B Madeleine Vionnet, collection notebook, Fall/Winter 1936. BHVP collection.
These notebooks with mimeographed sketches recorded the number of monthly sales of each model to purchasers (column A) and clients (C).

C Madeleine Vionnet, evening gown, gold and silver lamé, gilt leather belt, haute couture, Fall/Winter 1936. Paris, Musée des Arts Décoratifs, gift of Madeleine Vionnet, UFAC collection, 1952, inv. UF 52-18-854.

D Anonymous photo for the design registration of an evening gown by Madeleine Vionnet, no. 4202, Fall/Winter 1936, gelatin silver print, Paris, Musée des Arts Décoratifs, gift of Madeleine Vionnet, UFAC collection, 1952.

VIONNET

HOYNINGEN-HUENE

This silver and mauve lamé Directoire dress is one of the most distinguished and beautifully cut dresses in Vionnet's spring collection. The dress is circular and the molded top fits superbly. It will be copied many times in white or pale-colored crepe. Hattie Carnegie. Jewels from Boucheron. Coiffure, Guillaume of Elizabeth Arden.

A white muslin Directoire dress by Vionnet. The skirt is voluminous and at the top the material is gathered over the bust. The high waistline is accented with black velvet ribbon, which crosses in the back and fastens with a jewel. Vionnet. Bonwit Teller. Marshall Field, Chicago. Sydney of Bonwit Teller will do this coiffure.

83

A *Harper's Bazaar*, March 15, 1938, pp. 82–83. Photograph by George Hoyningen-Huene.

DIANA VREELAND

Marianne le Galliard

It was when she saw Diana Vreeland dancing at a party at the St. Regis Hotel in New York in 1936 that Carmel Snow invited her to write a column for *Harper's Bazaar*. Entitled "Why don't you...?" it was published until the 1940s. Vreeland gave free rein to her wild imagination, making all kinds of outlandish suggestions: "Why don't you paint a map of the world on all four walls of your boys' nursery so they won't grow up with a provincial point of view?... Why don't you rinse your blond child's hair in dead champagne to keep its gold, as they do in France?"[1] or "Why don't you have an ivory satin bedquilt embroidered with a sentimental poem in colored spangles and pearls, as did the Vicomtesse Charles de Noailles in Paris?"[2] Her surrealist and extravagant snippets of advice earned her a reputation in the fashion world as a bold, original, and eccentric character. After 1938, her columns were often parodied in *The New Yorker*: "If a perfectly strange lady came up to you on the street and demanded, 'Why don't you travel with a little raspberry-colored cashmere blanket to throw over yourself in hotels and trains?,' the chances are that you would turn on your heel with dignity and hit her with a bottle."[3] Vreeland was flattered by this teasing.

According to Richard Avedon, Diana Vreeland —official fashion editor of *Harper's Bazaar* from 1939 onwards—reinvented a profession that had previously been the preserve of society ladies targeting an exclusive readership. In contrast with the moderation and restraint of the Snow-Brodovitch duo, her exuberance was bound to set sparks flying. As *Bazaar* boasted in May 1941,[4] "She loves her job, declares that for her fashion is of the essence—she thinks, lives, and breathes it. And she is full of fireworks." Alongside her gift for finding new faces—such as Lauren Bacall in 1943 and China Machado in 1959—Vreeland was naturally able to capture her readers' attention and fire their imagination: "If it's not there in fashion, fantasize it!"[5]

Working in close collaboration with Louise Dahl-Wolfe, especially on the Americain fashion collections (Diana Vreeland was not invited to the Paris shows), she had the knack of creating magical worlds, with lacquer red (the color of her apartment on New York's Upper East Side) suggesting the splendors of India or the earth natural tones of the Arizona desert recalling the origins of fashion. Many of her color slogans became cult catchphrases: "Pink is the navy blue of India," "The best red is to copy the color of a child's cap in any Renaissance portrait."[6] Dorothy Kay Thompson's character who declares "Think pink!" in the 1957 Stanley Donen movie, *Funny Face*, was probably more Vreeland than Snow—as was the outrageous fashion editor played by Grayson Hall in William Klein's *Who Are You, Polly Maggoo?* in 1966. The preposterously extravagant and snobbish Vreeland had all the qualities of a Hollywood star.

As the well-born wife of a wealthy banker, Diana was perfectly au fait with social etiquette. She had made many appearances in *Vogue*'s society pages in the 1920s, and a January 1936 issue of *Harper's Bazaar* shows her striding purposefully along, in a photo taken by Martin Munkácsi just before she was hired by Snow. Luxury, society life, and appearances held no secrets for her, and after years spent perfecting her inimitable style, she could be counted on to add the finishing touches to a model's outfit before a photo shoot. Nail varnish, accessories, hairstyle—nothing was left to chance.

In this respect, she followed the lead of Daisy Fellowes, a member of the Paris smart set who ran the Paris office of *Harper's Bazaar*. Daisy—an heiress to the Singer sewing machine fortune—was raised by her aunt Winnaretta Singer, Princess de Polignac, a great patron of the arts. Vreeland was also perfectly at home in the "salon community" of French and American artists and intellectuals. Paris-born, French-educated and a distinguished representative of New York Café Society, she had a vast network of influence even before she joined *Harper's Bazaar*. For Snow, Vreeland represented "The new world of the International Set"[7] and, as such, she had no difficulty getting the super-rich and reputedly inaccessible Jacqueline de Ribes, Gloria Vanderbilt, Marella Agnelli, Barbara "Babe" Paley to pose for Richard Avedon. It was also Vreeland who championed "unconventional" beauties, deliberately turning their flaws into assets. Her "Triumphs over plainness,"[8] to use Truman Capote's expression, were Diana Vreeland's key contribution to *Harper's Bazaar*.

1. Diana Vreeland, "Why don't you...?," *Harper's Bazaar*, vol. 69, no. 2686, August 1936, p. 65.
2. Diana Vreeland, "Why don't you...?," *Harper's Bazaar*, vol. 71, no. 2708, April 1938, p. 103.
3. S. J. Perelman, "Frou-Frou, or the Future of Vertigo," *The New Yorker*, April 8, 1938.
4. The Editor's Guest Book, *Harper's Bazaar*, vol. 74, no. 2751, May 1941, p. 40.
5. James Brady, "Diana Vreeland: Fashion's Empress Decrees a 'Delicious Occasion'," *New York Magazine*, December 17, 1973, p. 95.
6. Illeana Douglas, "Bringing Diana Vreeland to Life," *Harper's Bazaar*, January 2007, p. 87.
7. Carmel Snow and Mary Louise Aswell, *The World of Carmel Snow*, New York, McGraw Hill, 1962, p. 103.
8. Truman Capote, "A Gathering of Swans," *Harper's Bazaar*, vol. 92, no. 2975, October 1959, p. 124.

A *Harper's Bazaar*, January 1942, p. 38.
Photograph by Louise Dahl-Wolfe
(model: Diana Vreeland).

KODACHROME BY LOUISE DAHL-WOLFE

BLACK WITH BROWN... A SHAWL WITH SLACKS. CIGAR-BROWN SLACKS IN CROWN TESTED RAYON AND COTTON. A BRASSIERE COVERED BY A FRINGED BLACK SHAWL IN RAYON JERSEY. JAY THORPE. I. MAGNIN, CALIFORNIA.

Harper's Bazaar, January 1942

ONE OF FRANK LLOYD WRIGHT'S FAMOUS HOUSES. CLINGING LIKE AN EAGLE'S NEST TO A MOUNTAINSIDE. THE MID-CALF SKIRT IN BLACK LINEN, BELTED OVER A HALTER-NECK CHALLIS SCARF. JAY THORPE. I. MAGNIN, CALIFORNIA.

KODACHROME BY LOUISE DAHL-WOLFE

A *Harper's Bazaar*, January 1942, pp. 40–41. Photographs by Louise Dahl-Wolfe (models: Diana Vreeland and Bijou Barrington).

A B
- A *Harper's Bazaar*, May 1943, p. 49. Photograph by George Hoyningen-Huene.
- B Mainbocher, afternoon dress, cotton poplin, sequin embroidery, Spring/Summer 1943. Paris, Musée des Arts Décoratifs, gift of Patricia-Willshaw, UFAC collection, 1966, inv. UF 66–38–15 ABCD.

Main Rousseau Bocher, the first American couturier to show his collections in Paris, continued his activity in the United States after 1939. This short dress with matching gloves reflects an elegance and luxury in keeping with the photographic styling of Diana Vreeland.

A1 A2 B
A3 A4

A *Harper's Bazaar*, covers, (A1) May 1948 (model: Virginia Stewart), (A2) June 1953 (model: Jean Patchett), (A3) December 1953 (model: Evelyn Tripp), (A4) July 1941. Photographs by Louise Dahl-Wolfe.

B *Harper's Bazaar*, May 1946, p. 98. Photograph by Louise Dahl-Wolfe (models: Betty Bridges and Bobby Monroe).

79

The essence of all that is Schiaparelli

humor in fashion. And now she ha[s]
new shoes by Monsieur Perugia of
Two minutes after her collectio[n]
that we could no longer wear all [b]
our new evening dresses, but inste[ad]
soles as thick as beefsteaks. These
an inch thick and the straps contra[st]
purple leather straps with rose lea[ther]
blue straps with purple soles, blu[e]
the limits of your imagination, un[til]
case it is smarter to wear an all-wh[ite]
out so that a tall woman will no[t]
kinked soles, so that you tread on
straps, a lining of red gold kid ar[e]
contrast to the rest of the slipper
there are also thick-soled sandals, b[ut]
surdly and the smarter street sanda[l]
Schiaparelli herself wears an all-bl[ack]
sole. She has another with black k[id]
dals look smart in the daytime, an[d]
more Perugia sandals of pale beig[e]
coats, you wear short gloves of da[rk]
color, then natural-chamois slip-on[s]
match exactly, regardless of the co[lor]
any shoes this spring, readjust you[r]
you do not need to have quiet feet. [In]
great ladies wore extraordinary san[dals]
very near future will do so, too.

Madame Schiaparelli posed for Harper's Ba[zaar]
dresses—a tiny pink silk fez incrusted wit[h]
dery. From it drift two dreamy silken scar[ves]
the chin. Gold balls massed on a golden cha[in]

A "The Essence of all that is Schiaparelli," *Harper's Bazaar*, 15 March 1938, pp. 54–55. Illustrations by Marcel Vertès.

B André Perugia for Padova, model made for Elsa Schiaparelli, sandal, suede, gilt kidskin trim, Spring/Summer 1938. Paris, Musée des Arts Décoratifs, gift of Patricia Lopez-Willshaw, UFAC collection, 1966, inv. UF 66-38-54 AB.

C André Perugia for Padova, model made for Elsa Schiaparelli, sandal, kidskin, Spring/Summer 1938. Paris, Musée des Arts Décoratifs, gift of Patricia Lopez-Willshaw, UFAC collection, 1966, inv. UF 66-38-52 AB.

80

creative spirit does not think in terms of the
sent, but way in the past or in the future. Therein lies
genius of Schiaparelli. She's archaic. She's stratospheric. There's
960 twang to her 1860 furbelows. Her mannequins move
he beat of old forgotten Oriental melodies or to
tunes that have never yet been written. And whether you
y her ideas or pass them by with a smile,
e's new life there, and vision. She revolutionized mate-
s. She used color in a new way. She thought
a new silhouette. She introduced a sense of
all eyes on the feet by presenting these

own in Paris, it became apparent
all silver or all gold slippers with
l-like sandals of colored kid, with
soles are actually seven-eighths of
lor . . . so you have, for instance,
es, purple straps with cerise soles,
with cerise soles. And so on to
r dress is dead white and in that
l. Sometimes the soles are scooped
ller. Sometimes they are really clogs with
A thick sole of green kid has black antelope
pipings. A thin sole matches the end of a heel in
kid is combined with silver kid. By day,
seem to teeter-totter along the streets a trifle ab-
ore conventionally designed. Madame
l with a suede top and a black leather
s and vermilion-red soles. Oxblood-red san-
in the season there will be
ith the oxblood-red and dark blue
Or if your suit is mustard
pale beige sandals the gloves will
our print. Before you buy
f view. To be a perfect lady,
in Persia, in Cleopatra's Egypt, very
many colors. The great ladies of the

e of her new Oriental head-
stones and paillette embroi-
rame her face and tie under
r bracelet and huge pendant.

 Little shoes with great soles, all designed by André Perugia of Padova for Schiaparelli, and all exclusive with Saks Fifth Avenue.

Striped kid straps on cork

Satin lined with kid

A kinked sole

A high and mighty sole

An elevated suede moccasin

Removable lacings

SURREALISM

Marianne le Galliard

Erté's Art Deco style seems to have gone out of fashion in the 1930s. In Alexey Brodovitch's view, it was time to recruit more up-to-date graphic designers, so he hired the poster artist Adolphe Mouron, known as Cassandre—a painter, typographer and art director at the Alliance Graphique studio. Cassandre is best known for his advertising posters, such as the one for the Au Bûcheron furniture store (which earned him first prize at the 1925 International Exhibition of Decorative Arts in Paris), or the now famous posters for the Nord-Express and Étoile du Nord trains and for the *Atlantique* and *Normandie* luxury liners.

Cassandre's first covers in 1936 featured part cubist, part surrealist designs that changed the identity of *Harper's Bazaar*. Erté's exotic world of dance and theater, ornamentation, and elegant curves made way for a very different atmosphere conveyed by more massive designs. The new covers featured illustrations that were visible from a distance: a foot, a mouth, a pair of scissors, a tree... The lack of depth of field and absence of decoration highlighted the objects depicted. Cassandre also decided to reduce the *Harper's* of the magazine's name and focus on the *Bazaar*. The word "Harper's" (associated with the British version created in 1929, while "Bazaar" referred to the American version) found itself positioned along the diagonal formed by the letter Z, leaving plenty of room for the word "Bazaar" at the top of the page. On Cassandre's very first cover in August 1936, the letters of "Bazaar" (which gained an extra A in 1929) jump about like the little girl skipping rope. Until the adoption of the Didot typeface for good in 1939, Cassandre tested different typographies, inserting stars, dotted lines, and interlacings, treating the magazine's title as a part of the overall composition. During this experimental phase, *Harper's Bazaar* conveyed the impression of a fluctuating, dreamlike world in which intelligibility was not really a priority—even William Randolph Hearst admitted that he found such covers incomprehensible.[1] Enlargements (such as the close-up view of a zipper on the cover of the September 15, 1938 issue) and apparently absurd figural scenes (like the June 1939 cover featuring flying crustaceans) were inspired by the surrealist style, also reflected in the photographs of Man Ray.

Like many other photographers working in the surrealist vein (Dora Maar, Jacques-André Boiffard, Eli Lotar), Man Ray put his innovative photography to the service of advertising and fashion from the 1920s onwards. His work for famous couturiers (Poiret, Lanvin, Vionnet, Schiaparelli, Chanel) and for *Vogue* and *Vanity Fair* made his name and earned him a comfortable living. The American-born artist had settled in Paris in 1921, and frequented the artistic avant-garde—surrealists André Breton, Max Ernst, and Philippe Soupault, artists Pablo Picasso, Francis Picabia, and Igor Stravinsky, photographers Baron de Meyer and George Hoyningen-Huene... As a painter, photographer and sculptor, Man Ray used various techniques to develop his experimental approach to photography: negative images (solarization), rayography, unusual framings, etc. As soon as Brodovitch became art director of *Harper's Bazaar* in 1934, he invited him to contribute to the fashion pages. Then started a regular collaboration which lasted until 1940, when Man Ray returned to the United States.

Harper's Bazaar made the surrealist style known to a wide audience in the prewar years. Man Ray used a wide range of graphic resources in his photography, creating illusory effects with animate and inanimate figures (the mannequin was a popular surrealist theme) and framing figures in unusual ways, very often cropping them at the head.[2] An article on coloring gray hair, in a February 1937 issue, featured a photograph by Man Ray using solarization, based on the inversion of black and white. Another image in the November issue, showing a model with her lips colored with superimposed red, illustrates an article on applying lipstick as a "badge of courage". Man Ray also imbued the magazine with a touch of eroticism, hinting at the models' bodies beneath the transparency of their dresses. Some of his work is powerfully suggestive: there is something highly provocative and contemporary in the close-up of a man's hand, picking up a scarf at a woman's feet. A few years later, fashion photographer Guy Bourdin recognized the influence of Man Ray on his own work.[3]

Brodovitch also recruited other contributors with surrealist connections: Leonor Fini, Joseph Cornell—and Salvador Dalí, a regular guest in *Bazaar*. One of Dalí's first "fashion paintings," called *Dream Fashions*, appeared in the September 1935 issue. The artist wrote a text on Surrealism in Hollywood in June 1937, and was photographed by Hoyningen-Huene as he posed next to Gala in an elaborate mise-en-scene reproducing his painting *The Sublime Moment*. His collaborative projects with designer Elsa Schiaparelli (who was staunchly supported by Carmel Snow) include the lobster dress and shoe hat featured in the magazine in April and September 1937 (and known to have been worn by Daisy Fellowes).[4]

With the November 1936 issue, featuring a double-page spread on the exhibition "Fantastic Art, Dada, Surrealism"[5] at the MoMA in New York, a collage by Max Ernst (exhibited at the Julien Levy Gallery) and a photograph by Man Ray

1. Letter from William Randolph Hearst to Carmel Snow, December 7, 1936, William Randolph Hearst Papers, Bancroft Library, University of California, Berkeley.
2. The headless woman was a surrealist motif evoking Max Ernst's 1929 collage novel, *The Hundred Headless Woman* (*La Femme 100 têtes*).
3. Guy Bourdin met Man Ray in 1951 and became his protégé. Man Ray wrote the preface to the catalogue for his first exhibition of photographs at the Galerie 29 in 1952.
4. The lobster dress was photographed by George Platt Lynes in the April 1937 issue, vol. 70, no. 2694, p. 87. The shoe hat was sketched by Marcel Vertès on page 69 of the September 15, 1937 issue.
5. "The Surrealists," *Harper's Bazaar*, vol. 69, no. 2689, November 1936, pp. 62–63.
6. A Singer machine perhaps? Singer sewing machines were invented by Daisy Fellowes's grandfather, Isaac Merritt Singer.
7. It is tempting to imagine American collector Peggy Guggenheim—a member (with Daisy Fellowes) of the cosmopolitan elite of Paris, close to the artistic avant-gardes of the 1920s—as a reader of *Harper's Bazaar*.

in which a model poses in front of one of his paintings, *Observatory Time: The Lovers*, one can understand that *Harper's Bazaar* was far more than an exchange and meeting place for surrealist artists. It played an active role in taking Surrealism to the American elite by combining and legitimizing the aesthetics and interconnections of Surrealism and fashion: the glorification and mythification of woman, the fetishizing of objects, everyday life made marvelous—principles shared by fashion advertising. Lautréamont, whose idea of beauty inspired the surrealists, had associated two fashion-related elements (sewing and accessories): "As beautiful as the chance encounter of a sewing machine[6] and an umbrella on an operating table." Thus Cassandre's bizarre magazine covers act like riddles, opening the door to a theater of the absurd. The photomontages and deformations in the work of Man Ray, Maurice Tabard, and Herbert Bayer result in the "irruption of the extraordinary" advocated by André Breton. And finally, the absurd suggestions in Diana Vreeland's columns have something of the quality of automatic writing.

Like surrealist art, *Harper's Bazaar* was a dream-producing machine, creating images that stimulated the viewer's visual appetite. With its indexical layout displaying surrealist principles for a readership composed of modern art collectors and clients,[7] the magazine clearly contributed to enhancing the movement's value on the American art market.

In September 1939, Max Ernst's painting *The Angel of the Home, or The Triumph of Surrealism* was a threatening presence in the background of a fashion photograph—an intimation of darker times to come.

A *Harper's Bazaar*, March 15, 1939, cover. Illustration by A. M. Cassandre.

A1	A2	A3
A4	A5	A6

B

A *Harper's Bazaar*, covers, February 1938 (A1), August 1938 (A2), April 1940 (A3), June 1939 (A4), September 15, 1938 (A5), April 1939 (A6). Illustrations by A. M. Cassandre.

B *Harper's Bazaar*, January 1937, cover. Photograph by Man Ray.
 This was the first color photograph to appear on the cover of *Bazaar*. The use of Kodachrome resulted in warm colors and flattering skin tones that encouraged photographs of the body and bare skin.

Harper's BAZAAR
January 1937

WINTER RESORTS
50 CENTS · 15 FR. IN PARIS · 2/6 IN LONDON

A A *Harper's Bazaar*, November 1937, p. 107. Photograph by George Platt Lynes (model: Frances Farmer). The Musée des Arts Décoratifs holds the collection drawing (in different colors) of the Elsa Schiaparelli evening gown worn by Frances Farmer in this photo. The drawing shows that the glittery bodice forms a large heart shape–red in the drawing, black in the photo.

B B Elsa Schiaparelli, collection drawing, ink and gouache on paper, Fall/Winter 1937. Paris, Musée des Arts Décoratifs, gift of Elsa Schiaparelli, UFAC collection, 1973, inv. UF D–73–21–1445.

C D
E

C Elsa Schiaparelli, evening gown, silk by Ducharne, haute couture, Fall/Winter 1938. Paris, Musée des Arts Décoratifs, gift of Patricia-Willshaw, UFAC collection, 1966, inv. UF 66-38-3.

D Elsa Schiaparelli, collection drawing, ink and gouache on paper, Fall/Winter 1938. Paris, Musée des Arts Décoratifs, gift of Elsa Schiaparelli, UFAC collection, 1973, inv. UF-D-73-21-2047.

E *Harper's Bazaar*, September 1, 1938, p. 83. Photograph by George Hoyningen-Huene.

88

The Woman Who Lost Her Head

• This woman is the national nightmare. At the first scent of victory she walks out on her war job, walks into the shops. She buys by the dozen, yawns at inflation, thinks she's pretty coony to stock up while the going is good. Multiplied by the thousands, she is draining the shops, cornering merchandise needed by others, shooting up prices, paving the way for postwar breadlines. She is the disgrace, the despair of America—this hit and run shopper, this selfish, complacent little woman who has lost her head.

A *Harper's Bazaar*, March 1, 1940, p. 62. Photograph by Man Ray.
B *Harper's Bazaar*, September 1943, p. 89. Photograph by Herbert Matter.

VICTORY

Marianne le Galliard

Despite the threat of imminent war, Carmel Snow took one of the first transatlantic flights to see the new collections in Paris in the summer of 1939. Her devotion to the French fashion industry led her to take risks in a capital city where the future was uncertain.[1] In a letter published in the October issue of *Harper's Bazaar*, she describes the empty streets, the lack of taxis, the cut-off telephones... Couture houses such as Lelong and Molyneux were closed, and no clients were to be seen at Schiaparelli or Chanel. While in Paris, she met up with Marie-Louise Bousquet, painter and set designer Christian Bérard, and Boris Kochno, director of the Ballets Russes of Monte Carlo. She also saw again Marcel Vertès, who designed numerous covers for *Harper's Bazaar* during the war, and the photographer Erwin Blumenfeld, whom she hired in 1939.[2] The letter ends with an expression of her profound gratitude to all the women she had worked with over the years, praising their courage in these times of crisis.[3] On September 3, 1939, when France and Britain declared war on Germany, Snow returned to the United States. She did not go back to France until the winter of 1944.

In the meantime, *Harper's Bazaar* was taking a new direction. The November 1939 issue opened with an editorial declaring that fashion had to go on: "The French have decreed that fashion shall go on, even in the dark, anxious nights. Though no one wears full dress, everyone makes an effort to be as elegant as possible, not only for the morale of their friends, but to keep up France's greatest industry, on which so many workers depend."[4] Until September 1940, a few months after the armistice and the German occupation of France, the magazine continued to publish images of French fashion, mostly taken by the photographer Jean Moral. The March 15, 1940, issue[5] gave news of the writers Colette, Jean Giono, Sacha Guitry, and Antoine de Saint-Exupéry, representatives of the French spirit. The issue published on September 1, 1940, was the first to appear without fashions from Paris. Henceforth, the focus switched to American designers such as Charles James, Claire McCardell, Bonnie Cashin, and Vera Maxwell: "We are starting late, but the truth is we are just being born. We've got to experiment and all the way down the line—in design, fabrics, buttons, buckles and the whole bag of tricks."[6]

The same issue gave thanks to the magazine's Paris contributors Cassandre, Jean Moral, Marcel Vertès, and François Kollar (who had been called up or had volunteered for the French army) and to *Bazaar*'s Paris correspondent, Louise Macy, who took part in the war relief effort. When the United States joined the war in December 1941, the magazine was gripped by nationalistic fervor: the covers featured the colors of the American flag, the articles called for patriotism, encouraging readers to purchase war bonds. For example, the March 15, 1942, issue announced that fifty percent of advertising revenue would go to the funding of military operations. The cover of the July 1942 issue, featuring the American flag, was awarded the Cross of Honor and Patriotic Service Cross by the United Flag Association.

Pragmatism was the order of the day. *Harper's Bazaar* gave specific clothing instructions that were a far cry from Vreeland-style fantasies: "Forget about Nylon and silk. They belong to the past and the Government. Watch for the new rayon stockings and be the first to launch them... Keep right on wearing the slim, abbreviated silhouette that uses minimum yardage."[7] Uniform-clad models posed in front of propaganda posters showing the "V" of victory or exhorting readers to "Buy a Share in America," and the magazine ran a plethora of articles on women soldiers in action. Praise went to volunteers contributing to the war effort, women reporters (such as Margaret Bourke-White in the March 1, 1940, issue),[8] the staff of the Red Cross (whose symbol, like the American flag, became a recurrent motif), and the women working in aviation, the steel industry, the US army, parachute making... The outfit that best represented this period of crisis was the uniform—the military or work uniform, symbolizing the fighting and austerity of the period.

There were few photographs of occupied France, which was perhaps just as well. French fashion had lost its dazzle, and it was not until 1944 that hope re-emerged. Rebecca West predicted in August 1944: "France will soon lie shining under the sun."[9] In November 1944, Colette contributed to *Harper's Bazaar* for the first time "since the liberation of her beloved city." Carmel Snow bravely decided to return to France in the winter of 1944, at her own risk. The Battle of the Bulge was raging in the Ardennes. Her journey took her from Miami to La Trinité in Martinique, where she took a flight to Dakar. From there, she traveled by train through Spain to France. Once in Paris, she met up with Marie-Louise Bousquet and her familiar circle of friends. She hired Marie-Louise as correspondent for *Harper's Bazaar* in 1946, and set about reviving the French fashion industry. Her efforts were rewarded with the Legion of Honor in 1949.

1. Carmel Snow was already in Paris during World War I as a member of the American Red Cross.
2. Cecil Beaton and Erwin Blumenfeld left *Vogue* for *Harper's Bazaar* in 1938 and 1939 respectively.
3. Carmel Snow, "Letters from Paris, August 28, 1939," *Harper's Bazaar*, vol. 72, no. 2729, October 1939, pp. 51, 108.
4. Carmel Snow, "The Pulse of Fashion," vol. 72, no. 2730, November 1939, p. 49.
5. The March 15 and September 15 issues were "French issues," fully devoted to the new Paris collections. By doubling the frequency of the monthly magazine in March and September, *Harper's Bazaar* could give its readers the latest fashion news and rival the bi-monthly *Vogue*.
6. Carmel Snow, *The Fashion Group Bulletin*, October 1940, p. 2.
7. "Dress as the War Production Board wants you to," *Harper's Bazaar*, vol. 75, no. 2763, March 15, 1942, pp. 60–61.
8. *Harper's Bazaar*, vol. 73, no. 2734, March 1, 1940, p. 142.
9. Rebecca West, "France" (illustrated by André Kertész), *Harper's Bazaar*, vol. 78, no. 2792, August 1944, pp. 42–43.

A *Harper's Bazaar*, December 1941, cover. Photograph by Erwin Blumenfeld.

HITTING THE SILK

• Marine parachute troops at practice drift silently down at dawn into an airdrome somewhere in the East. • Above: A girl looks to the Paramarines in a tweed suit and topcoat of red, white, and blue Rob Roy check, pure wool. Philip Mangone, at Bonwit Teller; Carson Pirie Scott, Chicago; L. S. Ayres, Indianapolis.

PHOTOGRAPHS BY MUNKACSI

A "Hitting the Silk," *Harper's Bazaar*, March 1, 1942, pp. 68–69. Photographs by Martin Munkácsi.

94

Harper's Bazaar, September 1945, cover.

A C A *Harper's Bazaar*, July 1943, cover. Photograph by Erwin Blumenfeld.

B1 B2 B *Harper's Bazaar*, covers, March 1945 (B1) and November 1944 (B2). Photographs by Louise Dahl-Wolfe (model: Lise Fonssagrives).

C *Harper's Bazaar*, September 1945, cover.

NEW LOOK

Marianne le Galliard
Éric Pujalet-Plaà

The economic boom in America in the immediate postwar era boosted advertising in *Harper's Bazaar*, with resultant revenues that allowed the magazine to publish more articles on art, theater, and dance. During her trip to France in 1944, Carmel Snow met Henri Cartier-Bresson and hired him for his first reportage on the Western Front. The images appeared in March 1945.[1] Cartier-Bresson became a regular contributor to *Bazaar* until Snow's departure in 1957. Lisette Model and Roman Vishniac started publishing photo feature stories in 1944. In 1945, they were joined by Henri Cartier-Bresson, Bill Brandt, Brassaï, and Ronny Jaques.

The appearance of full-page photographs, independent of the fashion photos, was a first for a fashion magazine.

The old world had been reduced to rubble. Carmel Snow was convinced that France would make a great comeback. After paying tribute to the courage of the fashion professionals who remained in France, the designers and the craftspeople—"without them Paris could not live"[2]—she sought to inspire a wave of optimism. Brassaï and Alexey Brodovitch's photographs of ballet,[3] published in the September 1945 issue, echoed the "V" for victory, painted across the cover as a sign of liberation. Hope was rekindled via new artistic expressions and inventions—and these were emerging from France. The June 1946 issue included photographs by Cartier-Bresson and Brassaï, portraits of Pierre and Marie Curie and Olivier Messiaen, and an article on the exhibition "Le Théâtre de la Mode."

In February 1947, Carmel Snow immediately grasped the impact of Christian Dior's first collection. She exclaimed, "Your dresses have such a new look!" thus coining the title of the collection and the style that would dominate the postwar years.

Carmel Snow had been following Christian Dior from his early years with Robert Piguet, just before the war, and shared the same friends who gravitated around Marie-Louise Bousquet, *Bazaar*'s correspondent in Paris. Christian Dior recalled how they met, in 1938, in his autobiography: "Piguet was a charming but changeable master… But he appreciated my ideas, and the models I designed for him were genuinely successful. I shall always remember my beloved Christian Bérard introducing me to Marie-Louise Bousquet—whom I barely knew despite the many friends we had in common—as the creator of *Café anglais*. This was a dress of *pied de poule* [houndstooth], with a trimming of lace, inspired by *Petites Filles modèles,* which had created a great stir that season. It was then than Marie-Louise Bousquet, always so helpful in her friendships with those who needed support and in whom she saw promise, introduced me to Carmel Snow of *Harper's Bazaar*, and I really began to think that I had arrived."[4] According to Dior, Snow then "commissioned some drawings." At the time, Christian Dior was also working as an illustrator for *Le Figaro*, contributing vibrant small sketches for the Thursday fashion page.

Dior learned the basics of illustration from two friends, Max Kenna and Jean Ozenne, an illustrator and designer, respectively. The latter was a cousin of Christian Bérard, a painter who had trained at the Académie Ranson and who contributed illustrations to *Bazaar*; Christian Dior had exhibited his work when he was running a gallery. Christian Bérard and his companion Boris Kochno were close friends of Carmel Snow, who mentions them in a description of Paris in August 1939: "One evening we gathered at the sidewalk café outside Fouquet's—darling Marie-Louise Bousquet, of our Paris office; our photographer Blumenfeld; Bérard, the artist; Boris Kochno, director of the Russian Ballet; and Marcel Vertès. The Champs-Elysées was, save for the full moon and the lights of the cigarettes, plunged into total darkness."[5]

Dior first appeared in *Bazaar* in July 1946, in a portrait by Cartier-Bresson, depicted in a window frame, at home on Rue Royale in Paris: "Christian Dior is a shy, self-effacing man, the least temperamental of designers. Before the war, he started selling paintings in an art gallery with Pierre Colle, failed, then took up dress designing, first at Piguet, now at Lelong."[6]

The creation of the House of Dior, with support from Marcel Boussac, was the big news of the season. Snow's interest was no doubt also piqued by the idea of seeing an illustrator, whose culture and artistic training she was familiar with, finally express himself in his own right. At the end of the show, it was the "look" that caught her attention, not the cut, the color, or the texture: the novelty was in the visual aspect, the drawing held pride of place. "Very often the models which captivate us now have been made from sketches which passed under our noses quite unnoticed."[7] The designer's concepts were transmitted through drawings to his workshops, where they were then reinterpreted in fabric. "An artistic creation, which depends on another brain for its interpretation, often produces some surprises for its author. This applies to dresses as much as to plays."[8] The finished dresses, designed as sculptures (often with bustiers or boned corsets), created sharply defined silhouettes.

In this highly structured world that extended to accessories and fragrances, Christian Dior's dresses imposed a predefined look that left

1. "American Red Cross—Western Front," *Harper's Bazaar*, vol. 79, no. 2799, March 1945, p. 74.
2. Carmel Snow, "Eight Pages from Paris," *Harper's Bazaar*, vol. 78, no. 2795, November 1944, p. 59.
3. In 1945, the book *Ballet*, which featured photographs taken by Brodovitch between 1935 and 1937, was published by J. J. Augustin in New York. The first edition of this work is now a prized collector's item.
4. Christian Dior, *Dior by Dior*, London, V&A Publishing, 2012.
5. Carmel Snow, "Letter from Paris—August 28, 1939," *Harper's Bazaar*, vol. 72, no. 2729, October 1939, p. 108.
6. "Paris designers are artisans," *Harper's Bazaar*, vol. 80, no. 2815, July 1946, p. 127.
7. Christian Dior, *Dior by Dior, op. cit.*
8. *Ibid.*
9. Carmel Snow, "Notes from Paris," *Harper's Bazaar*, vol. 80, no. 2813, May 1946, p. 209.

photographers with scant room to maneuver. Even before they were photographed, the dresses had become fixed in people's minds, like fashion illustrations, as if the designer had already foreseen their inclusion in the magazine. With Dior, mastery over the image reflected his perfect assimilation of the magazine's culture, its link to the creative process of haute couture. It reflected a transformation of the old world, now under the influence of Americans: "When I walk into a room with my *Harper's Bazaar* under my arm, it is literally grabbed out of my hands. They are crazy to see what we are doing, fascinated by the American fashions—they even like to look American. But their creativeness is good for us, too."[9]

Snow, who helped to promote a certain idea of the woman soldier during the war, was sensitive to the total break in style ushered in by Christian Dior's "femme-fleur." Beyond this ideal, which reinstated luxury, romanticism and certain outdated bourgeois traditions of prewar France, she intuited that Dior's femininity also incorporated elements of American culture. The extreme stylization of the body imposed by the "Corolle" and "En 8" lines that defined the *New Look* collection reflected the provocative curves of pin-up girls and the femmes fatales of films noirs derived from the tradition of the burlesque, a popular American phenomenon. Rita Hayworth, who played the captivating Gilda, star of the eponymous film by Charles Vidor, ordered twelve outfits from Christian Dior's first collection.

A *Harper's Bazaar*, May 1947, p. 133.
Photograph by Leslie Gill.
The photo taken in the Christian Dior shop shows the Toile de Jouy suggested by Christian Bérard. The pattern, created around 1795 by Jean-Baptiste Huet, represents a young shepherdess on a flowery swing; the original drawing is in the Musée des Arts Décoratifs.

SAM

A B

A *Harper's Bazaar*, April 1947, p. 187. Illustration by SAM.
B Copy of Christian Dior's *Chérie* dress, mercerized cotton, 1959, based on the Spring/Summer 1947 model. Paris, Musée des Arts Décoratifs, gift of the general trade union of the French cotton industry, UFAC collection, 1959, inv. UF 59-28-6 AB. According to Christian Dior, " the most ostentatiously New Look dress" was *Chérie*: "I liked this model so much that I christened it 'Chérie'. It had a tight bodice, a tiny waist, and eighty yards of pleated white faille descending almost to the hem in the enormous bustle of the skirt."

A B
C

A Christian Dior, *Bar* suit, shantung, wool crepe by Gérondeau et Cie, haute couture, Spring/Summer 1947. Paris, Musée des Arts Décoratifs, gift of Christian Dior, UFAC collection, 1958, inv. UF 58–29-1 AB.
 The *New Look* collection was synonymous with modernity. The star piece of the collection was the shapely *Bar* suit, which evoked the American lifestyle with its black and white combination hinting at the uniform of a barman –a key figure at the newly popular cocktail gatherings.

B Pat English, *Défilé du New Look*, 1947. Dior Héritage collection, Paris.
 The blonde woman with a hat and veil in the front row, to the right of the model, looks like Carmel Snow.

C Christian Dior, collection notebook, *Bar* model. Dior Héritage collection, Paris.

Dior

RIBBON is practically tying up Paris traffic; every couturier
with a colossal bow of green faille ribbon at the back. Dior call
• Above, right: Heavy black lace embroidered with ribbon (this love
pink satin ribbon sash. When the overskirt unhooks to become a

102

Balenciaga

LOUISE DAHL-WOLFE *Dior*

miles. • Above, left: Green-jeweled green velvet, dress "Irlande." Julius Garfinckel; Marshall Field. lace was a high note of the season), and a streaming his dress is a sheath. By Balenciaga. Henri Bendel.

RIBBON BOWS of velvet or faille tie across the breast of almost every cocktail and evening dress at Dior. • Above, a brown velvet ribbon bow on gray net that's embroidered all over with jeweled scales. When the woman moves across the ballroom floor, this dress glistens and gleams like some strange, beautiful fish. Henri Bendel; I. Magnin; Marshall Field; Morgan's, Canada. • In the background on both pages, reproductions of the famous eighteenth-century plan of Paris prepared by the economist Turgot.

HARPER'S BAZAAR, OCTOBER 1951

HARPER'S BAZAAR, OCTOBER 1951

A B

A Christian Dior, *Mexique* ball gown, tulle embroidered with sequins and glass tubes, velvet, haute couture, Fall/Winter 1951. Paris, Musée des Arts Décoratifs, gift of Mrs. H. de Ayala, UFAC collection, 1974, inv. UF 74-25-1.

B *Harper's Bazaar*, October 1951, pp. 188–189. Photograph by Louise Dahl-Wolfe (right model: Mary Jane Russell).
The models are standing in front of the Turgot map, showing Paris around 1730, also photographed by Dahl-Wolfe on page 93 of the August 1949 issue. *Harper's Bazaar* presented Paris is all its many aspects, both highbrow and lowbrow. This map was still visible in the editorial offices of *Harper's Bazaar* in the 1970s, during the tenure of Anthony T. Mazzola.

103

132

JEWELED HEADS · SPANGLED BALL GOWNS

(Continued from page 131) recognition when I saw Dior's flat crepe de Chine shirtwaist dresses, finely pleated by hand, the pleats of the skirt often mounted on a little yoke, the sleeves soft and full and caught into a wide shirt cuff like a man's (see page 151). Dior shows these in pale gray, steel gray, pale gray-blue, ink blue. Balenciaga has a divine black crepe de Chine. I think these easy little dresses are going to be a big fashion under the fur coat. I remembered the twenties again when I saw the coiffures of the mannequins, cut rather short, quite boyish and wind-swept at the sides. For evening Dessès showed a spit-curl coiffure of little circlets of lacquered hair, as if someone had poured a pot of glue over the girl's head and then set the loops carefully. Fans, long ropes of pearls, dangle earrings and necklaces of glittering paste have all been revived. And so have the day-length chemise dresses, straight as a string, either strapless or with narrow shoulder straps. Dior has one in black velvet with a tailored belt, embroidered all over with little jet tassels. Another is silver gray satin, embroidered with gray pearls and steel beads, with a narrow bead fringe at the bottom and a sash whose ends fall longer than the dress. These beaded dresses cost $800 in Paris, but we'll see cheaper versions everywhere, where girls have good legs. Again, legs will be a woman's crowning glory.

COATS AND SUITS—Style now depends on fabric quite as much as on cut. In the daytime there are very few flat wools. The Lesur wools shown at Dior and at Balenciaga are entirely new in texture. Nubby, porous, slightly hairy, they are still a little too heavy for dresses, but surely they will be worked out later in a lighter weight. Balenciaga also uses a good deal of chinchilla and duvetyn. For day, black comes first—this is the blackest season Paris has had in years. And the black looks particularly *(Continued on page 238)*

"ONCE AGAIN, SPARKLING ORNAMENTS FOR THE HAIR."
ABOVE, SCHIAPARELLI'S PENDANT OF PASTE
AND RHINESTONES, FASTENED ON A RHINESTONE BAND.
IT DOUBLES AS AN EARRING,
DANGLING ALMOST TO THE SHOULDER.

"NEW SPANGLES, LUMINOUS, IRIDESCENT, LIKE
JEWELS DROWNED IN THE SEA."
OPPOSITE, LEFT, DIOR'S TURQUOISE NET, TIERS OF
GLEAMING SEA SHELLS, WITH A TOUCH OF BLACK.
OPPOSITE, RIGHT, DIOR'S PINK TULLE
WITH A SPANGLED PEACOCK TAIL. BOTH DRESSES, I. MAGNIN.
PHOTOGRAPHED AT THE PRE CATALAN.

PHOTOGRAPHS BY RICHARD AVEDON

A "Jeweled Heads, Spangled Ball Gowns," *Harper's Bazaar*, October 1949, pp. 132–133. Photographs by Richard Avedon (model: Dorian Leigh).

B Rébé for Christian Dior, sample of sequin embroidery on tulle by Dognin for the *Junon* ball gown, haute couture, Fall/Winter 1949. Paris, Musée des Arts Décoratifs, gift of Rébé Brodeur, 1974, inv. 44926.

Rébé

RICHARD AVEDON

Marianne le Galliard

Richard Avedon was just twenty years old when he started working at *Harper's Bazaar*, in 1944. As opposed to the magazine's other photographers, the young man had virtually no experience, except for ID photos of sailors he had made as a photographer for the US Merchant Marine from 1942 to 1944, as well as some advertising shots for the Bonwit Teller store on Fifth Avenue in New York.[1]

Ferociously determined, Avedon arranged meetings with Alexey Brodovitch, leaving his portfolios behind with the art director and taking his classes at the New School for Social Research in New York. He felt that *Harper's Bazaar* had "the best writers, the best photographers. That was my dream, that was the pantheon, that was the place where you felt you were entering a world that you could be proud to be part of."[2] Won over by his ambition and his perseverance, Brodovitch ended up hiring him, a decision that would lead to one of the most remarkable human relations and artistic adventures in history of fashion photography.

Like Carmel Snow, Alexey Brodovitch, and Diana Vreeland, Avedon was an inventor, a fierce perfectionist, a man with a love of detail and a job well done. His fresh approach, his great respect for his teachers, his reverence for the history of the magazine—the photographs by Martin Munkácsi that covered the walls of his bedroom "filled his waking dreams" as a child[3]—made him a unique contributor. For twenty years, he reigned supreme at *Harper's Bazaar*: "*Bazaar* was my home. I remember rushing past the reflective windows of Longchamps on the way to the *Bazaar* offices, thinking I will see myself grow old running past these panes of glass."[4] For him, Snow and Brodovitch, whom he considered to be his one and only teacher, were the ultimate authorities in this new family: "Brodovitch was as rigorous and tough as my father. And Carmel was as warmhearted and open and accommodating and supportive as my mother."[5]

Junior Bazaar was his first testing ground. Carmel Snow, convinced that the magazine had to expand to include a younger readership, launched *Junior Bazaar* in 1943; it became independent in 1945, run by photographer Lillian Bassman. This supplement, " covering, the world of fashion, people, events, ideas for girls from 13 to 21,"[6] was groundbreaking, and was both a laboratory and springboard for Avedon.[7] This is where he tested out his first images with models captured smiling, running, and posing naturally. Playing with depth of field, he would deliberately isolate a model in the foreground, leaving the entire background completely out of focus. He gradually invented a new school,[8] combining influences ranging from Munkácsi's photographs, Ernst Lubitsch's films and interwar Parisian culture, that of a fantasized Paris with Picasso, Cocteau, Bérard, Colette. This was the world he had discovered as an adolescent, reading *Harper's Bazaar*, a world that Snow and Brodovitch had experienced and knew well.

"Studying and working with Alexey Brodovitch was certainly my strongest visual influence. My initial expression was instinctive... I would never have found the right direction myself."[9]

His second challenge occurred in Paris, in August 1947, this time with Snow, who commissioned him to photograph the new collections for the fall issue. It was a top secret mission. Louise Dahl-Wolfe, for years the official photographer for the Parisian collections, was not supposed to know that the young Avedon would also be on hand. This first exercise was a huge success: Avedon had his young wife, Doe,[10] play the roles of fictional characters, including Anna Karenina, Tolstoy's heroine, as well as a young Proustian girl in flower, set against an Impressionist backdrop.[11] These images ushered in a new era, heralding the magazine's golden age.

Avedon emerged victorious from his initiation that stretched from 1944 to 1947, becoming Carmel Snow's inseparable companion during the Paris collections.[12] A new column, "Carmel Snow's Paris Report," created in 1951, provided a showcase for his photographs, illustrating the latest fashion over sets of five and sometimes seven double pages. The cropping, layout decisions, and print quality were simply gorgeous. Alongside photographs taken in daylight on the streets—with recognizable images of the Pont Alexandre III, the Place de la Concorde, Parisian bistros—were others of Paris by night: leaving Maxim's, at the Pré Catalan, the Moulin Rouge, and the Shéhérazade nightclub. The show was everything. Grandiose. The tradition of ultimate luxury, as exemplified by French haute couture, was once again in full glory in the City of Light. Avedon's Paris was a huge feast for the eyes, for women, and for French fashion.

To further underscore this return to happy times, this revival of the art of seduction, Avedon drew on the history of Nadar and Louis Daguerre: "This is precisely how and where photography begins: in Paris, in this daylight, with an 8×10, in such a studio—a miniature version of the gritty romantic places that Nadar had worked in, and Daguerre before him. I wanted to use that frame and history as a reference for pictures that were new."[13] This appropriation of a romantic European past, this new joie de vivre, this return to sophisticated splendor that infused his photographs, helped to boost the French fashion industry.

Avedon's major innovation was his ability to transpose the spontaneity (under the influence of Munkácsi) and the spectacular in his settings, to create the illusion of a (deceptively) real and vibrant scene but one that was so dazzling it inspired dreams. It was the distillation of these two aspects,

1. Adolphe de Meyer, George Hoyningen-Huene and Man Ray were 53, 35 and 44, respectively, when they were hired by *Bazaar*, after working at *Vogue*, and Louise Dahl-Wolfe was nearly 50 in 1944.
2. Henry Béhar and Michel Guerrin, "Avedon," interview with Richard Avedon, *Le Monde*, July 1, 1993.
3. Richard Avedon wrote a tribute to Munkácsi in the June 1964 issue of *Harper's Bazaar*, vol. 97, no. 3031, pp. 64–69.
4. Amy Fine Collins, "Avedon," *Harper's Bazaar*, no. 3388, March 1994, p. 350.
5. Richard Avedon, interview with Calvin Tomkins, *Calvin Tomkins Papers*, New York, MoMA Archives.
6. Starting in 1935, Carmel Snow dedicated the August issues to "college fashion."
7. Carmel Snow also commissioned work from the photographer Toni Frissell, who took color photographs, not for *Harper's Bazaar* but for the *Junior Bazaar* supplement.
8. *Harper's Bazaar*, vol. 100, no. 3065, April 1967, p. 138: "Bazaar's history of photography and art reads like a museum program. The early days produced the great works in photography of Baron de Meyer and Hoyningen-Huene and Bazaar started the new school of photography with Avedon."
9. Richard Avedon, "Photography in Fashion—Fashion in Photography," *Portfolio Magazine*, Cincinnati, Zebra Press, no. 2, 1955.
10. Richard Avedon married Dorcas Nowell, whom he called Doe, in 1944. Photographs of this glamorous couple were regularly published in *Bazaar* until their divorce in 1949.
11. See "Anna Karenina" and "Tippets and Capelets," *Harper's Bazaar*, vol. 81, no. 2830, October 1947, pp. 182–183; and no. 2831, November 1947, pp. 170–171, respectively.
12. Louise Dahl-Wolfe continued to be asked to photograph the Parisian fashion shows, as was Gleb Derujinsky in the late 1950s.
13. Richard Avedon, *Made in France*, San Francisco, Fraenkel Gallery, 2001, n. p.
14. Dovima, Sunny Harnett and Suzy Parker are all three in the famous sequence from the film *Funny Face*, "Think Pink," by Stanley Donen in 1957. This passage, like all parts of the film dealing with fashion, was made with input from Avedon, who was far more than merely the "visual consultant," as listed in the opening credits.
15. "The constructed moment" refers to a conversation between Adam Gopnik and Richard Avedon that took place at the Metropolitan Museum of Art in New York in 2002.
16. "Dedicated to the trinity," Richard Avedon, *Made in France*, op. cit.

the spontaneity and the artifice, which made him one of the greatest fashion photographers of the twentieth century. From 1949 to 1950, he became staff editor and photographer for *Theatre Arts*, where he met actors, dancers, and acrobats; one could imagine that their ease in acting in front of his camera led him to develop new ways of photographing fashion. Avedon worked very closely with his models, Dovima, Sunny Harnett, Suzy Parker,[14] and Dorian Leigh. Because of their strong relationship, he could direct them like actresses, posing in the midst of acrobats on the street or smiling on a café terrace (October 1948), near a boxing ring (September 1948), in the arms of sweating cyclists (October 1949). His brilliant and intelligent staging was as much dream as it was reality, something that Richard Avedon called a "constructed moment."[15]

Avedon's photographic art, which was first created in the pages of the magazine, had a second life in book form, in which he could select and present a new way of looking at his images, without the editorial context. As a continuation of his working method, his first book, *Observations* (1959), followed by *Nothing Personal* (1964), were both three-way collaborations. Truman Capote wrote the text for *Observations*, while Brodovitch created the layout. *Nothing Personal* featured an essay by James Baldwin and was edited by Marvin Israel. The link with *Harper's Bazaar* was never really far away.

In 2001, three years before his death, he published an exceptional, limited-edition monograph of his images for *Harper's Bazaar* called *Made in France*. The reproductions of the engraver's prints, uncropped, with the pictures made by Avedon on the front page and with *Harper's Bazaar* notations on the back (description of the dresses by the advertisers, notes for captions), with crossed-out text and many bits of scotch tape, illustrate a desire to return to his roots, to the work done within the context of a magazine, with all that this entailed in terms of graphic design and advertising, the collaborative and experimental aspects, the concept of an image being part of the whole.

Richard Avedon dedicated *Made in France* "to the trinity: Carmel Snow, Alexey Brodovitch, and Diana Vreeland."[16]

A Elise Daniels with street performers, suit by Balenciaga, Le Marais, Paris, August 1948. *Harper's Bazaar* October 1948, p. 176. Photograph by Richard Avedon.

107

A C
B D

A "Paris," *Harper's Bazaar*, April 1948, pp. 124–125. Photograph by Richard Avedon (model: Comtesse Maxime de la Falaise).

B "Paris Street Scene: Suits," *Harper's Bazaar*, November 1947, pp. 168–169. Photographs by Richard Avedon (models: Renée and Doe Avedon).

C "The Hats of Paris by Night," *Harper's Bazaar*, October 1955, pp. 128–129. Photographs by Richard Avedon (models: Marlene Dietrich and Dovima).

D *Harper's Bazaar*, March 1948, pp. 178–179. Photographs by Richard Avedon (model: Elise Daniels).

The Hats of Paris, by Night

• Above: Balenciaga's evening toque of the same shiny emerald felt he uses by day—here swathed inches deep in white net, cockaded with feathers.
• Right: A hat to turn even Mrs. Miniver into a woman of mystery—Fath's magnificent white swansdown sailor, settled firmly over an invisible crown of net. Bergdorf Goodman; Neiman-Marcus.
• Below: Balenciaga's great white feathered wheel, banded around its circumference in snowy ermine and, like most of the hats of Paris, worn straight-on.

Marlene Dietrich (facing page), visiting Paris this autumn after a triumph at London's Café de Paris, has a special penchant for the cheerfully crowded terraces of the native *cafés de Paris*. Here, she wears one of Dior's already famous "borrowings" from the East—a pleated beige satin turban that's a triumph in its own right.

When a woman orders a ball gown, the designer's sky knows no limit. Above: A ball gown in water-lily shades, green taffeta with half the bodice in pale, yellow-green satin. The silk taffeta is so intricately shaped, so marvelously massed into drapery that every angle presents a new silhouette. This dress is custom made by Charles James. D. H. Holmes, New Orleans. • Opposite: Appliquéd with fluttering leaves and flowers, a great skirt of white imported Swiss organdie, and a tiny bodice with a fold of heavy pink satin that unfolds like a flower. Custom made by Hattie Carnegie. Diamonds, Harry Winston.

PHOTOGRAPHS BY RICHARD AVEDON

C rystallized here—in stiff, silk taffeta—the elegant, feminine fashion—natural
shoulder, defined bodice, narrow waist and moving, voluminous skirt.
A balance is struck, and the silhouette completed
with long-vamped, tall-heeled pumps and a side hat with a high flame of feathers.

RICHARD AVEDON

DRESS DESIGNED BY OMAR KIAM
FOR BEN REIG.
AT BERGDORF GOODMAN;
HIMELHOCH, JOSEPH HORNE.
BEIGE SUEDE GAUNTLETS.

A *Harper's Bazaar*, March 1948,
pp. 176–177. Photograph by Richard
Avedon (model: Elise Daniels).

Ca

• Givenchy'
touch them
collection ha
ideas. Given
His young
joyous; one
slender, with
here have s
hip; coats a
nary fabric
a layer of o
broidered a
hand-knitting
• In genera
best. Among
course. Woo
Jerseys ribbe
ing jersey f
evening. Du
Acetate and
patterned b
Satin, of co
smooth, dull
wrinkles an
intricate an
luxurious or

Dior's supp
site): high-
flat bow on
and Nelson
Givenchy's
its tapering
and slashed
Henri Bende

A B A "Carmel Snow's Paris Report," *Harper's Bazaar*, September 1954, pp. 202–203. Photographs by Richard Avedon (model: Sunny Harnett). B Christian Dior, *Angélique* gown, satin by Brossin de Méré, haute couture, Fall/Winter 1954. Paris, Musée des Arts Décoratifs, gift of Countess Cristiana Brandolini d'Adda Agnelli, UFAC collection, 1969, inv. UF 69-37-3.

112

el Snow's Paris Report

hats are so good nothing can
young. But this time his whole
thority and technique, as well as
now among the top designers.
and evening dresses are gay,
evening dress is white satin, very
, mink-banded satin scarf. Suits
kets, buttoned diagonally at the
ht, easy, narrow. One extraordi-
for coats and suits is made of
laced on a layer of cotton, em-
broidered in wool to look like
pears bulky but is light as air.
w materials are at their inventive
ols: smooth duvetyn. Tweed, of
lon woven with a puffy surface.
y like corduroy. Extra thin stock-
lier. Thin sheer black wool for
ed wool and metal from Staron.
ot with a gilt thread. Delicately
without sheen from Abraham.
d silky satin broadcloths, and
faille. Nylon velvet impervious to
incredible bloom. Everywhere
lamés and brocades, some so
meters a week can be produced.

gated line in pink satin (oppo-
its narrow skirt drawn into a
Bergdorf Goodman; Frederick
Renfrew of Canada; I. Magnin.
-banding white satin (right),
melted into a carved waistline
satin scarf threaded with mink.
nin; Wanamaker's, Philadelphia.

RICHARD AVEDON

Dior's Sinuous Evening Line is marked high,
like an Empire silhouette, then flows
supplely against the figure, narrowing as it goes.
• Above: His white georgette crepe dress
descends in gentle winding folds below a bosom banded
in black velvet and marked with a huge white rose.
These pages photographed at the Cirque d'Hiver,
where Sir Carol Reed is currently filming *Trapeze*.
• Opposite: Dior puts long, tight sleeves on his
grand décolleté dresses. Here, sleeved to the wrists:
his black velvet sheath, sashed high under the bosom
with a great streamer of white satin. Henri
Bendel; I. Magnin; Marshall Field. Perfume: his "Diorama."

A *Harper's Bazaar*, September 1955, pp. 214–215. Photographs by Richard Avedon (model: Dovima).
Above, the famous photograph "Dovima with Elephants," featuring the *Soirée de Paris* gown, one of Yves Saint Laurent's first designs for Christian Dior.

RICHARD AVEDON

Nightviews from Paris

• Left: Balmain's ivory chiffon dancing dress winds a shirred chiffon waistband above an air-blown skirt, tops them both with the delicious confection of a tiny sleeved bodice of ivory satin, sprayed with gold, blue and rosy beading. Bergdorf Goodman. Earrings from Arpad.
• Opposite: Patou drapes white satin slender as a needle beneath a high-waisted bodice embroidered in mother-of-pearl, loops a shining satin river over the arm. Satin of Du Pont Orlon; Hurel embroidery. Also shining: Patou's "Joy." The view, both pages: *chez* Sheherazade.

A "Nightviews from Paris," *Harper's Bazaar*, October 1956, pp. 140–141. Photographs by Richard Avedon (models: Suzy Parker and Gardner McKay).

PARIS—NEW YORK

Éric Pujalet-Plaà

At the end of *Rear Window*, Grace Kelly is browsing through an issue of *Harper's Bazaar*. She has solved the mystery of the crime, James Stewart is dozing, both legs in casts; calm has returned to Greenwich Village and she can finally delve into the beauty issue, published in October. The scene was filmed in 1953, one year prior to the release of the Alfred Hitchcock film. The magazine was not only a fashion accessory—it summed up a lifestyle; a world unto itself.

At the time, the high-society outlook and intellectual essence of the magazine had a single-minded focus, a combination of fashion, art and decoration, with references to personalities of the Café Society. This term, invented by Elsa Maxwell, who contributed to *Bazaar* in the 1930s,[1] described the "Tout-Paris on an international scale," which encompassed the couture clientele.

Couture was in the midst of a prosperous golden age dominated by Christian Dior, whose New Look, which received the Neiman Marcus award in 1948, had a profound impact on young designers (Pierre Balmain, Jean Dessès) and on the designs of their elders (Jacques Fath, Jeanne Lanvin, Marcel Rochas). Dior's influence extended to New York (with Charles James) and even to Hollywood costume designers. Meanwhile, Cristóbal Balenciaga was continuing the work he had begun prior to the war, and Gabrielle Chanel returned to the fashion world in France in 1954. For many of the prewar figures who continued to run their businesses, such as Elsa Schiaparelli and Madame Grès, the decade of the 1950s was like a miraculous renaissance.

Supported by *Bazaar*, designer fashion imposed a requirement that dress styles had to be revamped, and designated Paris as the place where this elite world would congregate. The famous designers obviously only dressed a small international clientele, but they balanced their budgets by selling exclusive models to American buyers. Haute couture was a laboratory of ideas, a focal point for all the French textile innovations, a vibrant conservatory of the many luxury craftsmen working in Paris.

Everything seemed to be going well; yet, the Café Society and haute couture were entering a downturn.

In 1958, Philippe Jullian described the decorative approach of the aging Café Society: "Despite a clear color scheme, there should be no trace of a decorator's hand; hobbies were placed on the tables; Fabergé if you were truly rich; small paintings by Mexican followers of Dalí or high-society imitators of Leonor Fini, combined with photographs by Barbara and d'Arturo. Paper flowers, a piece of rustic stoneware among this luxury could point to the lady's country of origin, Peru, Egypt or Ireland, but also to the country in which she lives.

Singular objects (Harpers-bizarre) were de rigueur (Victorian wooden horses rather than the ubiquitous imitations of T'ang funerary horses). It all may have looked a bit Fifth Avenue, with knick-knacks from Cartier or from Tiffany, but the chintz with large roses selected by Cecil Beaton came from London, the chairs from Paris, a souvenir of Lady Mendl, the mirror from Venice, gifts from Lily Volpi. Lots of small tables to hold glasses, large silver platters for drinks, because everyone drank a lot."[2]

His expression, "Harpers-bizarre," presents a slightly mocking view of the magazine. The presence of *Bazaar* was a given in chic apartments, judiciously placed on coffee tables. But Carmel Snow's look, Diane Vreeland's style, and the affected poses of the models were perfectly in synch with a world that was stylized to the extreme, a bit outdated—one that was somewhat parodied in 1957 in Stanley Donen's musical comedy *Funny Face*.[3]

It's the story of how a young model, played by Audrey Hepburn, is launched by a fashion magazine editor and a photographer. The role of the editor is a caricature, a hybrid of Snow and Vreeland; her song "Think Pink" is a reference to the world of Balenciaga, whose favorite color was pink. Richard Avedon himself served as a consultant and Fred Astaire starred as the photographer, Dick Avery.[4] Among other major contributions to the film, Avedon took the photographs used as freeze frames for the photo shoots of Audrey Hepburn in Paris.[5] Hubert de Givenchy, who had been mentored by Balenciaga, designed the actress's wardrobe; from his first collection, the designer had been wholeheartedly supported by Snow for whom "Givenchy is now among the top designers."[6] Hepburn was "Funny Face," the new face of fashion; she viewed Paris as the capital of existentialism. As an allegory for the magazine's literary ambitions, she represented the aspirations of young people in their prime, who did not relate to the sophisticated image of women published in the film's magazine, *Quality*.

Audrey Hepburn, therefore, personified the rise of a fashion counterculture that had, nevertheless, already been incorporated into the fashion world. Givenchy once again created Hepburn's outfits for Blake Edwards' *Breakfast at Tiffany's*, 1961, adapted from Truman Capote's novel. Its worldwide success confirmed the actress's role as the young designer's muse. With Givenchy, haute couture was reaching a younger audience. From this point onwards, New York had become a fashion capital, inspiring Paris.

The fate of haute couture played out in the years between *Rear Window* in 1954 and *Breakfast at Tiffany's* in 1961. In France, designers were launching ready-to-wear lines.

1. Elsa Maxwell wrote a regular column in *Harper's Bazaar* in 1937 and 1938 called "I have lived by my wits." She was known as one of the most famous professional hostesses from the 1920s through to the 1950s in Paris, New York, Los Angeles, and Monte Carlo. The term "Café Society" corresponds to the title of the magazine she launched in 1953. Only one issue was published. In 1957, she published her memoirs entitled *How to Do it or the Lively Art of Entertaining*.
2. Philippe Jullian, "Café Society, une amie de la duchesse de Windsor," *Les Styles*, Paris, Le Promeneur, p. 112. A journalist and art historian, Philippe Jullian was also an illustrator: he produced the drawings for Truman Capote's short story "The Grass Harp," published in the August 1951 issue of *Bazaar*.
3. Both Carmel Snow and *Harper's Bazaar* are acknowledged in the opening credits of the movie *Funny Face*: "We are most grateful to Mrs. Carmel Snow and *Harper's Bazaar* magazine for their generous assistance."
4. In *Funny Face*, the fashion photographer's name is Dick Avery (Dick is a diminutive of Richard) and the art director is called Dovitch. Thanks to *Bazaar* and Avedon's photographs, Hepburn received unwavering support, starting in 1951. Her portrait appeared on several covers in 1956.
5. Richard Avedon is listed as a "special visual consultant" and responsible for the "main title backgrounds." We now know that his participation was far more extensive: the freeze frames of Hepburn in Paris, as well as the "Think Pink" sequence show a direct link to Avedon's photographs. See also Robert M. Rubin's essay, "Vieux monde, New Look," in Robert M. Rubin and Marianne le Galliard, *La France d'Avedon, Vieux monde, New Look*, Paris, BnF Éditions, 2016, pp. 14–41.
6. Carmel Snow, "Carmel Snow's Paris Report," *Harper's Bazaar*, vol. 87, no. 2914, September 1954, p. 203.
7. Carmel Snow was no longer editor in chief after December 1957. She was given the (limited) role of Chairman of the Editorial Board in February 1959 before handing over full responsibility for operations to Nancy White. Brodovitch left *Bazaar* in August 1958 and was replaced by Henry Wolf.
8. The years 1957 to 1959 witnessed a profound period of change. There were numerous tributes: the film *Funny Face*, in 1957, followed by the publication of Avedon's first monograph, *Observations*, in 1959. That same year, the series "Audrey Hepburn, Mel Ferrer, *Paris Pursuit: A Love Farce*, directed by Richard Avedon" was published in the September issue, vol. 92, no. 2974. This photographic series ("directed by Avedon," as announced on the cover) harked back to his early years as a fashion photographer. A long article in *The New Yorker* in 1959 also looked back on Avedon's career with great praise: Winthrop Sargeant, "A Woman Entering a Taxi in the Rain," *The New Yorker*, October 31, 1958. Finally, the departure of Snow and Brodovitch effectively put an end to the regular collaboration between photographers Henri Cartier-Bresson, Lillian Bassman, Arnold Newman, Leslie Gill, and Robert Frank.
9. It is interesting to note that Truman Capote's 1958 short story was initially supposed to be published in *Harper's Bazaar*, but was ultimately printed by *Esquire* in its November 1958 issue.

Harper's Bazaar had a decisive influence on the careers of American designers and supported the boom in garments "Made in Italy."

This was a period of change: Christian Dior died in October 1957, the Christmas issue of *Harper's Bazaar* was Carmel Snow's last as chief editor.[7] Her niece Nancy White had taken over her role. Alexey Brodovitch left *Bazaar* in 1958, as did Louise Dahl-Wolfe,[8] preceding Diana Vreeland's departure for *Vogue* in 1962, followed by Richard Avedon in 1966.

In 1961, the year *Breakfast at Tiffany's* was released,[9] Carmel Snow died in New York. Her dedication to Dior and to Balenciaga foreshadowed the future of haute couture. The renaissance was soon assured by Yves Saint Laurent, who trained at Dior and with André Courrèges and Emanuel Ungaro, both of whom had worked with Balenciaga. By interpreting the ideal of childlike beauty that was so beloved by Balenciago, who created the "infants" style, then the babydoll dress, André Courrèges and Emanuel Ungaro would soon develop in the spring of 1965 the Courrèges "bomb," as this collection was described by Yves Saint Laurent. At the time, people were growing somewhat weary of the haute couture shows.

Yet, today, this difficult period is viewed as a mythological era. The issues from the late 1950s and early 1960s are now a major source of inspiration, as they provide a seamless portrayal of a specific literary period, at the dawn of a contemporary psyche.

A Philippe Jullian, illustration of the Café Society style published in his book *Les Styles*, Paris, Plon, 1961.
 An occasional contributor to Harper's Bazaar, Philippe Jullian illustrated Truman Capote's "The Grass Harp," in August 1952.

I Love New York

by Glenway Wescott

● What is the place to live? I have lived in fact, as most people do, hither and thither almost indifferently, wherever I could be near the one I loved, or where there appeared to be some economic advantage in my living, or where I expected to be able to work well. But what if I had not these motives? If nothing mattered to me; if I had given my talent up as a bad job, and therefore no longer felt obliged to live in any particular place for a specific purpose; if I had fallen out of love and it was final, and no one, none of my family, none of my customary dear friends, needed me or wanted me anywhere; and if, with nothing but my own inclination to consider, I had my choice of the entire earth—where should I choose to spend the rest of my life? The answer is New York.

New York, for its own sake, rather than Rome or London or Paris, although it is a disadvantageous place in many ways. Society in it is almost all alcoholic, and there are not nearly enough servants who take any pride or pleasure in their work. It boasts of its modernity, but it is a vain boast while millions have to go on dwelling in built-over brownstones, heating themselves up something unappetizingly on gas rings stuck in cupboards amid ineradicable cockroaches; and it has other shames and shortcomings. It is uncomfortable and it is expensive. The chances are that whatever you have to live on, whatever you do for a living, would entitle you to a higher standard of living somewhere else.

It is not even, in the strict sense of the aesthetic of cities, very beautiful. Think of Paris and Rome and London. New York is in a different category. As it grew, so little of it was ever planned ahead of time, and so little handed down to us about it as preconceived or traditional, that we think of it rather as landscape than as human construction and habitation. To be sure, it was humanity which aligned it in cliffs, and cut its faded canyons, and lifted it up and pieced it together nest by nest, rough-and-tumble around the horizon. But it might have been accident, the elements, the tides, and stubborn running water; or the instinctive work of generations of birds. Look at it, as you cross on a ferry from one of the islands out in the harbor: it consists of large dark sticks stacked this way and that, amid large withered reeds lapped by the waves; and hearing its congested traffic squawking, you half-expect some great thing to be startled up out of it, flapping panicky wings. Look up, as you walk or taxi south through the park: what you see is a part of a mountainside, with the atmosphere wound across it in wild vines, and when the night falls, the profusion of electricity ripening all over it.

I think it is the only great city with all the importance and activity and amusement of city life, which nevertheless appeals to the imagination like wild country. Its charm depends on the weather, the light and the dark, and the time of day, and the momentary emotion of the beholder. If we stop to consider it without emotion, or if we look too close, it is a disappointment; it is not at all according to human aestheticism or idealism. Like the wondrous works of God in nature, the other wondrous works of God in nature—glacier, jungle, flood, floor of the ocean—it is disorderly and unattractive in detail.

But we never care, having in mind a certain mirage to add to the reality; a visionary composite picture of it as a whole which makes us *(Continued on page 55)*

New York as it was, as it will be, and as New Yorkers have never ceased to think of it— in its glory by night.

PHOTOGRAPHS BY BERENICE ABBOTT

Balenciaga

Cerise Taffeta, Crushed over White Lace:
Balenciaga's volcanic short dancing dress, the décolletage scalloped in layers of lace, settled wide on the shoulders and tied off in wisps of sleeves; the skirt erupting in a flurry of folds over the lace petticoat. Adapted by Nanty, at Bergdorf Goodman; I. Magnin; Wanamaker's. I. Miller pumps.

A B
A *Harper's Bazaar*, April 1955, p. 130. Photograph by Louise Dahl-Wolfe.

B Balenciaga, short evening gown, taffetas by Lajoinie, broderie anglaise by Blackwell, haute couture, Spring/Summer 1955. Paris, Musée des Arts Décoratifs, gift of Michèle Rosier, UFAC collection, 1974, inv. UF 74-33-2.

FICTION

Marianne le Galliard
Éric Pujalet-Plaà

Literature was an integral part of *Harper's Bazaar* from the earliest years of its publication. In 1867, Charles Dickens contributed a short story written in collaboration with William Wilkie Collins.[1] Ever since this first piece of fiction, the magazine has been offering readers access to various literary genres, prose texts and verse. It reproduced and commissioned original texts, publishing for example, in 1907, a short story entitled *The Whole Family*, with texts by twelve different authors, including Henry James.[2]

The role of the fiction editor was essential. George Davis,[3] who held this job at *Bazaar* in the 1930s, was an author, a translator, and a talent scout. He traveled to Paris to meet French writers and apparently visited the salon of *Bazaar* correspondent Marie-Louise Bousquet,[4] about whom Christian Dior wrote in his autobiography: "In the days when Mme Jacques Bousquet held a salon in her little house in the Rue Boissière, I often went along on her 'day.' This was long before the period of the Place du Palais Bourbon when this day became celebrated as 'Marie-Louise's Thursday,' not only in Paris where it was a famous rallying point, but all over the world... She became a great friend and ally of mine, and just before the war introduced me to Carmel Snow, who had intended to ask me to do designs for *Harper's Bazaar*."

In 1944, Mary Louise Aswell, fiction editor for *Harper's Bazaar* from 1941 to 1952 following the tenure of George Davis, brought together an anthology of texts written by women and published by *Bazaar*, entitled *It's a Woman's World, a Collection of Stories from Harper's Bazaar*. The most famous authors included Colette, Virginia Woolf, Eudora Welty, Dorothy Parker, and Anita Loos. Simone de Beauvoir, Patricia Highsmith, and Carson McCullers joined this group of women after the war.[5] But men were not overlooked: Mark Twain, F. Scott Fitzgerald, Marcel Aymé, Vladimir Nabokov, Marcel Jouhandeau, Aldous Huxley, William Faulkner, André Gide, Jean Genet, André Malraux, Samuel Beckett, Raymond Queneau, Henry Miller, John Steinbeck, Tom Wolfe, Yukio Mishima, Jean-Paul Sartre, and Antoine de Saint-Exupéry all wrote for *Bazaar*. The magazine also published texts by fashion designers, photographers, and artists. Paul Poiret, Adolphe de Meyer, Salvador Dalí, and Elsa Schiaparelli penned works, sometimes providing their own illustrations to accompany them.

Illustrations for the regular articles and short stories were commissioned from an illustrator or a photographer: Virginia Woolf was illustrated by Cecil Beaton, Leslie Gill, and Man Ray; Henri Cartier-Bresson observed Truman Capote; Richard Avedon portrayed James Baldwin; and Louise Dahl-Wolfe cast her eye over W. H. Auden and Christopher Isherwood. Françoise Sagan, profiled by Tennessee William, posed for David Seymour.

Except for the first page, images did not necessarily relate to the texts alongside which they appeared. Henry James's story *An International Episode*, published in 1878,[6] framed a fashion illustration that had nothing to do with the narrative. Saul Bellow's *Dora* was printed next to images of costume jewelry on sale at Saks Fifth Avenue,[7] and the madness of Patricia's Highsmith character in "The Heroine" unfolded amid the ads.[8]

What set *Harper's Bazaar* apart was its appreciation for the writing and its willingness to adapt the typography to the words, using a large variety of styles. To fully appreciate the role played by the format of the script itself, it is important to understand that this was a source of graphic inspiration, part of the magazine's signature style. Alexey Brodovitch borrowed from different ways of producing letters, ranging from calligraphy to ink pads, also drawing on a vast world of characters, numbers, and signs. He incorporated aspects of the paper, as well as scotch tape and collages. The photographers made good use of these graphic writing styles and paper (backgrounds, posters, shop-front lettering in the background of fashion shoots). The editorial format was also sometimes adapted to the content. For Carmel Snow's "Letters from Paris" or her "Fashion Report," Brodovitch designed the pages to look like dispatches or telegrams. Literature, essays, fashion reviews, art texts, and pneumatics all received the same graphic treatment under the direction of the Snow-Brodovitch-Vreeland trinity. Vreeland's "Why don't you...?" column revived the style of the epigram, with illustrations sometimes as simple as graffiti.

Brodovitch's obsessive approach to graphics spilled over into the photographs of Man Ray and Richard Avedon, whose silhouettes formed what appeared to be giant lettering. At *Bazaar*, graphic design was a passion that had been perpetuated since the early years of Marie-Louise Booth: the illustrator Eugène Grasset had designed a typeface (the Grasset-Didot), Erté devised an anthropomorphic alphabet, Cassandre created Yves Saint Laurent's monogram. A portrait by Avedon of Saint Laurent, published in March 1959, who posed in a "Y" shape, bolstered this link between script and identity.[9] Fabien Baron, creative director from 1992 to 1999, recalled the distinctive identity created by adding the second "A" to "Bazaar" in 1929 to reflect the American spelling of the word. And finally, in the January 2009 issue of *Bazaar*, Marc Jacobs appeared nude, covered with "Louis Vuitton" logos.

The literary texts published in *Bazaar* frequently referenced specific forms of writing. Paul Bowles's short story "The Echo"[10] started with a letter; Anita Loos's series, *Gentlemen Prefer Blondes*, was presented as a diary.[11]

Writing and graphics, which were at the heart of this luxury magazine's identity, finally came together in 1967 with the publication of facsimiles of four typescript pages from *The Third Mind* by William Burroughs,

1. Charles Dickens, Wilkie Collins, "The Overture, No Thoroughfare," *Harper's Bazar*, vol. 1, no. 8, pp. 138–139.
2. *The Whole Family, a Novel in Twelve Parts by Twelve Authors*, *Harper's Bazar*, vol. 41, no. 12, December 1907, pp. 1161–1170 (William Dean Howells, Mary E. Wilkins Freeman, John Kendrick Bangs, Mary Raymond Shipman Andrews, Mary Stewart Cutting, Alice Brown, Henry Van Dyke, Elizabeth Stuart Phelps, Elizabeth Jordan, Edith Wyatt, Mary Heaton Vorse, Henry James). The author William Dean Howells, under the direction of Elizabeth Jordan, editor in chief of *Bazar* from 1900 to 1913, initiated this project. The texts were brought together and published in 1908 by Harper and Brothers.
3. George Davis was the magazine's fiction editor from 1936 to 1941. A member of the Algonquin Round Table in the 1920s, he translated the texts by Salvador Dalí, Colette, and Marcel Vertès, and in the 1940s, befriended Carson McCullers, W. H. Auden, and Gypsy Rose Lee. He also wrote the tribute to Christian Bérard in the May 1949 issue.
4. During this period, George Davis was in contact with Jean Cocteau, Ernest Hemingway, Djuna Barnes, Christian Bérard, Kay Boyle, and James Stern (who also had texts published in *Bazaar*). See Sherill Tippins, *February House*, Boston, New York, First Mariner Books, 2006.
5. The first book on the history of *Harper's Bazaar*, titled *100 Years of the American Female* and published in 1967, showcased the writing of women authors, with texts by Kay Boyle, Marianne Moore, Flannery O'Connor, Isak Dinesen, and Susan Sontag, among others.
6. Henry James, *An International Episode*, vol. 11, no. 51, December 21, 1878, pp. 817–818.
7. Like all the articles in *Bazaar*, the first page of the literary texts nearly systematically included an image (illustration, fashion page, portrait). The overrun of the texts were then placed among the ads at the end of the issue. Saul Bellow's *Dora*, illustrated by a Kodachrome by Ernst Beadle, started on pages 118–119 of the November 1949 issue (vol. 83, no. 2855) and continued on at the end of the issue, pp. 188–190, then 198–199.
8. Patricia Highsmith, "The Heroine," *Harper's Bazaar*, vol. 79, no. 2804, August 1945, pp. 76–77, 116–124.
9. "Paris presents Pierre Cardin, Yves St. Laurent," *Harper's Bazaar*, vol. 92, no. 2968, March 1959, pp. 94–95.
10. Paul Bowles, "The Echo" (illustrated by Genevieve Naylor), *Harper's Bazaar*, vol. 80, no. 2817, September 1946, pp. 194–195.
11. The series appeared for the first time in *Bazar* in 1925. Journalist and essayist H. L. Mencken apparently advised Anita Loos to publish the story (originally written as a screenplay) in *Bazar*: "You are making fun of sex and that's never been done before in the USA. I suggest you send it to *Harper's Bazar*, where it'll be lost among the ads and won't offend anybody." (Anita Loos, "The Biography of a Book," *Gentlemen Prefer Blondes*, New York, W. W. Norton, 2014.)
12. "A Dreamlike Juxtaposition of Word and Image," William Burroughs, *The Third Mind*, *Harper's Bazaar*, vol. 100, no. 3069, August 1967, pp. 132–133.

"A Dreamlike Juxtaposition of Word and Image."[12] After this time, literature was gradually replaced by literary interviews.

The magazine created direct and indirect links across its pages; the fashion figures who were the farthest from the literary pages took on a poetic role that gave them a certain psychological depth, as if they, too, were fictional characters. This unspoken subliminal link has become clear over time; when browsing through older issues, it's striking to see the presence of images surrounding the texts, including advertisements, inseparable from the sentiment of the narrative.

The overall design of the magazine was based on a cinematic structure, with a succession of images. *Bazaar* was intricately linked to the world of film; in September 1914, the cover was dedicated to the epic film co-written by Gabriele D'Annunzio and Giovanni Pastrone, *Cabiria*. This connection was further confirmed with Orson Welles's *Citizen Kane*, inspired by William Randolph Hearst. Some of the texts that appeared for the first time in *Bazaar* were depicted in film: the musical comedy *Gentlemen Prefer Blondes* (1953), filmed by Howard Hawks, starring Jane Russell and Marilyn Monroe, *Reflections in a Golden Eye* (1967) by John Huston, with Elizabeth Taylor and Marlon Brando. These films were based on texts by Anita Loos in 1925 and Carson McCullers in 1940. We could also add to the list Blake Edwards's *Breakfast at Tiffany's* (1961), inspired from a short story by Truman Capote, an author discovered and promoted by *Harper's Bazaar*—even though this text had been rejected by the magazine.

A Portrait of Carson McCullers, *Harper's Bazaar*, October 1940, p. 60. Photograph by Louise Dahl-Wolfe. This portrait of the writer illustrated the publication of an excerpt of her novel *Reflections in a Golden Eye*.

A C
B D

A Virginia Woolf, "The Duchess and the Jeweler," *Harper's Bazaar*, May 1938, pp. 74–75. Photograph by Leslie Gill.

B William Burroughs, "The Third Mind," *Harper's Bazaar*, August 1967, pp. 132–133.

C Gertrude Stein, "The World is Round," *Harper's Bazaar*, June 1939, pp. 46–47. Illustrations by Dugo.

D Samuel Beckett, "Come and Go. A Dramaticule for John Calder," *Harper's Bazaar*, August 1969, pp. 136–137. Drawings by Sol LeWitt.

THE WORLD IS ROUND

BY GERTRUDE STEIN

Once upon a time the world was round and you could go on it around and around. Everywhere there was somewhere and everywhere there they were men women children dogs cows wild pigs little rabbits cats lizards and animals. That is the way it was. And everybody dogs cats sheep rabbits and lizards and children all wanted to tell everybody all about it and they wanted to tell all about themselves.

And then there was Rose.

Rose was her name and would she have been Rose if her name had not been Rose. She used to think and then she used to think again.

Would she have been Rose if her name had not been Rose and would she have been Rose if she had been a twin.

Rose was her name all the same and her father's name was Bob and her mother's name was Kate and her uncle's name was William and her aunt's name was Gloria and her grandmother's name was Lucy. They all had names and her name was Rose, but would she have been Rose if her name had not been Rose.

I tell you at this time the world was all round and you could go on it around and around.

Rose had two dogs a big white one called Love, and a little black one called Pépé, the little black one was not hers but she said it was, it belonged to a neighbor and it never did like Rose and there was a reason why, when Rose was young she was nine now and nine is not young no Rose was not young, well anyway when she was young she one day had little Pépé and she told him to do something, Rose liked telling everybody what to do, at least she liked to do it when she was young, now she was almost ten so now she did not tell every one what they should do but then she did and she told Pépé, and Pépé did not want to, he did not know what she wanted him to do but even if he had he would not have wanted to, nobody does want to do what anybody tells them to do, so Pépé did not do it, and Rose shut him up in a room. Poor little Pépé he had been taught never to do in a room what should be done outside but he was so nervous being left all alone he just did, poor little Pépé. And then he was let out and there were a great many people about but little Pépé made no mistake he went straight among all the legs until he found those of Rose and then he went up and he bit her on the leg and then he ran away and nobody could blame him now could they. It was the only time he ever bit any one. And he never would say how do you do to Rose again and Rose always said Pépé was her dog although he was not so that she could forget that he never wanted to say how do you to her. If he was her dog that was alright he did not have to say how do you do but Rose knew and Pépé knew oh yes they both knew.

Rose and her big white dog Love were pleasant together they sang songs together.

Love drank his water and as he drank, it just goes like that like a song a nice song and while he was doing that Rose sang her song. This was her song.

I am a little girl and my name is Rose, Rose is my name.
Why am I a little girl
And why is my name Rose
And when am I a little girl
And when is my name Rose
And where am I a little girl
And where is my name Rose
And which little girl am I am I the little
girl named Rose which little girl named Rose.
And as she sang the song and she sang it while Love did his drinking.

Why am I a little girl
When am I a little girl
Which little girl am I

And singing that made her so sad she began to cry, And when she cried Love cried he lifted up his head and looked up at the sky and he began to cry and he and Rose and he cried and cried and cried until she stopped and at last her eyes were dried.

And all this time the world just continued to be round.

Rose had a cousin named Willie and once he was almost drowned. Twice he was almost drowned. That was very exciting.

Each time was very exciting.

The world was round and there was a lake on it and the lake was round. Willie went swimming in the lake there were three of them they were all boys swimming and there were lots of them they were all men fishing.

Lakes when they are round have bottoms to them and there are water lilies pretty water lilies white water lilies and yellow ones and soon very soon one little boy and then another little boy was caught right in by them, water lilies are pretty to see but they are not pretty to feel not at all. Willie was one and the other little boy was the other one and the third boy was a bigger one and he called to them and come and they Willie and the other boy they couldn't come, the water lilies did not really care but they just all the same did not let them.

Then the bigger boy called to the men come and get them they cannot come out from the water lilies and they will drown come and get them. But the men they had just finished eating and you eat an awful lot while you are fishing you always do and you must never go into the water right after eating, all this the men knew so what could they do.

Well the bigger boy he was that kind he said he would not leave Willie and the other behind, so he went into the water lilies and first he pulled out one little boy and then he pulled out Willie and so he got them both to the shore.

And so Willie was not drowned although the lake and the world were both all round.

That was one time when Willie was not drowned.

Another time he was not drowned was when he was with his father and his mother and his cousin Rose they were all together.

They were going up a hill and the rain came down with a will, you know how it comes when it comes so heavy and fast it is not wet it is a wall that is all.

So the car went up the hill and the rain came down the hill and then and then well and then there was hay, you know what hay is, hay is grass that is cut and when it is cut it is hay. Well anyway.

The hay came down the way it was no way for hay to come anyway. Hay should stay until it is taken away but this hay the rain there was no much of it the hay came all the way and that made a dam so the water could not go away and the water went into the car and somebody opened the door and the water came more and more and Willie and Rose were there and there was enough water there to drown Willie certainly to drown Willie and perhaps to drown Rose.

Well anyway just then the hay went away, hay has that way and the water went away and the car did stay and neither Rose nor Willie were drowned that day.

Much later they had a great deal to say but they knew of course they knew that it was true the world was round and they were not drowned.

Now Willie liked to sing too. He was a cousin to Rose and so it was in the family to sing *(Continued on page 92)*

COME AND GO

A Dramaticule
For John Calder

Drawing by Sol LeWitt

BY SAMUEL BECKETT

Characters
FLO
VI
RU
Age undeterminable

Sitting center side, by side stage right to left FLO, VI, and RU. Very erect, facing front, hands clasped in laps.

VI: Ru.
RU: Yes.
VI: Flo.
FLO: Yes.
VI: When did we three last meet?
RU: Let us not speak.
Silence.
Exit VI right.
Silence.

FLO: Ru.
RU: Yes.
FLO: What do you think of Vi?
RU: I see little change.
(FLO moves to center seat, whispers in Ru's ear. Appalled.) Oh! *(They look at each other. FLO puts her finger to her lips.)* Does she not realize?
FLO: God grant not.

Enter VI. FLO and RU turn back front, resume pose. VI sits right. Silence.

FLO: Just sit together as we used to, in the playground at Miss Wade's.
RU: On the log.

Silence
Exit FLO left.
Silence.

RU: Vi.
VI: Yes.
RU: How do you find Flo?
VI: She seems much the same.
(RU moves to center seat, whispers in Vi's ear. Appalled.) Oh! *(They look at each other. RU puts her finger to her lips.)* Has she not been told?
RU: God forbid.

Enter FLO. RU and VI turn back front, resume pose. FLO sits left. Silence.

RU: Holding hands . . . that way.
FLO: Dreaming of . . . love.

Silence.
Exit RU right.
Silence.

VI: Flo.
FLO: Yes.
VI: How do you think Ru is looking?
FLO: One sees little in this light.
(VI moves to center seat, whispers in Flo's ear. Appalled.) Oh! *(They look at each other. VI puts her finger to her lips.)* Does she not know?
VI: Please God not.

Enter RU. VI and FLO turn back front, resume pose. RU sits right.

VI: May we not speak of the old days? *(Silence.)* Of what came after? *(Silence.)* Shall we not hold hands in the old way?

After a moment they join hands as follows: Vi's right hand with Ru's right hand, Ru's left hand with Flo's right hand, Flo's left hand with Vi's left hand. Vi's arms being above Ru's left arm and Flo's right arm. The three pairs of clasped hands rest on the three laps. Silence.

FLO: I can feel the rings.

Silence.

NOTES

Successive positions

1 Flo Vi Ru
2 Flo Ru
 Flo Ru
3 Vi Flo Ru
4 { Vi Flo Ru
 Vi Ru Flo
5 Vi Ru Flo
6 { Vi Ru Flo
 Vi Flo
7 Ru Vi Flo

Hands

Ru Vi Flo

(Continued on page 198)

by Tennessee Williams

On Meeting a Young Writer

Writing is the loneliest of all human occupations, and yet, whenever I meet a new young writer, one whose first book is a sensational best seller, or whose first play has gotten raves and is "the hottest ticket on Broadway," I see behind his shoulder, as I meet him, a phantom crowd of his newly acquired attendants, followers, companions; and I still have enough humanity left in me to almost cry for his plight. For writing is the loneliest of all vocations because it is meant to be so, and when it becomes a terrible public performance, he, the young writer, the beginning talent, is being industriously destroyed at his moment of birth as an artist. I see this phantom crowd over his shoulder. I see the beaming face of the publisher and his whole office staff, faceless but visible; or I see the producer and his whole office staff, particularly those in the publicity department. I see the faces of those who will interview him for the newspapers and television, I see the captains of steamships who will invite him to sit at their table. I see this adulatory host crowded together in the dim, comforting air of the library at the St. Regis or in the Plaza Bar. And I feel as if I were about to place an evergreen wreath on his grave, and that all about me the others are....

The wreath of laurel that is placed on the forehead of a young writer in our time, in our world, can easily turn into a golden band that tightens upon him until it cracks his skull like a dry pea pod.

The work of a writer, his continuing work, depends, for breath of life, on a certain privacy of heart—and how is he to maintain it with that wreath on his head and that crowd at his heels?

Once in a while you meet a young writer who seems able to do it. And this is my gray introduction to the vivid and luminous subject of Françoise Sagan.

When I met Françoise Sagan in Key West (she came down there to meet my house guest, Carson McCullers), I saw behind her this phantom host I've described, for her novel, *Bonjour Tristesse*, was already at the head of our American best seller list (as it had been in France); and, seeing back of her the pursuing pack, even hotter than usual on the scent of its quarry, I looked in her eyes for some clue as to the outcome of the race or flight, and I saw something in their gold-freckled brown depths, something cool in its detachment but warm in its sensibility, that made me feel reasonably safe about this young artist's future. I felt that she was the girl in her class most likely to succeed; that fame at nineteen would not be disgrace at twenty, nor ever. There was clarity and humor, not confusion and panic, in her young eyes. It was evening when I met her. I wondered if in the morning she would be at her typewriter banging out a new novel with panicky compulsion. Well, she wasn't. In the morning she was sun-bathing and swimming, and in the afternoon we went deep-sea fishing and in the evening, when it came again, she took the wheel of my sports car and drove it so fast, with such a gay smile, that I had to warn her of the highway patrolmen. I think a passion for speed is a healthy sign in a young artist: it shows that they know already the need to keep distance between them and the pack.

I liked Françoise, and Carson liked her, too. I am not at all surprised, now, that she has scored a second artistic triumph which is, incidentally, another and greater best seller. Of course in this game you are never "out of the woods," but I would bet on this French girl. Perhaps she doesn't have, now, at this moment in her development, the alarming, deeply disturbing, visionary quality of her literary idol, Raymond Radiguet, who died so young after a little great work, nor has she yet written anything comparable to Carson McCullers' *Ballad of the Sad Café*, but I have a feeling that if I had met Mme. Colette at twenty I would have noticed about her the same cool detachment and warm sensibility that I observed in the gold-freckled eyes of Mlle. Sagan. She is young and tender, and she is wise. She will not exchange the cow for a hatful of beans and find herself, the next day, in the ogre's oven!

Françoise Sagan, opposite, whose second novel *A Certain Smile* will be published this month by Dutton

Colette, Claudine, Gigi

by Colette

How old was I when I first began to write? When I wrote the first of the *Claudine* books, I was just twenty-two and had two braids of golden hair whose total length came to sixty-four inches. I can still look at them in one of my adolescent pictures and still remember the dire curse pronounced by my mother when I dared to cut them off.

The first thing I wrote—without signing it—was *Claudine à l'école*. Then, still anonymously, I wrote *Claudine à Paris, Claudine en ménage* and, to finish the series, *Claudine s'en va*. If my first divorce had not brought into my life an element of independence and variety, I might be working in this year of grace 1951 over a *Claudine at Eighty*, which the critics might judge indicative of a promising writer's career.

In spite of my anonymity I acquired a pleasant but treacherous reputation as a country girl turned author. A poet of my acquaintance, Catulle Mendès, who has left behind him a name neither glorious nor obscure, took it upon himself to simultaneously encourage and distress me. "My dear, I have watched you ever since your first *Claudine*," he said. "You have created a literary type, a character, but you have no idea of where it may lead you. Quite unconsciously you are playing with forces which you believe are under your control. But one day you will discover that your creation really holds you in its power.... Go your way, my dear, but don't forget an old friend's warning. And remember, too, that a poet has something of a seer and sorcerer about him...."

My readers will agree that I took the poet's words to heart.

And now another feminine creature leafs through the pages in which I told her story. Do Gigi's childlike features, upon close scrutiny, bear any resemblance to those with which I endowed Claudine? Yes ... No ... Perhaps.... The strange thing is that I don't recognize her; she is pointed out to me by passers-by, by total strangers. She is dark and charming, as slender as the swamp reeds of my native province, with an ease and grace of movement such as a doe might envy.... I met her for the first time in Monte Carlo, where people turned around to stare after her; and for the second, in the shade of a Paris garden planted by Louis XIII. But I never expected to see her, armed with as much patience as if she were waiting expressly for me, on the old stairway of my Palais-Royal apartment. And yet I knew that among my closest friends, just as among strangers, admiration, curiosity and liking had won her a place and a name. And now, fateful little character, link between the life I breathed upon you and my own life, which you have come to influence so deeply, what will you bring me next? Carry me along the path of your mysterious destiny, where you are familiarly called by a child's nickname.... "That's Gigi ... You know, Gigi ..."

No, I don't yet know. But I am going to very soon.

GABRIELLE CLAUDINE COLETTE, France's beloved novelist, was photographed in bed in her sun-drenched room, walled in red velvet, that overlooks the Palais Royal in Paris. Nearing eighty, Colette receives visitors with the coquetry of an inveterate actress, writes still with the eloquence, the intensely personal orientation that has characterized her output for over fifty years. Her notes on Claudine and Gigi, the two heroines with whom she is irrevocably identified, were written especially for the Bazaar. Incidental intelligence: *The Indulgent Husband*, one of the Claudine books on which thousands of Colette readers were nurtured, is included in the volume of her works just brought out here by Dial Press. As for Gigi—whose story appeared in the Bazaar in 1946 and later became a film—she has come at last to Broadway in a play.

A C

B D

A Tennessee Williams, "On Meeting a Young Writer," *Harper's Bazaar*, August 1956, pp. 124–125. Photograph of Françoise Sagan by David Seymour.

B Colette, "Colette, Claudine, Gigi," *Harper's Bazaar*, December 1951, pp. 84–85. Photograph of Colette by Louise Dahl-Wolf.

C Joyce Cary, "Psychologist," *Harper's Bazaar*, May 1957, pp. 142–143. Photograph of Samuel Beckett by Brassaï.

D Alain Robbe-Grillet, "L'Immortelle," *Harper's Bazaar*, March 1966, pp. 206–207. Photograph of Alain Robbe-Grillet by Bill Brandt.

NUDES

Éric Pujalet-Plaà

The bikini—worn by Dovima and photographed by Toni Frissell—made its debut in May of 1947. It was, according to Diana Vreeland, the most important thing since the atom bomb. Yet nudity was rarely exhibited in the pages of the magazine, as it naturally focused more on images of textiles. Bare skin first appeared in the beauty pages in seaside stories in the summer issues; it wasn't until the 1990s, however, that a nude body was published on the cover.

The portrayal of nudity or quasi-nudity was initially linked to the popularity of sports and the sea in the 1920s. This was when people first started to travel to the Côte d'Azur during the summer months; up to then it had been more fashionable to spend the winters there. In 1924, the Ballets Russes performed *Le Train Bleu* about summer vacationers heading south. They would return relaxed, toned, and tanned—in short, Olympian. Sports photography, promoted by the magazine *Vu*, launched by Lucien Vogel in 1928, was in synch with the Greco-Roman ideal that Madeleine Vionnet was expressing in the clothes industry at the same time. In *Bazaar*, Erté, George Hoyningen-Huene, and Bernard Boutet de Monvel lavishly styled the sun-kissed bodies that Martin Munkácsi—who came from a background of sports journalism—suddenly brought to life.

Nudity then became an exercise in style for the photographers. Swimming and the beach were perfect pretexts for reclining poses that fitted handily in the horizontal composition of the double-page spread, Alexey Brodovitch's most creative format. At this point, a new aesthetic approach to silhouette took hold, with views from above, the body reclining in grass or on the beach, anticipating Hiro's experiments with foreshortening in the 1970s.

Thanks to the nude, the fashion silhouette shed its vertical framework and came to life. It was no longer the standard for clothing proportions, but dictated a vision of the body.

In February 1946, Salvador Dalí challenged the canons of postwar beauty in *Bazaar*. He titled his article "Painting after the Tempest,"[1] which he illustrated with a portrait of Gala baring her left breast, just as the "Dame de Beauté" (Lady of Beauty, referring to Agnès Sorel, a favorite of King Charles VII of France) lent her features to Jean Fouquet's painting *Virgin and Child Surrounded by Angels*.[2] For the April 1947 issue of *Bazaar*, the famous *New Yorker* illustrator Saul Steinberg sketched a standing female nude, wearing a laurel wreath.[3] His spare and childlike inimitable line summed up the prevailing ironic view toward academic culture and ancient history.

Most postwar artists renounced classical figurative representation. In this context, the study of the nude in *Bazaar* was perpetuating a form of classicism. Standing or reclining, photographed or sketched, with the image emphasizing a complexion or curve, or highlighting a certain accessory, its references were always linked to the legacy of the arts and the culture of drawing. By publishing nudes, *Bazaar* was perhaps the custodian and restorer of a way of seeing based on a study of the body. This was a culture inherited from the Academy of Fine Arts, except that it was, in this case, focused on women and their bodies as the ultimate model.

In 1967, the double cover of *Bazaar*'s anniversary book, *100 Years of the American Female*, featured the torso of a bare female model viewed from the front and back, standing, her arms raised, legs together, photographed by Richard Avedon and designed by Henry Wolf. It was the body of an anonymous woman (her head, arms, and legs were cropped out). Glenda Bailey drew her inspiration for the cover of her first issue as editor in chief, in February 2002, from this front and back view of a nude. The two shots by Patrick Demarchelier portray Gisele Bündchen perched atop stilettos in a contrapposto pose, wearing a transparent red Armani dress that plunged to her navel and was slit thigh-high. It was not a true nude but, by this point, the dress was no more than an adornment.

The duality of the imagery was clear: the woman and the magazine are one, her body at the heart of *Bazaar*. This image is perfectly in line with the original concept of the magazine, as defined in 1867: "Being intended largely for LADIES, IT WILL BE DEVOTED A CONSIDERABLE SPACE to the matters which fall under their jurisdiction, such as dress and household affairs."[4] This photograph comes as a reminder that this jurisdiction also extends to the body.

As the primary target audience, women were openly viewed by *Bazaar* as objects, subjects, themes, mediums, and authors. Very early on, for example, *Bazaar* gave a large role to women photographers (Toni Frissell, Lillian Bassman, Louise Dahl-Wolfe, Lisette Model, Diane Arbus) and authors (Virginia Woolf, Colette, Edith Sitwell, Eudora Welty, Patricia Highsmith, Jane Bowles, Simone de Beauvoir, Françoise Sagan). *Bazaar* promoted recognition for women in every field by, for example, showcasing the work of artist Germaine Richier in 1953, whose practice, sculpture, was "considered to be the ultimate male discipline," or that of Cindy Sherman[5] in 2016. The achievements of these artists also helped forge the image of women.

1. *Harper's Bazaar*, vol. 80, no. 2810, February 1946, pp. 128–129.
2. Jean Fouquet, *Virgin and Child Surrounded by Angels*, 1451–1452, Antwerp, Royal Museum of Fine Arts, inv. 132.
3. *Harper's Bazaar*, vol. 81, no. 2824, April 1947, pp. 166–167.
4. *Harper's Bazar*, vol. 1, no. 1, November 1867, p. 2.
5. Laura Brown, "Cindy Sherman. Street Style Star," *Harper's Bazaar*, no. 3641, March 2016, pp. 454–463.

A *Harper's Bazaar*, October 1947,
p. 188. Photograph by E. P. Reves-Biro.

A B

A Reard of California by Louis Réard, bikini, printed cotton, c. 1946. Paris, Musée des Arts Décoratifs, purchased 2004, inv. 2004.7.98.1–2.

B *Harper's Bazaar*, May 1947, pp. 162–163. Photograph by Toni Frissell (model: Dovima).

TONI FRISSELL

ONE WONDERFUL WAY TO TAKE THE SUN . . . COMPLETELY COVERED WITH "SUTRA" LOTION TO FILTER OUT THE BURNING RAYS . . . JUST BARELY COVERED WITH A TOKEN SUNNING SUIT OF GREEN AND WHITE MALLINSON RAYON. BY SCHNURER. $14.95. MADE TO ORDER, AT SAKS FIFTH AVENUE.

urners, i.e.,

does vary
nds on the
e pigmen-
n with the
(redheads
n order to

available
time and
eas of the

any more
ough, are
d frequent

?
s in Africa

or a time
pigment is
you really
pass for a
est known

-tanning?
an be ab-
se trouble
oils, they
hich cling
e burn, if
page 245)

ABSENCES BY JACK LINDEMAN

I will plant lilies for the wings of your ears
While the sun bursts through clouds coining your eyes.
Where your hand grew wet dabbling in a game of streams
I remember your fingers,
Like pink grasshoppers turned bait
To feed the darting trout with love.
How many days passed between absences?
How many blank skies were starred with alphabets inventing you?
I see no dawns except in streaks of strewn hair,
Your color of gold. You are behind my eyes when I dream,
Bringing water when I thirst. My tongue can say you are here,
The season's precocious leaf wanting to shield
All suns from singeing me. I am tanned
Only by the beams from your eyes, taller than light years.
What physicist will teach a formula of wings
To reach your warmth of gold?

A photographic study of the nude by Richard Avedon,
in the classic spirit which, from Praxiteles to Matisse,
abhorring the demure and falsely modest,
turns rather to a candor and forthrightness of vision that alone
do homage to the elegant, mysterious beauty of the human body.

A Jack Lindeman, "Absences," *Harper's Bazaar*, January 1962, pp. 90–91. Photograph by Richard Avedon (model: Contessa Christina Paolozzi).

"The silence of the night in Tahiti is ... absolute. Nothing else exists; there is not even the cry of a bird to break the quiet.... I can feel all this permeating me, and at this moment I feel a sense of total repose." Purple and ivory fabric from Radio Hula, Inc. Bare necessity: Neutrogena's Sesame Seed Body Oil.

A "The silence of the night," *Harper's Bazaar*, December 1992, pp. 108–109. Photograph by Peter Lindbergh (model: Naomi Campbell).

A *Harper's Bazaar*, February 2002, front and back cover. Photographs by Patrick Demarchelier (model: Gisele Bündchen).

POP

Marianne le Galliard

1. Jane Trahey, "Space and the Sixties," *Harper's Bazaar, 100 Years of the American Female*, New York, Random House, 1967, p. 7.
2. Andy Warhol also started out as an illustrator for *The New Yorker* and *Seventeen*.
3. "Bea Feitler and Ruth Ansel became last March the double-talented, two-hearted art editor of Harper's Bazaar," The Editor's Guest Book, *Harper's Bazaar*, vol. 97, no. 3027, February 1964, p. 93.
4. The fashion pages opened with this short introduction: "This issue, guest-edited by Richard Avedon, is a partial passport to the off-beat side of Now," *Harper's Bazaar*, vol. 98, no. 3041, April 1965, p. 143.
5. Richard Avedon's commercial photographs in *Bazaar* were part of the Pop Art movement, which also referenced advertising.
6. Donyale Luna was one of the very few African-American models at the time.
7. Robert Rauschenberg represented the triumph of American painting on an international level when he won Grand Prize at the 1964 Venice Biennale.
8. Tom Wolfe, "Act II: Reopening the Museum of Modern Art," *Harper's Bazaar*, vol. 98, no. 3036, November 1964, p. 168.
9. Nancy White, "Paris, fashion action—our reaction," *Harper's Bazaar*, vol. 98, no. 3040, March 1965, p. 155.

In 1967, *Harper's Bazaar* celebrated its hundredth anniversary in a book entitled *Harper's Bazaar: 100 Years of the American Female*, which depicted the 1960s from the viewpoint of Pop Art and the era's recent technological developments: "The first human space traveler goes to orbit. President Kennedy is assassinated. It's at last the era of civil rights. Pop art. Pop music, underground movies. The designers of the Sixties are still from France, Givenchy, Courrèges and Saint Laurent."[1] The author does not mention that one of the artists who launched the Pop movement began his career in *Harper's Bazaar*. This was Andy Warhol, who started out as a commercial illustrator for *Bazaar* in the early 1950s.[2]

Warhol's first sketches were discreet: uneven line drawings in the margins of the fashion pages. His drawings, often depicting shoes, gradually began to take over the space until they looked like store displays. On a page from the April 1956 issue, he drew perfume bottles whose colors were offset in relation to the shape of the objects. On other sketches, the lines were erased, as if they were print defects. During his period working with *Harper's Bazaar*, Warhol was probably in the process of defining what would become the Pop Art style in the United States in the 1960s. It was the magazine that inspired his reflections on standardized production, on the convergence of art and industry—with one as a producer of unique works and the other, mass merchandise. As a pure product of advertising culture, a proponent of mass communication, Warhol became, at *Bazaar*, a successful commercial artist. He could have been satisfied with this, but his subversive side drove him, in 1962, while abstract expressionism was at its height, to shift his ad work into the art world, or rather to incorporate industrial mechanization into his artistic output, which he presented to the institutional authorities, as represented by the galleries and the museums.

As Warhol's success grew, in December 1962 *Harper's Bazaar* commissioned work from him on the theme of the American automobile, which resulted in two double-page spreads featuring nine paintings by Warhol, paintings of ad images. It raised questions about what they really were: advertising images for brands of cars (written under each image) or photographed works of art? In the following issue, Warhol created a gallery of portraits of the era's celebrities: Jacques Rivette, Anna Karina, Tom Courtenay. The images had all the characteristics of the silkscreen works that he was doing at the time, with stenciling, the recycling of press photographs, the use of surface defects and the serial form. *Harper's Bazaar* was no longer a laboratory where Warhol was preparing his Pop inventions, but an apparatus challenging its own mechanisms, between advertising and artistic strategies, mass culture and high culture. To make it more confusing, *Harper's Bazaar* in June 1963 invited Warhol to publish photobooth shots (signed by Warhol) of well-known figures such as the charismatic curator at the Metropolitan Museum of Art, Henry Geldzahler, the artists Larry Poons and La Monte Young, and—Warhol himself.

While Pop Art had made its entry into *Bazaar* during the 1960s, one has to admit that its presence remained relatively discreet. The consumer culture with its Campbell's soup cans, the Warholian gesture minimizing the artist's manual intervention, promoting instead some kind of aesthetic scarcity, did not easily fit into a magazine dedicated to haute couture, luxury, and sophistication—and hence a certain form of elitism.

Nevertheless, the arrival of two new art directors, Ruth Ansel and Bea Feitler,[3] both twenty-five years old, ushered in a new energy that was less arty and more focused on youth culture.

As an example of this, the April 1965 issue by Ansel and Feitler, entirely edited by Richard Avedon, the only photographer for the issue, was a tour de force, a stand-alone synthesis of that year's reigning atmosphere of freedom and optimism.[4] It presented a fully assimilated, pure cocktail, an explosive mix of new artistic forms (Pop Art, underground film, the Courrèges "bomb"). By celebrating Avedon's twenty years at *Bazaar* prior to his departure for *Vogue*, the magazine went even further than promoting the canons of Pop Art. It created a sort of self-mirroring work by reabsorbing Pop imagery for advertising purposes.[5] With this wink-and-nod approach, which appears on the cover featuring Jean Shrimpton, *Harper's Bazaar* initiated a complete reappropriation of the Pop aesthetic. The pages were organized like a comic strip: Paul McCartney as an astronaut; Jean Shrimpton on the moon in a NASA spacesuit; Donyale Luna[6] in kinetic outfits; Jasper Johns, Robert Rauschenberg,[7] Bob Dylan, Henry

Geldzahler, Lew Alcindor (who later changed his name to Kareem Abdul-Jabbar), Ringo Starr; a text by Tom Wolfe on the new bohemia and by Renata Adler (writer for *The New Yorker*); Pop works of art by George Segal and Roy Lichtenstein; a collage by Stan Vanderbeek with figures from the underground cinema, including Andy Warhol, Bruce Conner, Jonas Mekas, Robert Frank, and Kenneth Anger. The photographic interplay using black and white (day/night, skin color, graphics, and the use of positives and negatives) were references to Courrèges's "Sputnik" dresses as well as to Op Art. There was a sense of freedom, an impetuous energy in tune with action painting, Pop Art, happenings, and with a vibrant and fun "now." The Art Gallery Society had replaced the Café Society.[8] Claes Oldenburg's sculpture *Bedroom Ensemble*, relegated to the background, appeared in a section about fashion, while George Segal's *Woman Washing her Feet*, to which a pair of sandals had been added to the foreground, became a fashion photograph in its own right. The caption, which indicated that the shoes are "fully a part of the sculpture," is a Duchampian ploy, playing with the confusion between art object and manufactured object. Thus, when Richard Avedon used photobooth shots to portray people in the special April 1965 issue, he borrowed Pop Art's signature use of appropriation and parody—a perfect way for him to turn a new page.

The issue is now a collector's item.

A *Harper's Bazaar*, April 1965, cover. Photograph by Richard Avedon (model: Jean Shrimpton).

Follow That Scent! A Mystery, with Clues

• When is a weeping woman like a best seller? When is a bundle of joy not a baby girl or boy? For the answers, study the clues under the perfume "portraits" sketched here. Each one represents a perfume; you guess its name. Advance clue: the perfumes included are famous-name fragrances—household words in the very best houses. Probably your favorite scent is here, right under your nose. To check your solutions, turn to the last page for the denouement.

1. One touch of Venus
2. Bon soir, Tristesse
3. They go overboard for this
4. Warning! Tender trap ahead!
5. You'll sparkle with it
6. It's supercolossal, it's incredible, it's . . .
7. "I have only my id to blame"
8. It's as easy as ABD to guess this
9. Plus ça change, plus c'est la même chose
10. Where do you come from, Baby Dear
11. For that head-in-the-clouds feeling
12. Breezy story
13. "I burn my candle at both ends . . ."
14. Audrey Hepburn starred here

WARHOL

Hand-in-Hand with the Chemise: The Pretty Glove

• The white glove has always been a special touch for spring, but here it takes on added interest— and colorful details— in a handful of pretty ways any of which can be *the* special touch for today's new basic fashion:

• From the top of this page, counterclockwise:
• A little glove that wins palms down— the large pearl button and loop now placed on the back of the wrist. In white nylon, by Shalimar. About $2. At Bloomingdale.
• On hand for spring: a French provincial design printed in black on a white handsewn cotton glove with a palm vent and white piping. By Fuchs. About $5. At Saks Fifth Avenue.

• Continuing counterclockwise (opposite page):
• At your finger tips, a prettily dotted line of blue French knots on a handsewn white cotton glove reaching just over the wrist. By Gant Madeleine. About $5. At Best's.
• Back-interest for a tailored glove— rows of white fagoting neatly aligned the length of a handsewn white cotton glove. By Fownes. About $3.50. At Arnold Constable.
• In striking contrast: the dash of black patent leather threading a wide band at the wrist of a white nylon glove. By Van Raalte. About $3. At Arnold Constable.
• This page, following the ribbon and starting below:
• Bright blue buttons cuff-link the side vent of a longer, smooth-fitting glove. By Hansen, in handsewn white cotton. About $3.50. At Franklin Simon.
• Palmy days ahead: a tailored white cotton glove with a trim belt and buckle detail and an off-center vent. Handsewn, by Dawnelle. About $4. At Franklin Simon.
• Hand-picked for all the rose red hues in bloom now— a pretty scattering of red roses on leafy green stalks. A longer glove, in piqué-sewn white cotton. By Crescendoe. About $4. At Lord and Taylor.
• A handful of diamonds—red ones at that— pave a short, cuffed glove of handstitched white cotton. By Wear-Right. About $4. At Lord and Taylor.

WARHOL

A C
B D

A "Follow that Scent! A Mystery, with Clues," *Harper's Bazaar*, April 1957, pp. 184–185. Illustrations by Andy Warhol.

B "Hand-in-Hand with the Chemise: The Pretty Glove," *Harper's Bazaar*, February 1958, pp. 136–137. Illustrations by Andy Warhol.

C "Deus Ex Machina," *Harper's Bazaar*, November 1962, pp. 156–157. Silkscreen by Andy Warhol.

D "Stop, Study and Applaud," *Harper's Bazaar*, December 1962, pp. 90–91. Silkscreen by Andy Warhol.

144

IN THE DISTANT GALAXY OF
CENTAURI, ON THE PLANET
ANTA, THE EARTH GIRL REC
TERS. SHE WILL CONQUER
CRUEL DICTATORSHIP OF SA
AXOS WITH HER BEAUTY...

TO ENCHANT THE ASTEROIDS, to cause Martians to
the earth girl, Ultima (naturally), leans upon her glo
of Ultima II cosmetics. Their texture—as vaporous, as
as rarified as the very atmosphere of outer space. Th
almost transparent colors—madly celestial delights. "W
to the moon wearing anything less?" asks Ultima, mod
ing over the creamy, seductive splendor of her Pewter
bounded with pale Snowfrost; her Aurora Beige Cre
tion; glowing Tawny Peach Blushing Creme; Aruba
stick—as yet another meteor flashes by, unnoticed. All

Meanwhile, back at the space station, our young lad
(below), unwilling to discard her precious earthling
out in a straight silk dress, futuristically designed in
white, black and pink—enough to send any solar sys
spin. By Bill Blass for Maurice Rentner, in Chardon-
crepe. About $190. At Bonwit Teller; Julius Garfinckel.
Gus Mayer. Pink stockings by Berkshire. Gustinettes

RICHARD AVEDON

A B A *Harper's Bazaar*, April 1965, p. 158.
Illustration by Katerina Denzinger.
B *Harper's Bazaar*, April 1965,
pp. 144–145. Photographs by Richard
Avedon (model: Jean Shrimpton).

144

THE GALACTIC BEAUTY TO THE RESCUE...

A B

A Courrèges, ensemble, wool serge, cotton grosgrain, haute couture, Spring/Summer 1965. Paris, Musée des Arts Décoratifs, gift of Courrèges, UFAC collection, 1976, inv. UF 76-23-2.

This outfit is from the famous collection that introduced the miniskirt and pants. The back view, including a white jacket with navy band, is a take on a child's sailor suit.

B "In Paris: Space Pace," *Harper's Bazaar*, March 1965, p. 169. Photographs by Melvin Sokolsky (model: Donna Mitchell).

In Paris: SPACE PACE

COURREGES (opposite). The deepest square neck, the broadest shoulder straps, the widest stripes of peppermint green and white—on a short sundress with its own topcoat. More white: the low-slung belt, hemband, and hat. Dress at Neiman-Marcus.

This page, left column starting from the top: the coat that matches the dress opposite: double-breasted with a turn-up collar.

Back view of the black-banded trousers, top shown on page 167. Black cross straps make a sun-trap of the crossed top.

Suspended skirt—hung from the shoulders on braces. The dress and its short jacket, in marmalade-on-white windowpane plaid.

Open and shut revers—one permanently flapped open—on a short white jacket. The sudden clash of stripes in orange and white lining the double-breasted jacket.

Top right: Black and white double windowpane checked wool coat, all bound in black.

Salt white gabardine suit: battle jacket with tiny sleeves, wrapped skirt, welt seams. At Bergdorf Goodman. And the newest Courrrèges hat—a Breton tied on the chin.

Low-slung evening pants held on the hipbone by pink satin ribbon. The jacket, held together by a ribbon bow. For the evening, boots have given way to strapped slippers.

MELVIN SOKOLSKY

204
COURREGES OF PARIS (right.) Graph paper checks; light green on white. The head-on look of the coat, straight shoulders, straight shape. The collar and cuffs, bias-cut white wool edging; the low-buckled belt, taut white patent leather.

GALITZINE OF ROME (opposite). The bathrobe coat totally on the bias: beige gabardine, edged with topstitching; curved shoulder easy as a bathrobe; wide belt, to use or not. At Lord and Taylor; I. Magnin.

Clear-cut Tailoring

RICHARD AVEDON

A B

A "Clear-cut Tailoring," *Harper's Bazaar*, April 1965, p. 204. Photographs by Richard Avedon.

B Courrèges, coat, wool, haute couture, Spring/Summer 1965. Paris, Musée des Arts Décoratifs, gift of Courrèges, UFAC collection, 1976, inv. UF 76–23–6. The graph-paper design looks like a notebook pattern, underscoring the geometry of the cut. The grid pattern on the fabric is a reference to camera viewfinder. Luxury pop design drew inspiration from the street and from the youth culture. It also resonated with the magazine's visual concept.

149

HIRO

Marianne le Galliard

Harper's Bazaar went through a pivotal period from 1958 to 1972, a tumultuous intermezzo between the economic prosperity of the 1950s and the post oil-crisis era, between the appointment of Nancy White as editor in chief and that of Anthony T. Mazzola. The quadrangular synergy created by Snow-Brodovitch-Vreeland-Avedon no longer existed —quite the opposite, in fact, as the magazine was facing internal conflict: the conservative outlook of the new editor, Nancy White,[1] who had come up through the ranks at *Good Housekeeping*, clashed with the flamboyance of Diana Vreeland, who eventually left *Harper's Bazaar* in 1962 for *Vogue*. She would be replaced by Gwen Randolph. In 1966, Avedon joined her at *Vogue*, shortly after his masterful work for the April 1965 issue.

The art directors who followed Brodovitch all strove to maintain a level of quality worthy of their predecessor. Henry Wolf, at *Harper's Bazaar* from 1959 to 1961, was a student of Brodovitch and former art director of *Esquire*. He was responsible for some of the magazine's most memorable covers: the December 1959 issue featuring Dovima balancing on a ladder holding the letter "A" of "Bazaar," as well as the exceptional September 1959 issue, which showcased "Audrey Hepburn, Mel Ferrer, *Paris Pursuit: A Love Farce,* directed by Richard Avedon." Under Wolf's editorship, Richard Avedon's photographs gradually shifted toward "sociological" portraits, with his series "Avedon: Observations."[2] He also hired new photographers, Saul Leiter and Melvin Sokolsky, who created the legendary images of models in bubbles floating above Paris. These now iconic images reflected Henry Wolf's fun, lighthearted spirit.

With Marvin Israel, who also perpetuated the Brodovitch legacy, *Harper's Bazaar* adopted a more serious and sometimes even disturbing tone, as with the portfolios by his protégée, the photographer Diane Arbus. As art director of the magazine from 1961 to 1963, he introduced the new American art scene, in which he also participated as a painter and photographer.[3] Fiction was gradually replaced by articles about art, like Geri Trotta's monthly column, "Not to be Missed." The magazine then became something of a merry "bazaar," with a trendy, intellectual bent. *Harper's Bazaar* was "the place to be": fashion pages with images by Hiro, James Moore, and Jeanloup Sieff, along with "fake" paparazzi photos taken by Avedon,[4] were published alongside "photographic essays" by Walker Evans, Lee Friedlander, and Diane Arbus.[5] Art galleries, with Sidney Janis and Leo Castelli in New York and Ileana Sonnabend in Paris, had never been so closely associated with the fashion world. The Ruth Ansel and Bea Feitler duo, former assistants of Marvin Israel, maintained the same spirit as Wolf-Israel, with a steady focus on whimsy and joie de vivre.

During this complicated period, Yasuhiro Wakabayashi, aka Hiro, was the only official staff photographer at *Harper's Bazaar* from 1958 to 1971. Rather than working with Irving Penn, the *Vogue* photographer whose minimalist style was closer to his own, Hiro chose to become Avedon's assistant in 1957. They would share the same New York studio throughout the early 1970s. Hiro's approach—less spontaneous and more concise—was diametrically opposed to that of Avedon. His photographs, characterized by sharp contours, the meticulous use of artificial lighting, and bold colors, exemplified *Bazaar*'s new direction, with its "atomic action photographs."[6]

Hiro introduced numerous innovations. For photographs of shoes, for example, he used the setting of an exhibition on atomic energy,[7] he had models walk on glossy paper as if they were trampling a page from the magazine,[8] and he assembled objects together in a sort of large abstract composition.[9] An owl, fish, or cow's hoof served as a support on which accessories were presented.[10] Using a large number of technical processes—a fisheye or wide-angle lens, backlighting from the floor, 3D cameras capturing the model from three different angles, multiple exposures—Hiro told stories that combined the Surrealism and *trompe l'œil* of René Magritte's paintings with the electric energy of the Sixties. His photographs created a connection between the Oriental tradition of garments as a flat surface and the artistic movements of the time, notably geometric abstract art. The radical look of the series "The Power of the Print"[11] illustrates this perfectly: the overhead views seem to literally flatten the clothes onto the page. The clothes have so merged with the page that they seem to have effaced the bodies of the models themselves. With his photographs, Hiro ushered in a concept of fashion that was totally independent of the silhouette. Just as the kimonos were a support for an artistic expression, the flatness of the magazine page offered a support on which Hiro could showcase fabrics and graphic motifs, at the expense of the lines of bodies and even facial features. Fashion was viewed as pure abstraction. The page and the garment merged as a single surface, which explains why he frequently used different types of paper, notably for covers, such as matte sepia paper[12] and high-gloss paper.[13]

It is interesting to note that an art movement had emerged at the same time. Hard-edge

1. Nancy White was Carmel Snow's niece, as well as the daughter of Hearst executive Thomas White.
2. "Avedon: Observations on the 34th First Family," *Harper's Bazaar*, vol. 94, no. 2991, February 1961, pp. 96–101; "Avedon: Observations on the U. N.," *Harper's Bazaar*, vol. 94, no. 2992, March 1961, pp. 164–169; "Avedon: Observations on the Capuchin Catacombs," *Harper's Bazaar*, vol. 94, no. 2994, May 1961, pp. 110–113; "Avedon: Observations on the Child Without," vol. 94, no. 2996, July 1961, pp. 76–77. *Observations* was also the title of his first monograph, published in 1959, with a text by Truman Capote and design by Brodovitch.
3. For example, with articles on Frank Stella (photographed by Diane Arbus) in July 1966, Edgar Varèse and Willem de Kooning (photographed by Robert Frank) in December 1962, Jean Tinguely in January 1963, and the Nouveaux Réalistes in February. He was also mentioned in the magazine, alongside Roy Lichtenstein, Agnes Martin, Tom Wesselmann, Larry Bell, and Kenneth Noland, in an article in the July 1966 issue.
4. "Mike Nichols Suzy Parker Rock Europe," *Harper's Bazaar*, vol. 95, no. 3010, September 1962, pp. 212–221.
5. Walker Evans, "The Unposed Portrait," *Harper's Bazaar*, vol. 95, no. 3004, March 1962, pp. 120–125; Walker Evans, "The Little Screens. A Photographic Essay by Lee Friedlander," *Harper's Bazaar*, vol. 96, no. 3015, February 1963, pp. 126–129; "Diane Arbus, Auguries of Innocence," *Harper's Bazaar*, vol. 97, no. 3025, December 1963, pp. 76–79. Marvin Israel and Diane Arbus formed a particularly creative duo, inspiring each other's work. Marvin Israel had a decisive influence on Diane Arbus's photographic art. Her first monography, published in 1972, one year after her death, was edited by her daughter Doon Arbus and Marvin Israel.
6. Editor's Guest Book, *Harper's Bazaar*, vol. 94, no. 2991, February 1961, p. 81.
7. *Harper's Bazaar*, vol. 94, no. 2991, February 1961, pp. 102–113.
8. *Harper's Bazaar*, vol. 94, no. 2998, September 1961.
9. *Harper's Bazaar*, vol. 100, no. 3068, July 1967, pp. 82–85.
10. *Harper's Bazaar*, vol. 97, no. 3025, December 1963, p. 84.
11. *Harper's Bazaar*, vol. 100, no. 3063, February 1967, pp. 135–147.
12. *Harper's Bazaar*, vol. 94, no. 2999, October 1961, cover.
13. *Harper's Bazaar*, vol. 103, no. 3097, December 1969, cover.
14. Frank Stella and Ellsworth Kelly's works were illustrated in *Bazaar*, as were those of Donald Judd, Sol LeWitt, Dan Flavin, Lucas Samaras, and Larry Bell.
15. Marshall McLuhan, "Hard-Edge," *Harper's Bazaar*, vol. 101, no. 3077, April 1968, p. 157.
16. Marshall McLuhan, *The Medium is the Message, An Inventory of Effects*, New York, Random House, 1967.

painting, linked to geometric abstraction and a reaction against abstract expressionism, illustrated the same characteristics: bright colors, an immaculate flat surface and "hard edges." Hiro was certainly aware of this movement, as artwork by certain of its proponents, like Frank Stella and Ellsworth Kelly, was reproduced in *Bazaar*.[14] "Contemporary fashion is full of Hard-edge design... It is the World of Happenings where surfaces and events grind against each other, creating new forms... To a large extent, Hard-Edge reemerged as a visual mode because it was definite, a reaction to the expressionist modes that preceded it. Pop and Op were related, both using colors and forms contained by hard, definite lines. In emphasizing the periphery of forms, Hard-Edge reemphasized the tactile."[15] This analogy between Hard-edge and fashion was provided by the media analyst Marshall McLuhan in an article for the April 1968 issue of *Harper's Bazaar*. Asked to write about his ideas on media and its links to fashion,[16] he made a connection that seemed in perfect synch with Hiro's style: the image structuring the garment as a flat surface and affixed to glossy paper heightened the quality of the materials and fabrics at the expense of the lines of the body.

Hiro broke down barriers, freeing up the liberation of the silhouette, a vision that also surfaced among Japanese designers several years later, in the 1980s, with Issey Miyake, Kenzo, and Yohji Yamamoto.

Hiro remained loyal to *Harper's Bazaar* and continues to be a regular contributor to the magazine.

A *Harper's Bazaar*, February 1967, cover. Photograph by Hiro (model: Alberta Tiburzi).

Powerlines (foreground)
—a zigzagged network of high voltage
pinks and purples cooled by
green, black and white.
Sound waves (background)
—high-frequency color in circuit-breaking curves.
Alma Davies jewelry. Fiorentina sandals.
Both pages: wool mark dresses
by Bill Blass for Maurice Rentner,
in Pomezia wool.

THE
POWER
OF
THE
PRINT

A "The Power of the Print," *Harper's Bazaar*, February 1967, pp. 138–139. Photograph by Hiro (models: Agneta Darin, Marola Witt).

B Jacques Henri Lartigue, Hiro and Alberta Tiburzi during a photo shoot for *Harper's Bazaar*, New York, October–November 1966. Page 91 of the 1966 album.

C "The Power of the Print," *Harper's Bazaar*, February 1967, p. 145. Photograph by Hiro (models: Agneta Darin, Marola Witt).

152

THE PAPER
SHOE

Paper, coiled for action in psychedelic curves of color. Experience in depth for this time, this place, designed by Kathryn Stoll for Herbert Levine.

A B

A Frank Stella, *Bampur*, 1966. Los Angeles County Museum of Art.

B "The Paper Shoe," *Harper's Bazaar*, July 1967, p. 84. Photograph by Hiro.

A B
　　　C

A "Paris: The Patchwork Garden," *Harper's Bazaar*, April 1969, p. 147. Photograph by Hiro (models: Agneta Darin and Neil Selkirk).

B Jacques Henri Lartigue, photoshoot by Hiro at the *Harper's Bazaar* studio, Paris, January–February 1966. Page 30 of the 1969 album.

C Andrée Brossin de Méré, sample of a silk gazar printed with ten colors, "Les sulfures," collection Spring/Summer 1969. Paris, Musée des Arts Décoratifs, gift of Marguerite Binz, 2004, inv. 2004.14.180.

An haute couture textile designer, Andrée Brossin de Méré created thematic collections inspired from photographs of vegetables, flowers, jewelry, and glass, like this pattern of sulfurous spheres. He adds a psychedelic tone to the folk aspect of this patchwork piece for Yves Saint Laurent.

157

PORTRAIT

Marianne le Galliard
Éric Pujalet-Plaà

1. *Harper's Bazaar*, vol. 87, no. 2908, March 1954, p. 152.
2. *Harper's Bazaar*, no. 2924, July 1955, p. 49.
3. *Harper's Bazaar*, vol. 89, no. 2928, November 1955, p. 119.
4. *Harper's Bazaar*, vol. 89, no. 2933, April 1956, p. 2.
5. *Harper's Bazaar*, vol. 94, no. 2998, September 1961.

In the 1970s, improvements to the optical quality of the telephoto lens and multilayered lenses, which transmitted light more effectively, along with better processing techniques for color film, fueled the trend for extremely close-up portraits. Under the aegis of Anthony T. Mazzola, the *Bazaar* covers presented a recognizable style, whether they were shot by Francesco Scavullo, Albert Watson, Marco Glaviano, Rico Puhlmann, Bob Stone, or Steve Schapiro. Faces were framed very tightly, inspected by the lens that revealed, with pin-sharp focus, details of an iris, eyelashes, eyebrows, and tanned skin, which linked the magazine's cover to its beauty section. With such tightly cropped images, beauty depends on mastering the art of cosmetics and on an extremely codified type of lighting: no shadows cast on the face and backlighting to create a halo effect around the hair.

In this serial production, the essential variable became the fame of the cover subject. The beauty of the actress or model, from Farrah Fawcett to Joan Collins, Lisa Bonet, Brooke Shields, Cybill Shepherd, Sophia Loren, Andie MacDowell, and Isabella Rossellini, radiated in full glory on the covers of *Bazaar* in the 1970s and 1980s.

Their images on the cover were larger than life, offering a view that was closer than any human eye could ever have in real life. The magazine, read at home or placed on a coffee table, therefore invited into the private sphere the faces of celebrities who revealed themselves to be cheerful, intimate friends. This sense of intimacy could be heightened by the inclusion of a sports accessory or the detail of a gorgeous evening dress, which had become more festive and less formal with the arrival of the disco age.

These close-up portraits on the *Bazaar* covers perpetuated the tradition of the *beau monde* portrait, a pictorial genre at which certain illustrators during the Roaring Twenties excelled, including Jean-Gabriel Domergue and Bernard Boutet de Monvel. They were also part of the golden age in a long history of photographic portraits in *Bazaar*. Until the 1940s, photography had often been used to portray high-society women wearing haute couture outfits, which created a certain degree of confusion between the concept of the society portrait and that of the fashion photograph.

Adolphe de Meyer and Man Ray were prominent portraitists, but it was not until the 1940s that portraits became a photographic genre in *Bazaar*, thanks to Bill Brandt, Henri Cartier-Bresson, and Arnold Newman. For example, Cartier-Bresson portrayed Alfred Stieglitz, Truman Capote, and Constantin Brancusi, while Brandt captured T. S. Eliot, Edith Sitwell, Oliver Messel, Graham Greene, Cecil Beaton, Peter Brook, Peter Sellers or Francis Bacon in 1952. This portrait was placed in the magazine opposite Bacon's painting *Study after Velázquez's Portrait of Pope Innocent X*.

Each portrait was created from intersecting visions, using a specific type of equipment (Leica, Rolleiflex, Hasselblad, or view camera), with distinct optical characteristics and different visual results. Richard Avedon, for example, played with the special effects of wide-angle lenses. He introduced the extreme close-up in portraiture, cropping the image so that the face filled up the entire page, immortalizing for example Humphrey Bogart,[1] Katharine Hepburn,[2] and Marian Anderson.[3] In April 1956, Avedon produced the first celebrity portrait on the cover: "the little girl in the big hat is Audrey Hepburn, playing a real-life role as a fashion model,"[4] followed by that of Sophia Loren.[5] The first male portrait appeared on the February 1965 cover of *Bazaar*, featuring Steve McQueen in a tuxedo.

Given the rich culture of painting and photography that ran throughout the history of *Harper's Bazaar*, the portraits from Mazzola's era deserve special consideration: they have something of the high-society portrait given the fame of the subjects; the family portrait for their intimacy; and are also related to devotional paintings for the model of femininity they conveyed. It's interesting to note that the disco years had something of the Baroque to them, which implied an openness to the sacred, to the divine, and to divas—a trend that was exemplified in 1988 with the cover portrait of Madonna, virginal, sassy, and demure all at the same time.

The *Bazaar* cover portraits in the 1970s and 1980s, following in a long line of figurative imagery, ushered in a type of representation that is still the predominant standard for glossy magazines. Under the direction of Liz Tilberis, in the 1990s *Bazaar* turned to immediately recognizable supermodels for the covers. The supermodels weren't actresses, singers, or princesses, but they were hugely famous.

In December of 1995, Lady Diana also became a fashion celebrity on the cover of *Bazaar*. Under Glenda Bailey's editorship in the 2000s, this star-making treatment also extended to fashion designers, who were widely portrayed on the inside pages. The images of major labels were represented by their head designers, when the story involved a Karl Lagerfeld, Marc Jacobs, or Phoebe Philo. Portraits of designers became a genre of its own—Liu Bolin took it to the extreme in his images of Maria Grazia Chiuri and Pierpaolo Piccioli, Alber Elbaz, Angela Missoni, and Jean Paul Gaultier, who literally disappear into their own work.

A Portrait of Giorgio De Chirico, *Harper's Bazaar*, July 1966, p. 103. Photograph by Bill Brandt. Portrait published to illustrate "Surrealism or 'The White-haired Revolver'" by Annette Michelson.

FEB. 1965 HARPER'S BAZAAR 75¢

THE SOFT TOUCH IN FASHION WITH STEVE McQUEEN

THE BAZAAR LOOK

MIND YOUR KNEE MANNERS

GLORIA GUINNESS ON INFLUENCE

A Harper's Bazaar, February 1965, cover. Photograph by Richard Avedon (model: Steve McQueen).

B Harper's Bazaar, April 1956, cover. Photograph by Richard Avedon (model: Audrey Hepburn).

Harpers BAZAAR

April 1956

Incorporating Junior Bazaar

**FLOWERS:
IN FASHION
IN ART
IN BEAUTY**

60 cents

Cover 1 (Oct.)

HARPER'S BAZAAR
OCT. $1.50

BETTER SEX BEGINS AT 40

SPECIAL ISSUE
OVER-40 & FABULOUS!
HOW YOU CAN LOOK YOUNGER EVERY DAY

- BAZAAR EXCLUSIVE
STOP-THE-CLOCK:
15 FAMOUS OVER-40 BEAUTIES SHOW YOU HOW

- BY STEPHEN BIRMINGHAM
THE KENNEDY WOMEN
SECURE, SHREWD, SENSATIONAL

THE FLAB-AWAY YOUTH DIET
Take off 10 years in 7 days

SOPHIA LOREN
FABULOUS AT ANY AGE

NEW CASUAL STYLE...
Terrific fall-weather fashion you'll wear everywhere

Cover 2 (Jan.)

HARPER'S BAZAAR
JAN. $2.00

GREAT NEWS!
STARTING HERE...
YOUR BEST YEAR

BREAKING UP WITHOUT FALLING APART

HAIR FRENZY? PROS SOLVE YOUR WORST PROBLEMS

FLASH & DASH
THE HOT FLIRTS!
FLYAWAY SKIRTS
BRIGHT BARGAINS
NIGHT DELIGHTS

ALL-STAR PETITES SHORT SEXY FASHION

EASY UPLIFT! BEAUTIFUL BREASTS IN ONE MONTH

NOBODY'S PERFECT
50 BEAUTY COVER-UPS

Cover 3

HARPER'S BAZAAR

EVERYWOMAN'S
OVER-40 SPECIAL!
HOW TO LOOK YOUNGER EVERY DAY

REVITALIZE
FAMOUS BEAUTIES TELL YOU HOW TO TAKE OFF WRINKLES, YEARS, INCHES

NIP & TUCK
WILL YOUR FACE-LIFT BE A LETDOWN?

THE FLABAWAY YOUTH DIET

STOP-THE-CLOCK HAIRSTYLE
NEW COLOR, CARE

FARRAH FAWCETT
FABULOUS AT 40

YOUR COMPLETE **PRE-DIVORCE** SURVIVAL GUIDE

SUPER SHORT CUTS TO YOUR BEST **FALL LOOKS**

Cover 4 (Aug.)

HARPER'S BAZAAR
AUG. $2.00

PREMIERE: KIDS' BAZAAR

OVER-40 & SENSATIONAL!
special issue
How to look younger every day

The Dare-To-Bare Diet
slender hips in 30 days

FOUNTAIN OF YOUTH BEAUTY BOOK:
famous over-40 beauties tell you how to take off pounds, wrinkles, years

hot flash!
Super sex during menopause

Second thoughts on your first face-lift

secret danger signals
Are you alcohol-proof?

Joan Collins' foolproof over-40 makeup guide

your fashion special
NEWS! 200 BIG HIT LOOKS
the best for fall

APRIL 1971 HARPER'S 75c
BAZAAR

FASHIONS FOR A YOUNGER YOU

TWENTY YEARS OF LOOKING THIRTY. HOW TO DO IT

WHAT IS A BEAUTIFUL WOMAN? BY GLORIA GUINNESS

7 SNARES THAT LEAD MEN TO AFFAIRS

A	B	E
C	D	

A *Harper's Bazaar*, October 1980, cover. Photograph by Albert Watson (model: Sophia Loren).

B *Harper's Bazaar*, January 1987, cover. Photograph by Marco Glaviano (model: Laura Valentine).

C *Harper's Bazaar*, January 1979, cover. Photograph by Marco Glaviano (model: Farrah Fawcett).

D *Harper's Bazaar*, August 1985, cover. Photograph by Rico Puhlmann (model: Joan Collins).

E *Harper's Bazaar*, April 1971, cover. Photograph by Bill King (model: China Machado).

A	B1	B2
	B3	B4

A Liu Bolin, *Lost in Fashion–Alber Elbaz for Lanvin*, 2011, *Harper's Bazaar*, March 2012, pp. 410–411. The Chinese artist camouflaged several designers so that they became invisible within the motifs of their own brands. "All I try to do is be invisible," said Alber Elbaz.

B Lanvin by Alber Elbaz, dresses, petrol blue chiffon, red kidskin, green satin, navy blue silk faille and pale blue satin, ready-to-wear Spring/Summer 2011; 2010; 2008; 2009. Paris, Musée des Arts Décoratifs, gift of Lanvin, 2011, inv. 2011.68.16; 13; 2; 3.

165

LIZ TILBERIS— FABIEN BARON

Jérôme Recours

As it approached the 125th anniversary of its magazine, Hearst, Inc. intended to restore *Harper's Bazaar* to its former glory. How? By creating spectacular editorial content.

Born in the U.K. in 1947, Liz Tilberis trained in the fashion business before joining British *Vogue* in 1967 as an intern. In the 1970s and 1980s, she became an assistant, then fashion director for the magazine. In 1987, Anna Wintour left her position as editor in chief of British *Vogue*, offering the lead role to Tilberis, which she accepted. This consecration made Tilberis one of the most influential fashion magazine editors. She then became editor in chief of *Harper's Bazaar* on April 1, 1992. Taking over from Anthony T. Mazzola, she had put together her own staff by the month of May. Her first hire was photographer Patrick Demarchelier, with whom she had worked on British *Vogue*. He introduced her to Fabien Baron, who was hired as creative director.[1] Fabien Baron, in turn, brought in Paul Cavaco and Tonne Goodman, who became fashion directors, as well as Peter Lindbergh, who began a long collaboration with Tilberis and Baron. A new era began for *Harper's Bazaar*, which reconnected with the avant-garde of the 1930s to the 1950s.

Fabien Baron, born in 1959 in Antony, France, is a creative director, graphic artist, director, editor in chief, and photographer. He studied typography and page design and became interested in photography at a young age after discovering the work of Guy Bourdin and Helmut Newton. In the 1980s, after an interview with Alexander Liberman, editorial director at Condé Nast in New York, he was hired by *Self* and *GQ*, then joined the world of advertising. He became creative director of *Vogue Italia*, then of *Interview* Magazine.[2] In 1992, when Liz Tilberis contacted him, he had been working with Madonna, with whom he made the scandalous book *Sex*.

The first issue by the Tilberis-Baron team came out in September 1992. The cover, which ASME ranked ninth among the top ten magazine covers of the last forty years,[3] featured one of the most beautiful top models: Linda Evangelista. She is luminous, sinuous, her brown hair cut in a sleek bob, with a waving lock of hair curving around her right eye that gazes calmly into the lens from the center of the image, her face clearly standing out against the white background.

In this head shot by Patrick Demarchelier, she is wearing a black bodysuit by Donna Karan and raising her left arm to catch the second "A" of *Bazaar*, which has dropped—a nod to the famous December 1959 cover by Richard Avedon. Liz Tilberis and Fabien Baron commissioned a new typeface, HTF Didot, to modernize the one used previously, playing with the verticality of the letters and thin serifs. On the cover, a single headline: "Enter the Era of Elegance." For her first editorial, Liz Tilberis set the tone: "With this issue, *Harper's Bazaar* enters a new era. In putting the magazine together, the idea of modern elegance has been our central inspiration. Elegance—of mind as much as of appearance—implies intelligence, certainty of taste, a balanced and centered identity."[4] Liz Tilberis was channeling Carmel Snow: "Elegance is good taste, with a dash of daring." The same issue also included a feature called "Wild," photographed by Patrick Demarchelier. The composition of the headline, with overlapping letters of contrasting colors filling the entire page, heightened the significance of the adjective, ushering in the images that followed. The studio featured model Kate Moss, who posed spectacularly in brightly colored clothes, reinventing herself on each page. She exhibited a potential that would introduce her to America and turn her into an international icon.[5]

Seeking to publish the "best possible magazine," Liz Tilberis and Fabien Baron worked in synch to promote a "philosophy" rather than a "formula,"[6] through a style that developed from one issue to the next. The covers, most of which were shot by Patrick Demarchelier,[7] featured colorful, luminous portraits that stood out against a white background, portraying single figures,[8] women,[9] top models,[10] or celebrities,[11] all with a beauty that radiated inner strength. The framing, attitude, and pose, which regularly interacted with the layout of the magazine's title, all helped to create a sense of complicity with readers. For the fashion stories, photographer Peter Lindbergh worked with dramatic outdoor settings, creating images in sumptuous black and white. *Harper's Bazaar* basked in the aura of the top models, at the peak of their fame, as it continued to cement their own legends. It covered the saga of their most successful metamorphoses, in which the makeup, hair styling, and clothes went beyond mere artifice to embody the movement of each personality, inviting readers to decisively project themselves into the game of evolving fashions. An Englishwoman in New York, Liz Tilberis was aware she was addressing an American audience, which she introduced to international fashion. Beyond the clothes' styles of the 1990s, she created looks by partnering fashion designers and couturiers from the old and new worlds: Isaac Mizrahi and Chanel, Donna Karan and Dolce & Gabbana, Richard Tyler and Versace, Marc Jacobs and Yves Saint Laurent, Anna Sui and Helmut Lang, Calvin Klein and Jil Sander, Prada, Martin Margiela, John Galliano and Alexander

1. In the mid-1990s, the staff, which also included the hairstylists Garren and Julien d'Ys and makeup artists Laura Mercier, François Nars, Kevyn Aucoin, and Stéphane Marais, expanded to include photographers David Sims and Craig McDean, who came from the British magazines *The Face* and *i-D*, along with Terry Richardson and Nathaniel Goldberg.
2. Magazine created by Andy Warhol in 1969.
3. ASME: American Society of Magazine Editors.
4. "Editor's Note," *Harper's Bazaar*, New York, no. 3369, September 1992, p. 33.
5. After this session, Fabien Baron recommended her to Calvin Klein, who chose her several months later for his underwear ad campaign featuring Mark Wahlberg, photographed by Herb Ritts, which was the start of a legendary collaboration.
6. *Fabien Baron: Defining Decades of Fashion*, Look TV, 2013.
7. Over a period spanning 78 covers, Patrick Demarchelier photographed 64 of them, and Peter Lindbergh, 8; the others were created by Terry Richardson, Enrique Badulescu, Mario Testino, and Wayne Maser.
8. Except for the couples formed by Winona Ryder and Daniel Day-Lewis, Cameron Diaz and Matt Dillon, and Liz Hurley and Hugh Grant.
9. Actors Daniel Day-Lewis and Matt Dillon appeared, but alongside Winona Ryder and Cameron Diaz, respectively. Only Tom Cruise had the honor of making the magazine cover solo, for the last issue edited under the aegis of Baron and Tilberis, in July 1999.
10. Among the supermodels, Linda Evangelista, Christy Turlington, and Kate Moss accumulated the largest number of covers (seven each), followed by Amber Valletta (six), Nadja Auermann (four), Cindy Crawford tied with Claudia Schiffer and Shalom Harlow (three), and then Naomi Campbell (two).
11. Notably Winona Ryder, Liz Hurley, Madonna, and Princess Diana.
12. Anaya Suleman, "The Creative Class/Fabien Baron, Art Director," in https://www.businessoffashion.com, April 23, 2013.
13. On their website, ASME praised the "transformation of the magazine from an 'also-ran' fashion magazine into one of the most cutting-edge and experimental of the big fashion glossies."
14. Marion Hume, "Fashion: Absolutely Fabien: In the Second of an Occasional Series on People Who Influence Fashion from within, Fabien Baron, Creative Director of the American Magazine *Harper's Bazaar*, Talks About His Career and His Much-imitated Graphic Wizardry," *The Independent*, London, June 5, 1994.
15. Mary Rourke, "Money. Power. Prestige. With So Much at Stake, Anna Wintour of *Vogue* and Liz Tilberis of *Harper's Bazaar* are Locked in a …: Clash of the Titans," *Los Angeles Times*, May 17, 1992.
16. *Harper's Bazaar* won the "Best Celebrity Cover" awards for the January 2006 issue with Julianne Moore, the February 2007 issue with Drew Barrymore, the March 2012 issue with Gwyneth Paltrow, and the March 2014 issue with Lady Gaga, as well as the "Cover of the Year" *Twilight* in December 2009. It was also awarded the Lucie 2007 for Mario Sorrenti's fashion story in July on the Fall/Winter collections.

McQueen. She placed a high priority on styling for these stories. With a penchant for clean lines and legibility, she promoted flattering clothes that she put together with poise and vitality, mixing labels, and challenged the "total look." As her arrival as editor in chief of *Harper's Bazaar* coincided with the emergence of grunge, Liz Tilberis, with Fabien Baron, gambled on a clean, clear appearance, where the construction of words against a white background accentuated their meaning and echoed the images, Fabien Baron revealed beauty in the contrasts between the images and the graphics. "I like things to be very simple and very direct and to have a certain balance. There has to be harmony but also vibration, it needs to be dynamic and powerful."[12] The dynamic combination of graphics, images and fashion, reminiscent of Alexey Brodovitch's style, restored an avant-garde, luxurious look to the magazine.[13] Named "the world's most beautiful fashion magazine" by the press,[14] *Harper's Bazaar* once again rivaled American *Vogue*.[15]

In December 1993, Liz Tilberis, diagnosed with ovarian cancer, began a courageous battle, finally succumbing to the illness on April 21, 1999. The July 1999 issue of *Harper's Bazaar* paid homage to her with a "White Album" featuring sixty images by photographers and artists with whom she had worked, each one showcasing white clothes from the Fall/Winter collections. Hearst donated all the advertising revenue from the issue to the Ovarian Cancer Research Fund. Liz Tilberis's husband, Andrew, dedicated this epitaph to her: "Elegance and dignity were with her right to the end. She never lost those qualities."

Distraught over her death, Fabien Baron left *Harper's Bazaar*. Katherine Betts followed Liz Tilberis. Breaking with the Tilberis-Baron era, she redesigned the format with a radically different graphic style. She was then replaced in 2001 by Glenda Bailey, who hired as creative director Stephen Gan, who had come up the ranks during Liz Tilberis's tenure. Glenda Bailey and Stephen Gan reinstated the HTF Didot typeface, and constantly referred back to the Tilberis-Baron period. In her November 2001 editorial, Glenda Bailey wrote: "[The versions of *Bazaar*] created by Carmel Snow and Alexey Brodovitch, Liz Tilberis and Fabien Baron are legendary... I want this next era of the magazine to continue in the same inspiring tradition." Given the many awards that *Harper's Bazaar* has received since,[16] her wish has been amply fulfilled.

A *Harper's Bazaar*, September 1992, cover. Photography by Patrick Demarchelier (model: Linda Evangelista).

Wild

remember a time when genders were bent, rules broken, inhibitions shed, and all the best girls were pretty wild?

The Buffalo Girl tangles with Sergeant Pepper. This page: Velvet coat, about $2995, white organza blouse, about $655, and black rayon shorts, about $195. All from Ozbek. Hat, Phillip Treacy; necklace, Alan McDonald, both for Ozbek.

PATRICK DEMARCHELIER

Playing with Kate

Fashion is change, even in hairstyles. But when models refuse to cut their long hair, what's a runway hairstylist to do? Out of frustration, Guido Palau got creative, both at the Gianni Versace show and on the set with Kate Moss (who, rest assured, retained her long golden hair). Palau cut into inexpensive black hairpieces like this one (left), then pinned them on as bangs, headbands, and hairy tiaras. Even Kate had a laugh. Opposite page: Mascara Flash in Champagne and Diormatic Waterproof Mascara in Black. Both, Christian Dior.
Hair by Guido Palau
Fashion editor: Sarajane Hoare
Photographed by David Sims

Harper's BAZAAR

Perfection!

A "Wild," *Harper's Bazaar*, September 1992, pp. 314–315. Photograph by Patrick Demarchelier (model: Kate Moss).

B "Playing with Kate," *Harper's Bazaar*, July 1997, pp. 118–119. Photograph by David Sims (model: Kate Moss).

C *Harper's Bazaar*, December 1992, cover. Photograph by Patrick Demarchelier (model: Kate Moss). The snow globe in Kate Moss's hand refers to Citizen Kane, the character in Orson Welles's eponymous film, inspired by William Randolph Hearst. This image is a return to the formal and theatrical elegance of the 1940s.

A Well opener logo designed by Fabien Baron, 1992.
B *Harper's Bazaar*, December 1993, pp. 144–145. Photograph by Peter Lindbergh (model: Amber Valletta)
C *Harper's Bazaar*, February 1997, pp. 210–211. Photograph by Michael Thompson (model: Kirsty Hume).

Angel's-eye view. Elizabeth Arden Ceramide Time Complex Moisture Cream leaves skin pure and bright.

Rock On

Skintight tubes, electric leathers, slashed necklines, and sharp stilettos. Spring's tough chic comes through in these kick-ass dresses. Opposite page: Black nylon leotard bra dress, about $635, Isaac Mizrahi. Fashion editor: Elissa Santisi. Photographed by Michael Thompson

171

pink

Innocent or shocking. Pretty, sexy and sometimes perverse. That's pink. And it's hot. Opposite page: Freshwater pearl multistrand necklace, about $780, Janis Savitt for M-J Savitt. At select Saks Fifth Avenue stores. Fashion editor: Elissa Santisi. Photographed by Raymond Meier

tough

TOUGH LUXE

GOING ON A POWER TRIP? TAKE A FEW STRONG PIECES — LIKE METALLIC TROUSERS, A TIGHT TEE WITH LEATHER SLEEVES, OR A ZIPPERED SKIRT — AND THROW THEM INTO THE MIX. IT'S BEYOND CLASSIC. OPPOSITE PAGE: WOOL FELT BALMACAAN COAT, ABOUT $1,695, RALPH LAUREN COLLECTION AT BERGDORF GOODMAN, NYC. FASHION EDITOR: SARAJANE HOARE. PHOTOGRAPHED BY PATRICK DEMARCHELIER

A	C
B	D

A *Harper's Bazaar*, March 1998, pp. 350–351. Photograph by Raymond Meier.

B *Harper's Bazaar*, August 1999, pp. 110–111. Photograph by Patrick Demarchelier (model: Carolyn Murphy).

C *Harper's Bazaar*, December 1998, pp. 262–263. Photograph by Frederik Lieberath.

D *Harper's Bazaar*, June 1999, pp. 166–167. Photograph by Patrick Demarchelier (model: Christy Turlington).

BAILEY'S *BAZAAR*

Lola Barillot

Hired in 2001 as editor in chief for *Harper's Bazaar*, Glenda Bailey brought fresh energy to the flagging magazine by commissioning ambitious photo essays that exemplified her guiding principles: they had to be lavish, whimsical, and magnificent. The magazine promoted the haute couture collections in a grandiose and jubilant style.[1] *Bazaar* returned to its longstanding tradition of theatricality. Starting in the 1910s, many of the illustrators who contributed to *Harper's Bazaar* were also scene designers, including Léon Bakst, who designed costumes and sets for the Ballets Russes. Glenda Bailey and Stephen Gan, the magazine's creative director, introduced a fresh spirit of fantasy by emphasizing humor, parody, and the use of dramatic staging, all part of an eclectic pop dynamic that encompassed *Bazaar*'s recurring themes, which ranged from fairy tales to epic tales.

Jean-Paul Goude, who became famous in the early 1980s as director of mega productions for the actress and singer Grace Jones, did several fashion shoots in the 2000s. The artist's devotion to *Bazaar* had influenced his professional life: "What really mattered to me, aside from my favorite illustrators, was the elegance of the layout, the blend of text and images in certain American magazines—*Esquire*, first of all, for its covers; and *Harper's Bazaar*, which I devoured. Penn, Avedon, Hiro, all those photographers for whom fashion was a starting point and whose every composition radiates elegance and glamour."[2]

In December 2003, Goude produced his first fashion series for *Bazaar*, "An Haute-Couture Fantasy."[3] It illustrated the magazine's penchant for ambitious photo compositions and a desire to show what's behind the scenes: a "making of" about the world of fashion. Karl Lagerfeld is holding aloft Linda Evangelista, who's dressed in a Chanel couture gown, while Gan tosses confetti and Goude is sweeping up. The fashion designer, creative director, and photographer are all as important in this image as the top model in the center of the photo. Furthermore, Linda Evangelista's unrealistic pose references those that Goude had been creating since the 1970s by cutting, rearranging, and reassembling his photographs, a process he calls the "French Connection." This technique imparted a nearly supernatural sculptural beauty to the models, who participated in the fantastical, magical construction of the photograph. In *Bazaar*, "photographers often blur the lines between fashion and fantasy."[4] And beyond the making of the image, the various participants were enthusiastic about the encounters and the event itself; what mattered was the celebration, being part of the party: "We have spent the last 10 years celebrating the fun in fashion and we love that designers are always in on the joke."[5]

In September 2015, Carine Roitfeld,[6] Stephen Gan, and Jean-Paul Goude created "Icons," a photographic series based on a fantasy concept in which they turned contemporary stars into historical figures from popular culture. "Our aim is to make ideas iconic. Fashion reflects what's going on in our world, and *Bazaar* makes pop culture fashionable. In the process, we've cast fashion's most intriguing talents in unexpected scenarios"[7], said Bailey in 2011. Oprah Winfrey was dolled up as Glinda, the good witch from *The Wizard of Oz*. She wore a candy pink Ralph Lauren dress and looks to be flying in the middle of an artificial décor of constellations. Mariah Carey appeared as Marie Antoinette, wearing a Tom Ford corset in a pastiche of Jean-Honoré Fragonard's *The Happy Accidents of the Swing*.[8] This genre painting[9] had been widely popularized in prints early on and had become well-known in popular culture. The pop diva was therefore interpreting a pop image.

Similarly, for John Galliano's tenth anniversary with Dior, *Bazaar* commissioned a photo piece from Simon Procter called "Galliano's Glorious Reign."[10] A former fine-arts student in painting and sculpture, the photographer drew on academic historical paintings for his fashion shoots. His approach to contrasts and colors, and the meticulous framing of close-ups had overlaps with the fine arts. His artificial backgrounds were more theatrical. These effects showcased the looks from the twenty haute couture collections designed by John Galliano, highlighting his distinctive theatricality, opulence, and exuberance.

Glenda Bailey also reinforced the bond with her readers by referencing many of the best moments in the magazine's history as cultural milestones, in the process ensuring the

1. Glenda Bailey, "Editor's Letter," *Harper's Bazaar*, no. 3596, September 2011, p. 208.
2. Jean-Paul Goude, Patrick Mauriès, *Tout Goude*, Paris, Éditions de la Martinière, 2005, pp. 18–19.
3. *Harper's Bazaar*, no. 3505, December 2003, pp. 151–163.
4. *Ibid*.
5. Glenda Bailey, "Editor's Letter," *op. cit.*
6. Carine Roitfeld has been *Bazaar*'s global fashion director since 2012, after working as editor in chief of *Vogue Paris*.
7. Glenda Bailey, "What an adventure," *Harper's Bazaar Greatest Hits*, New York, Abrams, 2011, p. 4.
8. London, The Wallace Collection, inv. P430.
9. Starting in the seventeenth century, a hierarchy in academia was established for pictorial genres, ranging from the most to least important. History painting, which includes religious, mythological, and battle scenes, was at the top of the pyramid, while *petit genre* painting was at the bottom.
10. *Harper's Bazaar*, March 2007, pp. 426–435.
11. "Why don't you…?" *Harper's Bazaar*, no. 3568, March 2009, pp. 372–383.
12. "Avedon in Paris," *Harper's Bazaar*, November 2001, pp. 248–253.
13. Richard Avedon, *Made in France*, San Francisco, Fraenkel Gallery, 2001, n. p.

alive. She paid tribute to Diana Vreeland, for example,[11] with an image of Sarah Jessica Parker, of *Sex and the City* fame, photographed by Peter Lindbergh to look like the famous fashion editor. The actress also wrote her own version of the "Why don't you…?" column. In November 2001, *Bazaar* also published some of its archival images, rediscovered by Richard Avedon when the archives were moved. These included engraver's prints of fashion shots, complete with annotations by Alexey Brodovitch and notes by Carmel Snow,[12] revealing the preparatory work involved in designing the pages of *Bazaar*. This article also coincided with the publication of the photographer's work in book format.[13]

The explosion of the Internet in the 2000s profoundly altered the relationship between the fashion press and its readership: the looks on the runways were available nearly immediately on the web, and the development of specialized fashion blogs introduced new editorial approaches to the subject. Thanks to this "big machine," Glenda Bailey was able to maintain the success of the glossy magazine.

The pageantry of the photo shoots that blended fantasy with global fashion celebrities, combined with a vision of the magazine as representing real life, imbued the magazine with an enveloping and warm aura that welcomed readers into a big happy family.

A *Harper's Bazaar*, April 2010, cover. Photograph by Mark Seliger (model: Demi Moore).

MARIAH CAREY
AS
MARIE ANTOINETTE

"I'm pretty much the opposite of Marie Antoinette, but it's always fun to throw on a costume."

Tom Ford
Corset, Tom Ford.
Shoes, Manolo Blahnik.
Jacket, skirt, petticoats, and stockings, Le Vestiaire.
Hair: Olivier Schawalder; makeup: Tom Pecheux;
manicure: Anatole Rainey.

A *Harper's Bazaar*, September 2015, pp. 602–603. Photograph by Jean-Paul Goude (model: Mariah Carey).

A *Harper's Bazaar*, March 2007, pp. 428–429. Photograph by Simon Procter.
In the spirit of great historical painting, Simon Procter celebrated John Galliano's tenth year at Christian Dior by bringing together designs from several haute couture collections conserved by Dior Heritage.

B Christian Dior by John Galliano, Georgette crepe dress (detail), embroidered trim and sequins by Montex, pleated silk chiffon ruffled skirt trimmed with Valenciennes lace, satin-trimmed slip, haute couture, Fall/Winter 2003. Collection Dior Héritage, Paris.

C Christian Dior by John Galliano, haute couture fashion show, Fall/Winter 2003.

179

DEEP FREEZE

Take the snowy landscape by storm in high-drama outerwear

Photographs by Txema Yeste

Puff piece. Jacket and dress, Givenchy. Balaclava, Alanui.
FASHION EDITOR: Joanna Hillman

A *Harper's Bazaar*, September 2019, pp. 326–327. Photograph by Txema Yeste (model: Aya Jones).

A C
B D

A *Harper's Bazaar*, September 2019, pp. 344–345. Photography by Sebastian Kim (model: Giedre Dukauskaite).

B *Harper's Bazaar*, November 2014, pp. 292–293. Photography by Jeffrey Westbrook.

C *Harper's Bazaar*, September 2014, pp. 584–585. Photography by Sebastian Faena (model: Lady Gaga).

D *Harper's Bazaar*, September 2013, pp. 558–559. Photography by Richard Burbridge.
 Bazaar's graphic design, under Elizabeth Hummer, is based on elegance and an inventive use of typography. It underscores the power of the magazine's photographs.

182

LADY GAGA

KL: Choupette is my muse. Is Asia your musical inspiration? **LG:** Asia is my inspiration for many things. She has really shown me the importance of living in the moment. If I don't, I'll miss a precious look on her face! She is a very romantic and loving animal, and this sort of poetry is what art is all about, I think. Interaction. She loves to sit with me when I record jazz. She never barks or makes noise; she just looks at me with her big ears. **KL:** I think animals are better muses than human beings—they'll never fall out of fashion. What do you think of animals? **LG:** I love animals. They communicate with us entirely with love, something we all should do. Asia and my love will never be out of fashion—it is unconditional. **KL:** What are you into? What's your next fashion "trip"? **LG:** I've been recently enjoying looking far and wide for the best vintage fashion I can find. Clothing with a story, a past. Heavy fabrics, jewels, veils. My latest trip is feeling a connection to all women throughout history through fashion. I love wearing clothes knowing that I'm carrying the spirit of previous fashionistas, and living out more of their fantasies, and my own. I believe clothes carry the soul of the designer and the person wearing them forever, so I look for clothes with a soul. Perhaps it's something only I can see. But I know it's real. **KL:** Where do you see your look evolving? **LG:** I could tell you, but then I'd have to kill you. Who knows? But when I sing jazz with Tony Bennett, I want to wear dresses made for real ladies, turn off all the lights, and have you hear only my voice cutting through the darkness. **KL:** I wonder if you'll end up extremely classic one day. Do you think classic can be daring too? **LG:** Very. **KL:** I can picture you doing "Miss Otis Regrets" with Tony Bennett. I love that song. Please tell me about your new album with him [*Cheek to Cheek*]. **LG:** Tony has completely changed my life. It's been a sort of secret that I've been singing jazz since I was 13. I was a jazz singer before I was a pop singer. Tony is such a gentleman. He really treats me like a lady. I feel so healed by my relationship with him because some men were very bad to me when I was young and in the studio. Tony showed me what the elegant and old-school cats were like. Our recording sessions were beautiful, memorable. We've built a deep friendship. There are 60 years between us, but when we sing together there is no distance. This album is pure jazz, songs from the Great American Songbook, played by both Tony and my respective jazz musicians and friends. **KL:** I love Billie Holiday's "It's Easy to Remember (and So Hard to Forget)." In life, I always say, most people are easy to forget and hard to remember. Do you like Billie Holiday? What are your musical inspirations for this type of music? **LG:** I used to listen to Billie Holiday every Sunday with my mother, but I fell in love with Ella Fitzgerald. She is to me the quintessential jazz vocalist. Her life story, the pain and wisdom, the whiskey in her throaty voice. I felt connected to her because it's these types of women, the lush ladies of swing, who've made me feel like no matter what happens, I can always turn a tragedy into a great performance. That's the romance of theater. **KL:** How long is your world tour? Is it around the world in 80 days? **LG:** Seven months. **KL:** Do you have a different look planned for every city? I dare say, fashion could be your victim. **LG:** I don't have my looks planned, but it's a nice compliment to suggest so. Thank you. I bring lots of vintage pieces with me—jewels, hats, bags—and I'm also very fortunate to get sent beautiful couture and runway looks all over the world. I just wear what makes me feel good for the day. Right now I'm enjoying feeling like a lady. Wearing dresses, in love, walking Asia in gardens, singing jazz with Tony Bennett... **KL:** I heard you're going to Dubai for the first time. I hope you like it. I loved it when I showed the Chanel Dubai collection there. **LG:** I'm very excited to go there, see my fans, give them the show of a lifetime. And, of course, I must explore the local designers and go shopping! **KL:** I would call you the world's ever-changing fashion icon. How does it feel to be chosen as Carine Roitfeld and *Bazaar*'s icon? You change all the time, but to me you stay the same Gaga. How do you manage that? **LG:** It's an honor for you to say that, Karl. You are very classic. Classic for me is something that changes all the time, like a drifting anchor. Even though I'm changing all the time, I'm always thinking of iconography—which is repetition of images—so I'm *always* different. I'm in a way wearing the same outfit over and over, but I'm just a different expression of the same woman. When I leave the house, I bear the souls of fashionistas who came before me; I continue to live glamorously to celebrate them. I'm just being me. ■

Gaga and Asia, the world's hottest new couple. Jacket, bra, skirt, hat, and bag, Chanel. See Where to Buy for shopping details. Sittings editors: Michaela Dosamantes and Ben Perreira; hair: Akki; makeup: Tom Pecheux for Estée Lauder; manicure: Mar y Sol for Chanel Le Vernis; production: Evelien Joos; on-set production: Helena Martel Seward

JEFF KOONS MUSES ON SURREALIST RENÉ MAGRITTE TO CELEBRATE MOMA'S NEW EXHIBITION

"One of the beautiful things about Magritte's work is that it's really made for the viewer to participate in."
—Jeff Koons

Photographs by Richard Burbridge

Harper's BAZAAR

RIHANNA
KILLER FASHION

A B C
D E

A *Harper's Bazaar*, March 2015, cover. Photograph by Norman Jean Roy (model: Rihanna).

B *Harper's Bazaar*, August 2009, cover. Photograph by Peter Lindbergh (model: Kate Winslet).

C *Harper's Bazaar*, November 2018, cover. Photograph by Alexi Lubomirski (model: Julia Roberts).

D *Harper's Bazaar*, March 2019, cover. Photograph by Mariano Vivanco (model: Cardi B.)

E *Harper's Bazaar*, October 2018, cover. Photograph by Camilla Akrans (model: Zoë Kravitz).

185

SPHERES

Marianne le Galliard

This journey through time, from 1867 to the present, under the auspices of *Harper's Bazaar*, is like a journey into a crystal, to borrow from the title of one of George Sand's novels, written in 1864,[1] about a character's initiatory journey between dream and reality, transported into enchanted lands, from a geode to the center of the earth: "We were in a fantastical garden …Here, volcanic action had produced vitreous trees which seemed covered with flowers and fruit made from gemstones, and whose shapes vaguely recalled those of our earthly vegetation."[2]

The marvelous intellectual and aesthetic experience inspired by the magazine is clearly something of an initiation as well. Its fictional framework comes entirely from the world of fairy tales: the *Bazaar* reader, by undertaking work on herself, aspires to a metamorphosis. By reading the magazine, she will become more beautiful, more luminous, more modern. The effect is to elevate awareness, as if *Harper's Bazaar* were a camera obscura, or rather a crystal ball that reveals, through enchantment, another facet of the world, the hidden side of the universe.

These comparisons could appear to be incongruous if images of eyes and especially those of spheres were not so ubiquitous in the pages of the magazine: Erté's recurring tondo compositions, Cassandre's eyes drawn on covers, and, starting in the 1960s, the lunar landscape depicted as a poetic and visionary goal.

In the early issues of *Bazaar,* through the 1910s, the sphere primarily referred to the social domain: the sphere of influence with its salons and clubs, and the domestic sphere, the traditional realm of women, a concept challenged by the magazine's first editor in chief, Mary Louise Booth. In the 1920s and 1930s, the motif of the circle symbolized the sun, which tanned the newly bared skin of women.[3] At night, all eyes turn to the sky, hoping for a glimpse of Lanvin and Chanel's new stars.[4] In Man Ray's cover for the January 1937 issue, a woman's hand rests on a celestial globe representing constellations. The diamond on her finger, a symbol of perfection, rivals the splendor of the stars.

The entire image relates to the magazine's oracular function. By studying the stars as signs revealing the world order, *Harper's Bazaar* seeks to unlock the secrets of the future. The challenge is to predict the trends and directions to come and to focus attention on the future of fashion design. Also, starting in the 1950s and 1960s,[5] with the advent of the jet age and space exploration, fashion was rocketed into the stratosphere, into a galactic world:[6] "We have crossed the threshold of space."[7]

Under the influence of the far-fetched utopias introduced by science fiction, technologies and automated society, the pages of *Bazaar* relayed this fascination with speed, radically altering our understanding of time and space, which had become impulsive, instantaneous, and limitless. "Capture the pulse of our time—a big time—full of action, jet-thinking, climate-crossing, buoyancy, color."[8] From Richard Avedon's models at Cape Canaveral (February 1960) to the "Rocket (Wo)man" (June 2017), along with Melvin Sokolsky's floating women (March 1963) and the lunar expedition (December 1966, June 2010), fashion welcomed new fields of exploration and encounters. To borrow Blaise Pascal's words: "It is an infinite sphere, the center of which is everywhere, the circumference nowhere."[9] The perfect shapes and reflecting surfaces of Yayoi Kusama's metallic spheres (September 2016), Georges Tourdjman's talismans (October 1968), and Richard Buckminster Fuller's geodesic domes exemplified the idea of uniform movement. Electrons orbit around a nucleus; the planets around the sun. Everything and infinity. The atom and the solar system. The stages of life. The sun and the moon. A pearl around a woman's neck. Phases, cycles. A journey with neither beginning nor end. The sphere is feminine. As headlined in the October 2018 issue, "The Future is Female."

In our current global village, with the euphoria of mass communication media, in this era where everything is performance and globalization, a singular time in which

1. Mary Louise Booth praised George Sand's work in *Harper's Bazar* as early as 1868.
2. George Sand, *Laura: A Journey into the Crystal*, London, Pushkin Press, [1864], 2004.
3. "Facing the Sun," *Harper's Bazaar*, vol. 9, no. 3, December 1933, pp. 102–103.
4. "And So… Far Into The Night," *Harper's Bazaar UK*, vol. 8, no. 3, June 1933, pp. 47–103.
5. A new column appeared in the mid-1960s, called "Eye on the Sky," by Xavora Pové.
6. "The Galactic Girl on the Moon," *Harper's Bazaar*, vol. 98, no. 3041, April 1965, pp. 158–163.
7. Alice S. Morris, "The Star and the Stars," *Harper's Bazaar*, vol. 92, no. 2965, December 1958, vol. 92, pp. 69–71.
8. *Harper's Bazaar*, "The Bazaar Look," vol. 95, no. 3003, February 1962, pp. 75, 152.
9. Blaise Pascal, *Thoughts*, Paris, Léon Brunschvicg, [1660], 2006, p. 11.
10. *Le Faux Miroir*, Brussels, Musée des Beaux-Arts. This painting was reproduced in Jeff Koons's article on Magritte, in the September 2013 issue, pp. 558–563.
11. Oddly enough, the actress Agnes Moorehead, who starred as the witch in the American TV series *Bewitched*, where she reads *Harpies Bizarre* also played the role of Citizen Kane's mother in Orson Welles's film.

the supremacy of the press is being challenged, *Harper's Bazaar* has a planetary influence: it is published in thirty-two countries and regions around the world, including China (2001), the Middle East (2007), India (2009), and Vietnam (2011). The sphere now represents this interdependent environment, this globalized world, where cultural, mental, and technological boundaries have shifted. The journey into the crystal is ongoing, the phenomena invisible to the naked eye are being revealed. Like the eye in René Magritte's *The False Mirror*,[10] reflecting a sky studded with clouds around an iris that appears to be a black star, *Harper's Bazaar* is the transformed reflection of the world. Readers see an image of femininity that goes far beyond a tangible reality. It is a modified depiction, an exalted view of reality, a pure invention. The eye sees the projection of a marvelous image, a mental image. In every way, the magazine is far more than a showcase, and its role largely exceeds that of a mirror of our time. By deconstructing the apparatus to reveal its inner workings, it is clear that the imagery created in the pages of *Harper's Bazaar* consists of multiple layers with interacting personalities, content (text and images), artistic movements, mindsets, and techniques. The history of changing fashions has therefore been forever crystalized in people's minds, etched in the collective imagination.

Like the snow globe of Citizen Kane, the fictional character inspired by William Randolph Hearst, press magnate and owner of *Harper's Bazaar* since 1913,[11] the magazine contains an entire world, a world of illusions that refracts lights and gives us a glimpse of wondrous visions.

A *Harper's Bazaar*, October 1968, p. 179. Photograph by Georges Tourdjman.

MARCH 1963 HARPER'S BAZAAR 60c

GREAT NEWS! THE PARIS AND AMERICAN COLLECTIONS BLOWING FASHION SKY-HIGH

Harper's BAZAAR

NEW HEIGHTS
JENNIFER ANISTON

188

A	B	D
	C	

A *Harper's Bazaar*, March 1963, cover. Photograph by Melvin Sokolsky (model: Simone d'Aillencourt)

B *Harper's Bazaar*, December 2014, cover. Photograph by Melvin Sokolsky (model: Jennifer Aniston).

C *Harper's Bazaar*, August 1949, p. 93. Photograph by Louise Dahl-Wolfe (model: Mary Jane Russell).

D Portrait of Richard Buckminster Fuller, *Harper's Bazaar*, October 1959, p. 182. Photograph by Hans Namuth.

A *Harper's Bazaar*, March 2007, pp. 386–387. Photograph by Peter Lindbergh (model: Magdalena Frackowiak).
The prototype Dolce & Gabbana corset dress, shown in the Spring/Summer 2007 collection, is part of the Musée des Arts Décoratifs collection, gift Dolce & Gabbana, inv. 2007.105.1.

Bibliography

Over 150 years of the history of *Harper's Bazaar* are evoked here with a brief chronological reminder of its editors in chief since 1867. For each period, reading suggestions are provided for further knowledge of the magazine's cultural and historical context in terms of illustration, graphic design, photography and fashion. The list is obviously not exhaustive and is not intended to exclude other fields, such as architecture, music, literature, theater and the fine arts.

1867–1913
From the magazine's beginnings to its acquisition by Hearst

Editors
 Mary Louise Booth (1867–1889)
 Margaret Sangster (1889–1899)
 Elizabeth Jordan (1900–1913)

Stella Blum, *Victorian Fashions and Costumes from Harper's Bazar, 1867–1898,* New York, Dover Publications Inc., 1974.
Elizabeth Ann Coleman, *The Opulent Era: Fashions of Worth, Doucet and Pingat,* London, Thames & Hudson, 1989.
Yves Badetz, Stephen Calloway, Guy Cogeval, Lynn Federle, *Beauté, morale et volupté dans l'Angleterre d'Oscar Wilde,* Paris, Skira Flammarion, 2011.
Renée Davray-Piekolek, *Femmes fin de siècle, 1885–1895,* Paris, Paris-Musées, 1990.
Amy de la Haye, *The House of Worth: Portrait of an Archive,* London, V & A Publishing, 2014.
Tricia Foley, *Mary L. Booth: The Story of an Extraordinary 19th-Century Woman,* Scotts Valley, CreateSpace Independent Publishing Platform, 2018.
Raymond Gaudriault, *La Gravure de mode féminine en France,* Paris, Éditions de l'Amateur, 1983.
Catherine Join-Diéterle, Françoise Tétart-Vittu, *Sous l'empire des crinolines*, Paris, Paris-Musées, 2008.
Meredith Roy, *Mathew Brady: Photographe de Lincoln,* Paris, L'Harmattan, 2004.
Anne Murray-Robertson-Bovard, *Eugène Grasset: Une certaine image de la femme*, Milan, Skira, 1998.

1914–1933
The Erté years

Hans Nadelhoffer, *Cartier*, San Francisco, Chronicle Books, 2007.

Joanne Olian, *The House of Worth: The Gilded Age 1860–1918*, New York, Museum of the City, 1982.

Chantal Trubert-Tollu, Françoise Tétart-Vittu, Jean-Marie Martin-Hattemberg, Fabrice Olivieri, *La Maison Worth: Naissance de la haute couture, 1858–1954*, Lausanne, La Bibliothèque des Arts, 2017.

Diane Waggoner (ed.), *The Pre-Raphaelite Lens: British Photography and Painting, 1848–1875*, London, National Gallery of Art, 2011.

Editors
William Martin Johnson (1913–1914)
Hartford Powell (1914–1916)
John Chapman Hilder (1916–1920)
Henry Blackman Sell (1920–1926)
Charles Hanson Towne (1926–1929)
Arthur H. Samuels (1929–1933)

Stéphane-Jacques Addade, *Bernard Boutet de Monvel*, Paris, Éditions de l'Amateur, 2001.

Juliet Bellow, *Modernism on Stage: The Ballets Russes and the Parisian Avant-Garde*, Abingdon-on-Thames, Routledge, 2016.

Robert Brandau, *De Meyer: A Singular Elegance*, New York, Knopft, 1976.

Mary E. Davis, *Ballets Russes Style: Diaghilev's Dancers and Paris Fashion*, London, Reaktion Books, 2010.

Romain de Tirtoff, aka Erté, *Things I Remember: An Autobiography*, New York, Quadrangle/New York Times Book Co., 1975.

Gabrielle Chanel, manifeste de mode, exhibition catalogue, Paris, Paris-Musées, 2020.

Pamela Golbin (ed.), *Madeleine Vionnet*, New York, Rizzoli, 2010.

Sophie Grossiord (ed.), *Jeanne Lanvin*, Paris, Paris-Musées, 2015.

Boris Kochno, Sergej Pavlovic Dăgilev, Aleksandr Nikolaevic Benua, *Diaghilev and the Ballets Russes*, New York, Harper & Row, 1973.

Harold Koda, Andrew Bolton, Nancy J. Troy, *Poiret*, New Haven, Yale University Press, 2007.

Amanda Mackenzie Stuart, *Diana Vreeland: Empress of Fashion*, London, Thames & Hudson, 2013.

Jérôme Picon, *Jeanne Lanvin*, Paris, Flammarion, 2002.

Paul Poiret, *En habillant l'époque*, Paris, Grasset, 1930.

Emmanuelle Polle, *Jean Patou: Une vie sur mesure*, Paris, Flammarion, 2013.

Dominique Sirop, *Paquin*, Paris, Éditions Adam Biro, 1997.

Valerie Steele, *Fashion and Eroticism: Ideals of Feminine Beauty from the Victorian Era to the Jazz Age*, New York, Oxford University Press, 1985.

Alexander Vreeland, *Diana Vreeland: The Modern Woman: The Bazaar Years, 1936–1962*, New York, Rizzoli, 2015.

Diana Vreeland, *Inventive Clothes 1909–1939. The 10s, The 20s, The 30s*, New York, Metropolitan Museum of Art, 1973.

Lisa Vreeland, *Diana Vreeland: The Eye Has to Travel*, New York, Abrams, 2011.

1934–1957
Carmel Snow

Vince Aletti, Carol Squiers, *Avedon Fashion 1944–2000,* New York, Abrams, 2009.
Quentin Bajac, Clément Chéroux, Guillaume Le Gall, Philippe-Alain Michaud, Michel Poivert, *La Subversion des images. Surréalisme. Photographie. Film,* Paris, Centre Georges Pompidou, 2009.
Dilys E. Blum, *Shocking! Schiaparelli,* Philadelphia, Philadelphia Museum of Art, 2004.
Hamish Bowles et al., *Schiaparelli and the Artists,* New York, Rizzoli, 2017.
Christian Dior: Designer of Dreams, London, Thames & Hudson, 2017.
Louise Dahl-Wolfe, *Louise Dahl-Wolfe: A Photographer's Scrapbook,* New York, St. Martin's/Marek, 1984.
Christian Dior, *Christian Dior et moi,* Paris, Bibliothèque Amiot-Dumont, 1956.
Eleanor Dwight, *Diana Vreeland,* New York, William Morrow, 2002.
William A. Ewing, *The Photographic Art of Hoyningen-Huene,* London, Thames & Hudson, 1998.
William A. Ewing, *Erwin Blumenfeld 1897–1969: A Fetish for Beauty,* London, Thames & Hudson, 1996.
Deborah Fausch, *Architecture in Fashion,* Princeton, Princeton Architectural Press, 1994.
Guillaume Garnier (ed.), *Paris-Couture-Années Trente,* Paris, Paris-Musées/Société de l'histoire du costume, 1987.
Jérôme Gautier, *Dior: New Looks,* London, Thames & Hudson, 2015.
Pamela Golbin (ed.), *Balenciaga Paris,* London, Thames & Hudson, 2006.
Martin Harrison, *Appearances: Fashion Photography Since 1945,* New York, Rizzoli, 1991.
Klaus Honnef, Enno Kaufhold, *Martin Munkacsi,* Göttingen, Steidl, 2005.
Marie-André Jouve, Jacqueline Demornex, *Balenciaga,* Paris, Éditions du Regard, 1991.
Boris Kochno, *Christian Bérard,* Paris, Nicolas Chaudun, 2012.
John Esten, Willis Hartshorn, *Man Ray: The Bazaar Years,* New York, Rizzoli, 1989.
Henri Mouron, *Cassandre: Affiches, Arts graphiques, Théâtre,* Milan, Skira, 1985.
Alexandra Palmer, *Christian Dior: History and Modernity, 1947–1957,* Monaco, Hirmer Verlag, 2019.
Robert Riley, *American Fashion: The Life and Lines of Adrian, Mainbocher, McCardell, Norell, and Trigere,* New York, Quadrangle/New York Times Book Co., 1975.
Penelope Rowlands, *A Dash of Daring: Carmel Snow and Her Life in Fashion, Art, and Letters*, New York, Atria Books, 2008.
Anne-Marie Sauvage, *A.M Cassandre: Œuvres graphiques modernes,* Paris, BnF Éditions, 2005.
Elsa Schiaparelli, *Shocking Life: The Autobiography of Elsa Schiaparelli,* London, V & A Publishing, 2018.
Carmel Snow, Mary Louise Aswell, *The World of Carmel Snow,* New York, McGraw Hill, 1962.
Deborah Solomon, *Lillian Bassman: Women,* New York, Abrams, 2009.
Georges Tourdjman, Allan Porter, *Hommage à Alexey Brodovitch,* Paris, Grand Palais, Ministère de la Culture, 1982.
Alain Weill, *Cassandre,* Paris, Hazan, 2018.

1957–1972
The pop years

Editors
 Nancy White (1957–1971)
 James Brady (1971–1972)

Richard Avedon, Truman Capote, *Observations,* New York, Simon and Schuster, 1959.
Richard Avedon, James Baldwin, *Nothing Personal,* New York, Atheneum Publishers, 1964.
Christian Caujolle, William Klein, *William Klein,* Arles, Actes Sud, 2008.
Claire Clouzot, *William Klein: Films,* Paris, Marval, 1998.
Bruno Feitler, *Design de Bea Feitler,* São Paulo, Cosac & Naify, 2012.
Thomas Frank, *The Conquest of Cool, Business Culture, Counterculture and the Rise of Hip Consumerism,* Chicago and London, University of Chicago Press, 1997.
Salvatore Gervasi, *Audrey Hepburn et Hubert de Givenchy, une élégante amitié,* Lausanne, Favre, 2017.
Hubert de Givenchy, *Givenchy: 40 ans de création,* Paris, Paris-Musées, 1991.
Valérie Guillaume, *Courrèges,* Paris, Assouline, 2000.
Hiro, Mark Holborn, *Hiro: Photographs,* Boston, New York, Bulfinch Press, 1999.
Philippe Jullian, *Les Styles,* Paris, Le Promeneur, 1992.
Jean-Noël Liaut, *Cover Girls and Supermodels 1945–1965,* New York, Marion Boyars, 1996.
Jean-Noël Liaut, *Hubert de Givenchy, entre vies et légendes*, Paris, Grasset, 2000.
Françoise Mohrt, *The Givenchy Style,* Paris, Assouline, 1998.
Jane Trahey, Nancy White, *Harper's Bazaar: 100 Years of the American Female,* New York, Random House, 1967.
Twiggy, *Twiggy in Black and White,* London, Simon and Schuster, 1997.
Andy Warhol, Suzie Frankfurt, *Wild Raspberries,* New York, Little, Brown and Company, 1998.
Henry Wolf, *Visual Thinking: Methods for Making Images Memorable,* New York, American Showcase Inc., 1988.

1972–1999
Continuity and change

Editors
Anthony Mazzola (1972–1992)
Liz Tilberis (1992–1999)

Fabien Baron, Adam Gopnik, *Works 1983–2019*, London, Phaedon Press Ltd., 2019.
Germano Celant, Harold Koda, *Giorgio Armani*, London, Royal Academy of Arts, 2001.
Grace Coddington, "On Liz," in *Grace: A Memoir*, London, Chatto & Windus, 2012.
Patrick Demarchelier, *Patrick Demarchelier*, Göttingen, Steidl, 2014.
Alicia Drake, *Beautiful People: Saint Laurent, Lagerfeld. Splendeurs et misères de la mode*, Paris, Gallimard, 2010.
Alan Flusser, *Ralph Lauren: In His Own Fashion*, New York, Abrams, 2019.
Martin Harrison, *Peter Lindbergh: Images of Women*, Monaco, Schirmer/Mosel, 2005.
Helmut Lang, *Helmut Lang Archive Book, 1986–2005*, distr. Idea Books.
Thierry-Maxime Loriot, Peter Lindbergh, *Peter Lindbergh: A Different Vision of Photography*, Cologne, Taschen, 2016.
Christian Lacroix, Patrick Mauriès, *Pêle-Mêle*, London, Thames & Hudson, 1992.
Suzy Menkes, Olivier Flaviano, Jeromine Savignon, *Yves Saint Laurent Haute Couture: Catwalk*, New Haven, Yale University Press, 2019.
Kate Moss with Fabien Baron, Jess Hallett, Jefferson Hack (eds.), *Kate: The Kate Moss Book*, New York, Rizzoli, 2012.
Florence Müller, Farid Chenoune, *Yves Saint Laurent*, New York, Abrams, 2010.
Catherine Ormen, *All about Yves*, London, Laurence King Publishing, 2017.
Marie Ottavi, *Jacques de Bascher: Dandy de l'ombre*, Paris, Séguier, 2017.
Alice Rawsthorn, Veit Gorner, Jenny Holzer, *Helmut Lang: Alles Gleich Schwer*, Monaco, Hirmer Verlag, 2009.
Hélène Schoumann, *Chloé*, Paris, Assouline, 2003.
Liz Tilberis, *No Time to Die: Living with Ovarian Cancer*, London, Weidenfeld & Nicolson, 1998.
Claire Wilcox, *The Art and Craft of Gianni Versace*, London, V & A Publications, 2002.
Claire Wilcox, *Fashion at the Edge: Spectacle, Modernity and Deathliness*, New Haven, Yale University Press, 2007.

1999–2019
The twenty-first century

Editors
Katherine Betts (1999–2001)
Glenda Bailey (since 2001)

Vince Aletti, *Issues: A History of Photography in Fashion Magazines*, London, Phaidon Press, 2019.
Glenda Bailey, *Harper's Bazaar: 150 years: The Greatest Moments*, New York, Abrams, 2017.
Glenda Bailey, *Harper's Bazaar: Greatest Hits: A Decade of Style*, New York, Abrams, 2011.
Glenda Bailey, *Harper's Bazaar Special Collector's Edition: Best Covers, 1867–2011*, New York, Hearst magazine, 2011.
Derek Blasberg, *Harper's Bazaar: The Models*, New York, Abrams, 2015.
Andrew Bolton, Karen Van Godtsenhoven, Amanda Garfinkel, *Camp: Notes on Fashion*, New York, Metropolitan Museum of Art, 2019.
Andrew Bolton, *Alexander McQueen: Savage Beauty*, New York, Metropolitan Museum of Art, 2010.
Andrew Bolton, Harold Koda, *Superheroes: Fashion and Fantasy*, New Haven, Yale University Press, 2008.
Susan Bright, Vince Aletti, *Face of Fashion*, New York, Aperture, 2007.
Pamela Golbin (ed.), *Fashion Icons*, Paris, Les Arts Décoratifs, 2014.
Pamela Golbin (ed.), *Louis Vuitton. Marc Jacobs*, New York, Rizzoli, 2012.
Pamela Golbin, *Valentino: Themes and Variations*, New York, Rizzoli, 2008.
Jean-Paul Goude, *Goude, Chanel: The Sketchbooks*, New York, Thames & Hudson, 2020.
Jean-Paul Goude, Patrick Mauriès, *So Far So Goude*, London, Thames & Hudson, 2005.
Goudemalion: Jean-Paul Goude, une rétrospective, Paris, Éditions de La Martinière, 2011.
Robert Fairer, *John Galliano for Dior*, New York, Thames & Hudson, 2019.
Karl Lagerfeld, Patrick Mauriès, *Chanel: The Karl Lagerfeld Campaigns*, London, Thames & Hudson, 2018.
Colin Mcdowell, *Galliano*, London, Weidenfeld Nicolson Illustrated, 2000.
Adelia Sabatini, Patrick Mauriès, *Chanel: Catwalk*, London, Thames & Hudson, 2016.
Dana Thomas, *Gods and Kings: The Rise and Fall of Alexander McQueen and John Galliano*, London, Penguin Books, 2016.
Claire Wilcox, *Alexander McQueen: Unseen*, New York, Thames & Hudson, 2016.
Claire Wilcox, *John Galliano: Unseen*, New Haven, Yale University Press, 2017.

Index

A Abbott, Berenice, 121
About, Edmond, 12
Adler, Renata, 141
Agha, Mehemed Fehmy, 54
Agnelli, Marella, 5, 72
Akrans, Camilla, 184
Aillencourt, Simone d', 189
Alcindor, Lew then Kareem Abdul-Jabbar, 141
Alexander McQueen, fashion house, 166
Alexeïeff, Alexandre, 54
Anna Sui, Maison, 166
Anderson, Marian, 46, 158
Anger, Kenneth, 141
Aniston, Jennifer, 189
Ansel, Ruth, 140, 150
Apollinaire, Guillaume, 30
Arbus, Diane, 54, 130, 150
Arbus, Doon, 150
Astaire, Fred, 118
Aswell, Mary Louise, 46, 72, 124
Auden, William H., 124
Auermann, Nadja, 166
Avedon, Doe see Doe Nowell
Avedon, Richard, 4–6, 10, 46, 47, 54, 60, 72, 104, 106–108, 111, 112, 115, 117–119, 124, 130, 135, 140, 141, 144, 149, 150, 158, 160, 166, 174, 175, 186
Avery, Dick, 118
Ayala, Madame H. de (donor), 103
Aymé, Marcel, 124

B Bacall, Lauren, 72
Bacon, Francis, 158
Badulescu, Enrique, 166
Bailey, Glenda, 5, 6, 130, 167, 174, 175
Barrington, Bijou, 75
Bakst, Léon, 30, 34, 54, 174
Baldwin, James, 107, 124
Balenciaga, Cristóbal, 4, 54, 118, 119
Balenciaga, fashion house, 46, 47, 107, 118, 123
Balmain, Pierre, 118
Barbara, 118
Barbier, George, 30, 54
Barnes, Djuna, 124
Baron, Fabien, 5, 7, 124, 166, 167, 170
Barrymore, Drew, 166
Barthes, Roland, 4
Bartholdi, Auguste, 12
Bassman, Lillian, 46, 54, 106, 118, 130
Bayer, Herbert, 63, 83
Beadle, Ernst, 63, 124
Beardsley, Aubrey, 24
Beaton, Cecil, 90, 118, 124, 158
Beaumont, Étienne de, 46
Beauvoir, Simone de, 124, 130
Beckett, Samuel, 124, 126, 129
Bell, Larry, 150
Bellow, Saul, 124
Benigni, Léon, 30, 41
Bérard, Christian, 46, 50, 90, 96, 97, 106, 124
Bernhardt, Sarah, 24
Betts, Katherine, 167
Bianchini Férier, 32, 54
Binz, Marguerite (donor), 157
Blackwell, Antoinette, 12
Blumenfeld, Erwin, 51, 90, 91, 95, 96
Bocher, Main Rousseau, 76
Bogart, Humphrey, 158
Boiffard, Jacques-André, 82
Bolin, Liu, 158, 164
Bonet, Lisa, 158
Booth, Mary Louise, 4–7, 12, 13, 15, 16, 18, 24, 124, 186
Boulet-Poiret, Denise, 32
Bourdin, Guy, 82, 166
Bourke-White, Margaret, 90
Bousquet, Marie-Louise, 46, 90, 96, 124

Boussac, Marcel, 96
Boutet de Monvel, Bernard, 30, 130, 158
Bowles, Jane, 130
Bowles, Paul, 124
Boyle, Kay, 124
Bradley, William H., 24, 25
Brancusi, Constantin, 46, 158
Brando, Marlon, 125
Brandolini d'Adda Agnelli, Cristiana, 112
Brandt, Bill, 46, 54, 96, 129, 158, 159
Brassaï, Gyula Halász, dit, 46, 96, 129
Breton, André, 82, 83
Bridges, Betty, 79
Brodovitch, Alexey, 5–7, 46, 54, 57, 64, 72, 82, 96, 106, 107, 118, 119, 124, 130, 150, 167, 175
Brooke, Peter, 158
Brooks, Romaine, 64
Brossin de Méré, 112, 157
Brown, Alice, 124
Fuller, Richard Buckminster, 186, 189
Bündchen, Gisele, 130, 139
Burne-Jones, Edward, 24
Burroughs, William, 124, 126

C Callot, Sœurs, 18, 64
Campbell, Naomi, 137, 166
Capote, Truman, 5, 72, 107, 118, 119, 124, 125, 150, 158
Caracciolo, Olga, 38
Cardi B., 184
Carey, Mariah, 174, 177
Cartier, Louis, 30
Cartier, fashion house, 54, 118
Cartier-Bresson, Henri, 46, 96, 118, 124, 158
Cary, Joyce, 129
Cashin, Bonnie, 90
Cassandre, Adolphe Mouron aka, 5, 52, 66, 82–84, 90, 124, 186
Castelli, Leo, 150
Caton Woodville, Richard, 19
Cavaco, Paul, 166
Chagall, Marc, 46
Chanel, Gabrielle aka Coco, 4, 82, 118
Chanel, fashion house, 38, 42, 90, 166, 174, 186
Chase, Edna Woolman, 54
Chénier, André, 12
Chiuri, Maria Grazia, 158
Clifford Barney, Natalie, 64
Cocteau, Jean, 46, 50, 106, 124
Colette, Gabrielle-Sidonie aka, 46, 90, 106, 124, 129, 130
Colle, Pierre, 96
Collins, Joan, 158, 163
Collins, William Wilkie, 124
Conner, Bruce, 140
Cornell, Joseph, 82
Courrèges, André, 4, 119, 140, 141, 146, 149
Courtenay, Tom, 140
Crawford, Cindy, 166
Cruise, Tom, 166
Curie, Marie, 96
Curie, Pierre, 96
Cutting Stewart, Mary, 124

D Daguerre, Louis, 106
Dahl-Wolfe, Louise, 46, 47, 54, 72, 73, 75, 78, 95, 103, 106, 119, 121, 123, 124, 125, 130, 189
Dalí, Gala, 82
Dalí, Salvador, 5, 82, 118, 124, 130
Daniels, Elise, 107, 108, 111
Darin, Agneta, 152
David, Jacques-Louis, 64
Davis, George, 46, 124
Day-Lewis, Daniel, 166
D'Annunzio, Gabriele, 125
De Kooning, Willem, 150
Dean Howells, William, 124
De Chirico, Giorgio, 159
Delpire, Robert, 46
Demarchelier, Patrick, 130, 139, 166, 167, 169, 173
Denzinger, Katerina, 144
Derain, André, 46, 54
Derujinsky, Gleb, 106
Dessès, Jean, 118
Diaghilev, Sergei, 54
Diaz, Cameron, 166
Dickens, Charles, 13, 124
Dietrich, Marlene, 108
Dillon, Matt, 166
Dior, Christian, 4, 6, 7, 96, 97, 99, 100, 103, 104, 118, 124
Dior, fashion house, 6, 46, 47, 54, 99, 112, 115, 119, 174, 178
Dolce & Gabbana, fashion house, 166, 191
Domergue, Jean-Gabriel, 30, 158
Donen, Stanley, 72, 106, 118, 123
Donna Karan, fashion house, 166
Donyale Luna, 140, 141
Doucet, Jacques, 18, 24
Dovitch, 118
Dovima, Dorothy Virginia Margaret Juba aka, 6, 106–108, 115, 123, 130, 132, 150
Drian, Adrien Désiré Étienne aka Adrien, 30
Dufy, Raoul, 46
Dugo, 126
Dulac, Edmond, 30
Dylan, Bob, 141

E Edward VII, 38
Edwards, Blake, 118, 125
Elbaz, Alber, 4, 158, 164
Eliot, T. S., 158
English, Pat, 100
Ernst, Max, 82, 83
Erté, Romain de Tirtoff aka, 4, 30, 32, 37, 38, 54, 82, 124, 130, 186
Eugénie, Empress, 22
Evangelista, Linda, 166, 167, 174
Evans, Walker, 46, 150

F Fabergé, Pierre-Karl, 118
Falaise, Maxime de la (comtesse) 108
Fath, Jacques, 118
Faulkner, William, 124
Faurer, Louis, 54
Fawcett, Farrah, 158, 163
Feitler, Bea, 140, 150
Félix, 18
Fellowes, Daisy, 5, 46, 72, 82
Ferrer, Mel, 150
Fini, Leonor, 46, 50, 82, 118
Flanner, Janet, 46
Flavin, Dan, 150
Fonssagrives, Lise, 95
Ford, Tom, 174
Fouquet, Jean, 130
Frackowiak, Magdalena, 191
Fragonard, Jean-Honoré, 174
Frank, Jean-Michel, 46, 50
Frank, Robert, 46, 54, 118, 141, 150
Friedlander, Lee, 150
Frissell, Toni, 106, 130, 132

G Galliano, John, 166, 174, 178
Gan, Stephen, 6, 167, 174
Garren, 166
Gaultier, Jean Paul, 158
Geldzahler, Henry, 140, 141
Genet, Jean, 124
Giacometti, Alberto, 46
Gide, André, 124
Gilda, 97
Gill, Leslie, 51, 54, 57, 60, 97, 118, 124, 126
Giono, Jean, 90
Givenchy, Hubert de, 118, 140
Givenchy, fashion house, 118
Glaviano, Marco, 158, 163
Glinda, 174
Goldberg, Nathaniel, 166
Goodman, Tonne, 166
Gopnik, Adam, 106
Goude, Jean-Paul, 174, 177
Grant, Hugh, 166
Grasset, Eugène, 24, 124
Greene, Graham, 158
Guggenheim, Peggy, 82
Guitry, Sacha, 90
Gypsy Rose Lee, 124

H Hall, Grayson, 72
Hambidge, Jay, 64
Harlow, Shalom, 166
Harnett, Sunny, 106, 107, 112, 123
Harper, Fletcher, 12
Harper, James, 12
Harper, John, 12
Harper, Joseph, 12
Hawks, Howard, 125
Hayworth, Rita, 97
Hearst, William Randolph, 30, 38, 46, 82, 125, 166, 167, 169, 187
Helmut Lang, fashion house, 166
Hemingway, Ernest, 124
Hepburn, Audrey, 118, 150, 158, 160
Hepburn, Katharine, 158
Héricourt, Jenny d', 12, 16
Highsmith, Patricia, 124, 130
Hinton, Charles Louis, 24, 26
Hiro, Yasuhiro Wakabayashi aka, 5, 54, 130, 150–152, 155, 157, 174
Hitchcock, Alfred, 118, 121
Hooper, Lucy Hamilton, 18
Hoppé, Emil Otto, 34
Hoyningen-Huene, George, 46, 51, 54, 60, 64, 65, 69, 71, 76, 82, 87, 106, 130
Huet, Jean-Baptiste, 97
Hugo, Jean, 46, 50, 52
Hugo, Valentine, 46
Hume, Kirsty, 170
Hurley, Liz, 166
Huston, John, 125
Huxley, Aldous, 124

I Ingres, Jean-Auguste-Dominique, 51
Iribe, Paul, 38, 54
Isherwood, Christopher, 124
Israel, Marvin, 54, 107, 150

J Jacobs, Marc, 124, 158, 166
James, Charles, 90, 118
James, Henry, 124
Janis, Sidney, 150
Jaques, Ronny, 96
Joan of Arc, 24
Jil Sander, fashion house, 166
John Galliano, fashion house, 166, 174, 178
Johns, Jasper, 141
Johnson, William Martin, 29
Jones, Aya, 180
Jones, Grace, 174
Jordan, Elizabeth, 124
Jouhandeau, Marcel, 124
Judd, Donald, 150
Julien, d'Ys, 166
Jullian, Philippe, 10, 11, 118, 119

K Kane, Citizen, 125, 169, 186, 187
Karenina, Anna, 106
Karina, Anna, 140
Kay Thompson, Dorothy, 60, 72
Kelly, Ellsworth, 150
Kelly, Grace, 118, 121
Kendrick Bangs, John, 124
Kenna, Max, 96
Kennedy, John F., 140
Kenzo, Kenzo Takada aka, 151
Kertész, André, 90
Kevyn Aucoin, 166
King, Bill, 163
Kip, Carola de Peyster, 57
Klein, Calvin, 166, 167
Klein, William, 72
Kochno, Boris, 90, 96
Kollar, François, 46, 90
Koons, Jeff, 186
Kravitz, Zoë, 184
Kusama, Yayoi, 186

L Laboulaye, Édouard de, 12
Lady Diana, 158, 166
Lady Gaga, 166, 182
Lady Macbeth, 24
Lady Mendl, Elsie de Wolfe aka, 118
Laferrière, fashion house, 18
Lagerfeld, Karl, 4, 158, 174
Landry, Miette, 15
Lanvin, Jeanne, 4, 37, 38, 45, 82, 118
Lanvin, fashion house, 164, 186
Larivière, Madame Jean, 43
Lartigue, Jacques Henri, 152, 157
Laura, Mercier, 166
Lawrence, D. H., 46
Lebel-Stapfer, Madame (donor), 45
Leegenhoek, Mrs. (donor), 26
Leigh, Dorian, 104, 107
Leiter, Saul, 54, 150
Leloir, Héloïse, 15
Lelong, fashion house, 90, 96
Le Monnier, Jeanne, 45
Lepape, Georges, 54
LeWitt, Sol, 126, 150
Liberman, Alexander, 166
Lichtenstein, Roy, 141, 150
Lieberath, Frederik, 173
Lincoln, Abraham, 12
Lindbergh, Peter, 5, 137, 166, 170, 175, 184, 191
Lindeman, Jack, 135
Lynes, George Platt, 82, 86
Loos, Anita, 6, 30, 46, 124, 125
Lopez-Willshaw, Patricia (conor), 76, 80, 87
Loren, Sophia, 158, 163
Lotar, Eli, 82
Louis Vuitton, fashion house, 20, 24
Lubitsch, Ernst, 106
Lubomirski, Alexi, 184
Lurçat, Jean, 51

M Maar, Dora, 82
MacDowell, Andie, 158
Machado, China, 72, 163
Macy, Louise, 90
Madame Grès, 118
Madame Roland, Jeanne Marie Phlipon aka, 13
Madonna, 158, 166
Magritte, René, 150, 186, 187
Mainbocher, 76
Malraux, André, 124
Man Ray, 38, 43, 50, 58, 64, 82–84, 89, 106, 124, 158, 186
Marais, Stéphane, 166
Marlborough, Charles Spencer-Churchill, 9th Duke of, 18
Marie Antoinette, 174
Martin, Agnes, 150
Martin Margiela, fashion house, 166
Marty, André-Édouard, 30
Maser, Wayne, 166
Matisse, Henri, 46, 51
Matter, Herbert, 57, 63, 89
Maugham, Somerset, 46
Maxwell, Elsa, 118
Maxwell, Vera, 90
Mazzola, Anthony T., 7, 103, 150, 158, 166
McCardell, Claire, 90
McCartney, Paul, 141
McCullers, Carson, 124, 125
McDean, Craig, 166
McFadden, Frances, 46
McKay, Gardner, 117
McLuhan, Marshall, 150, 151
McQueen, Steve, 6, 158, 160
McVickar, Harry Whitney, 24, 29
Meerson, Harry, 64
Meier, Raymond, 173
Mekas, Jonas, 141
Mencken, H. L., 124
Merson, Luc-Olivier, 24, 29
Messel, Oliver, 158
Messiaen, Olivier, 96
Meyer, Adolphe de, 30, 38, 39, 41, 43, 45, 46, 64, 82, 106, 124, 158
Michelson, Annette, 159
Miller, Henry, 124
Milon Aîné, 16
Mishima, Yukio, 124
Missoni, Angela, 158
Mitchell, Donna, 146
Miyake, Issey, 151
Mizrahi, Isaac, 158
Model, Lisette, 54, 96, 130
Molyneux, fashion house, 47, 90
Monroe, Bobby, 78
Monroe, Marilyn, 125
Moore, Demi, 175
Moore, James, 54, 150
Moore, Julianne, 166
Moorehead, Agnes, 186
Mora, José-Maria, 22
Moral, Jean, 46, 90
Morris, William, 24
Moss, Kate, 6, 166, 169
Munkácsi, Martin, 46, 49, 54, 55, 72, 93, 106, 107, 130
Murphy, Carolyn, 173

N Nabokov, Vladimir, 124
Nadar, Félix Tournachon aka, 106
Namuth, Hans, 46, 189
Napoleon III, 18
Nars, François, 166
Nast, Condé, 38, 46
Naylor, Genevieve, 124
Neff, Elinor Guthrie, 57
Newman, Arnold, 118, 158
Newton, Helmut, 166
Nijinski, Vaslav, 54
Noailles, Marie-Laure de, 72
Noailles, Les, 46
Noland, Kenneth, 150
Nowell, Dorcas aka Doe, 106

O Oldenburg, Claes, 141
Ophelia, 11, 24
Ozenne, Jean, 96

P Pagès, Pierre, 50
Paley, Barbara aka Babe, 5, 72
Paltrow, Gwyneth, 6, 166
Paolozzi, Christina (Contessa), 135
Paquin, fashion house, 18, 52
Paris, Marquise de (donor), 52
Parker, Dorothy, 124
Parker, Sarah Jessica, 175
Parker, Suzy, 106, 107, 117, 123, 150
Pascal, Blaise, 12, 186
Pastrone, Giovanni, 125
Patchett, Jean, 78
Pavlova, Anna, 54
Penn, Irving, 54, 150
Phelps, Elizabeth Stuart, 124
Philo, Phoebe, 158
Picabia, Francis, 82
Picasso, Pablo, 46, 54, 82, 106
Piccioli, Pierpaolo, 158
Piguet, fashion house, 96
Plutarch, 13
Poiret, fashion house, 54
Poiret, Paul, 30, 32, 82, 124
Pollock, Jackson, 46
Poons, Larry, 140
Prada, fashion house, 166
Procter, Simon, 174, 178
Puhlmann, Rico, 158, 163
Puvis de Chavannes, Pierre, 24

Q Queneau, Raymond, 124

R Radkai, Karen, 54
Ralph Lauren, fashion house, 174
Randolph, Gwen, 150
Raudnitz, fashion house, 18
Rauschenberg, Robert, 140, 141
Réard, Louis, 132
Raymond Shipman Andrews, Mary, 124
Raymond, Emmeline, 18
Rébé, 104
Renée, 108
Reves-Biro, Emery P., 131
Rhead, Louis J., 24, 29
Rhianna, 6, 184
Ribes, Jacqueline de, 5, 72
Richardson, Terry, 166
Richier, Germaine, 130
Ritts, Herb, 166
Rivette, Jacques, 140
Roberts, Julia, 184
Robbe-Grillet, Alain, 129
Rochas, Marcel, 118
Roitfeld, Carine, 174
Rose, Ben, 54
Rosier, Michèle (donor), 123
Ross, Denman Waldo, 64
Rossellini, Isabella, 158
Rossetti, Dante Gabriel, 24
Rouff, Maggy, 18
Roy, Norman Jean, 184
Russell, Jane, 125
Russell, Mary Jane, 103, 121, 189
Ryder, Winona, 166

S Sagan, Françoise, 124, 129, 130
Saint-Exupéry, Antoine de, 90, 124
Saint Laurent, Yves, 115, 119, 124, 140, 157
Salome, 24
Samaras, Lucas, 150
Samuels, Arthur, 46
Sand, George, 12, 186
Sandoz, Adolf, 18, 20
Sartre, Jean-Paul, 124
Scavullo, Francesco, 54, 158
Schapiro, Steve, 158
Schiaparelli, Elsa, 4, 52, 80, 82, 83, 86, 87, 118, 124
Schiaparelli, fashion house, 46, 54, 86, 90
Schiffer, Claudia, 166
Scott Fitzgerald, Francis, 124
Segal, George, 141
Seliger, Mark, 175
Selkirk, Neil, 137
Sellers, Peter, 158
Sem, Georges Goursat aka, 64
Seymour, David, 124, 129
Shepherd, Cybill, 158
Shields, Brooke, 158
Shrimpton, Jean, 141, 144
Sieff, Jeanloup, 150
Sims, David, 166, 169
Sims, Dr J. Marion, 12
Singer, Isaac Merritt, 82
Singer, Winnaretta, 72
Sitwell, Edith, 130, 158
Snow, Carmel, 4, 6, 7, 10, 38, 46, 47, 50, 54, 64, 72, 82, 83, 90, 96, 97, 100, 106, 107, 112, 118, 119, 124, 150, 166, 167, 175
Sokolsky, Melvin, 146, 150, 186, 189
Sorrenti, Mario, 166
Soupault, Philippe, 5, 54, 82
Staël, Germaine de, 13
Starr, Ringo, 141
Steichen, Edward, 38
Stein, Gertrude, 46, 64, 126
Steinbeck, John, 124
Steinberg, Saul, 130
Stella, Frank, 150, 155
Stern, James, 124
Stewart, James, 118
Stewart, Virginia, 78
Stieglitz, Alfred, 38, 158
Stone, Bob, 158
Stravinsky, Igor, 54, 82

T Tabard, Maurice, 83
Taylor, Elizabeth, 125
Tchelitchew, Pavel, 46
Tériade, 46
Testino, Mario, 166
Thayaht, Ernesto Michahelles, 64, 66
Thompson, Michael, 170
Tiburzi, Alberta, 151, 152
Tiffany, fashion house, 118
Tilberis, Liz, 5, 7, 10, 158, 166, 167
Tinguely, Jean, 150
Tolstoy, Leo, 106
Tomkins, Calvin, 46, 54, 106
Tourdjman, Georges, 54, 186, 187
Towne, Charles Hanson, 46
Tripp, Evelyn, 78
Trotta, Geri, 150
Turlington, Christy, 166, 173
Turgot, Michel-Étienne, 103
Twain, Mark, 24, 124
Tyler, Richard, 166

U Underwood, Clarence F., 24
Ungaro, Emanuel, 119

V Valentine, Laura, 163
Valletta, Amber, 166, 170
Van Dyke, Henry, 124
Vanderbeek, Stan, 141
Vanderbilt II, Alice Claypoole, 18, 22
Vanderbilt, Gloria, 72
Vanderbilt, Consuelo, 18
Vanderbilt, William Kissam, 24
Varèse, Edgar, 150
Versace, fashion house, 166
Vertès, Marcel, 46, 80, 82, 90, 96, 124
Vidor, Charles, 97
Vionnet, Madeleine, 4, 58, 64, 66, 69, 82, 130
Vionnet, fashion house, 47, 66
Virot, Madame, 18
Vishniac, Roman, 96
Vivanco, Mariano, 184
Vogel, Lucien, 30, 130
Volpi, Lily, 118
Vorse, Mary Heaton, 124
Vreeland, Diana, 4, 6, 7, 10, 46, 72, 73, 75, 76, 83, 90, 106, 107, 118, 119, 124, 130, 150, 175

W Wahlberg, Mark, 166
Warhol, Andy, 5, 140, 141, 143, 166
Watson, Albert, 158, 163
Welles, Orson, 169, 186
Welty, Eudora, 124, 130
Wescott, Glenway, 121
Wesselmann, Tom, 150
West, Rebecca, 90
White, Nancy, 7, 118, 140, 150
White, Thomas, 150
Wilde, Oscar, 24
Wilkins Freeman Mary E., 124
William, Tennessee, 124, 129
Winfrey, Oprah, 174
Winslet, Kate, 184
Wintour, Anna, 166
Witt, Marola, 152
Wolf, Henry, 7, 118, 130, 150
Wolfe, Elsie de, 5
Wolfe, Tom, 124, 140, 141
Woolf, Virginia, 46, 124, 126, 130
Worth, Charles Frederick, 6, 18, 20, 22
Wright, Mrs., 12
Wyatt, Edith, 124

Y Yamamoto, Yohji, 151
Yeste, Txema, 180
Young, La Monte, 140
Yves Saint Laurent, 4, 124, 166

Z Zakrzewska, Dr Marie E., 12

197

This book was published in conjunction with the
"Harper's Bazaar. First in Fashion" exhibition held at the Musée des Arts Décoratifs in Paris, from February 27 to July 14, 2020.

Exhibition created by MAD, Paris, with support from American Express, Veronica Chou and GRoW @ Annenberg, with special thanks to Regina and Gregory Annenberg Weingarten.

AMERICAN EXPRESS

GRoW@ ANNENBERG

MAD

Chairman
Pierre-Alexis Dumas

CEO
Sylvie Corréard

Director of the Musée des Arts Décoratifs
Olivier Gabet

Production and International Relations Director
Yvon Figueras

Communications Director
Olivier Hassler

EXHIBITION

Curators
Éric Pujalet-Plaà
Assistant Curator at the Musée des Arts Décoratifs

Marianne le Galliard
Ph.D. in art history, specializing in photography

Assisted by
Lola Barillot
Documentation and Coordination

Production
Jérôme Recours
Head of Exhibitions Department

Anaïs David
Deputy Production Assistant

Charlotte Frelat
Production Assistant

Design and layout
Studio Adrien Gardère

Francesca Galdangelo
Carole Pfendler
Project Managers

Felicie Barbey
Assistant

CATALOGUE

Head of Publications and Images
Chloé Demey

Editorial Coordination and Picture Research
Violaine Aurias

Copy Editor
Penelope Iremonger

Translation from French
Lisa Davidson, Sally Laruelle

Graphic design and typeset
Baldinger•Vu-Huu
André Baldinger & Toan Vu-Huu

Assisted by
Stéphane Toque

Original cover concept
Baldinger•Vu-Huu

English version
Elizabeth Hummer

ACKNOWLEDGEMENTS

We would first like to extend very special thanks to Glenda Bailey, editor in chief of *Harper's Bazaar*, for her total involvement in this project, her enthusiasm for transmitting the history of the magazine, and her generosity in sharing her immense knowledge and her vision. For the first time, an exhibition is exploring the history of the magazine that essentially wrote the story of fashion and, through her, an entire magazine cooperated with this project. Our warmest gratitude for her most valuable assistance, her sense of humor and her energy, as well as to the entire *Harper's Bazaar* staff, notably Elizabeth Hummer, Design Director.

We would also like to most sincerely thank Veronica and Silas Chou, as well as Regina and Gregory Annenberg Weingarten for their exceptional support for this exhibition.

Our thanks also go to Marina French Kellen, who helped facilitate the restoration of many textile works.

The renovation of the fashion galleries was made possible through the generosity of Christine and Stephen A. Schwarzman.

The fashion and textiles collections of the Musée des Arts Décoratifs benefit from the constant support of the DEFI.

This exhibition would not have been possible without loans from institutions, fashion houses, and collectors, to whom we extend special thanks for their generosity:

Charenton-le-Pont, Donation Jacques Henri Lartigue
Marion Perceval

Dallas, DeGolyer Library
Anne E. Peterson

Figueres,
The Gala-Salvador Dalí Foundation
Montse Aguer Teixidor
Laura Bartolomé
Rosa Aguer

Göteborg, Röhsska Museet
Nina Due
Josefin Kilner

Kent, Kent State University Museum
Joanne Fenn
Sarah J. Rogers
Sara Hume

Lille, Librairie Diktats
Antoine & Nicolas

Nantes, Musée d'Arts de Nantes
Sophie Lévy
Claire Tscheiller

New York, Vince Aletti

New York, The Richard Avedon Foundation
James Martin

New York, Tricia Foley

New York, Helmut Lang
Helmut Lang
Joakim Andreasson

Paris, Archives de Paris
Guillaume Nahon
Dominique Juigné

Paris, Archives Balenciaga
Gaspard de Massé

Paris, Baron & Baron
Fabien Baron
Joseph Beydoun
Fatti Laleh

Paris, Bibliothèque Historique de la Ville de Paris
Emmanuelle Toulet
Alain Durel

Paris, Cartier
Renée Franck
Anne Lamarque
Anne Dubus

Paris, Centre National des Arts Plastiques
Béatrice Salmon
Laetitia Dalet

Paris, Centre Pompidou–Musée National d'Art Moderne
Bernard Blistène

Paris, Chanel
Hélène Fulgence
Sarah Piettre

Paris, Chloé
Géraldine Sommier

Paris, Dior Heritage, Christian Dior Couture
Soizic Pfaff
Perrine Scherrer
Solène Aureal
Justine Lasgi
Hélène Starkman
Jennifer Walheim

Paris, Fondation Pierre Bergé–Yves Saint Laurent
Madison Cox
Aurélie Samuel
Lola Fournier

Paris, Jérôme Gautier

Paris, Jean-Paul Goude
Jean-Paul Goude
Virginie Laguens

Paris, Lanvin
Laure Harivel

Paris, Musée de l'Assistance Publique–Hôpitaux de Paris
Camille Pérez
Axelle Abelin

Paris, Musée d'Orsay
Laurence des Cars
Élise Dubreuil

Paris, Éric Pujalet-Plaà

Paris, Jérôme Recours

Paris, Archives de la Maison Schiaparelli
Francesco Pastore

Paris, Van Cleef & Arpels
Lise Macdonald

Rennes, Musée des Beaux-Arts de Rennes
Jean-Roch Bouiller
Guillaume Kazerouni
Anne-Laure Le Guen

Troyes, Médiathèque Jacques Chirac
Catherine Schmit
François Berquet
Véronique Saublet Saint-Mars

Marianne le Galliard would like to extend special thanks to James Martin, director of the Richard Avedon Foundation, for his kindness and inspiration, as well as Ruth Ansel, Hiro, Maggy Geiger, Sakata Eiichiro, Gideon Lewin, Donna Mitchell, Neil Selkirk, and Georges Tourdjman. Thanks also to Elizabeth Hummer, design director of *Harper's Bazaar*, for her enthusiasm and insightful advice, as well as to all those who facilitated access to sources crucial to research on *Bazaar*: Catherine Aurerin at the Bibliothèque Nationale de France, Quentin Bajac at MoMA, Michel Brodovitch, Bruno Feitler, Karin Kato from the archives and research department of *Bazaar*, Sébastien Quéquet and Earl Steinbicker. Merci to Ivan Pavlov, for his genuine advice, always. Finally, the author would like to express her gratitude to Bob Rubin.

Éric Pujalet-Plaà would first like to thank Giuseppe Fadda for having taught him about illustration. Grateful thanks also to Laurent-François Gérard-Monnié for sharing his knowledge of photography, to Sergio Bini, aka Bustric, for his love of theater, to Odile and Marc Étaix for their passion for cinema and to Melissa Pinon for her insights into painting. Thanks to Glenda Bailey, Elizabeth Hummer, Catherine Aurerin, Jean-Paul Goude, Virginie Laguens, Fabien Baron, Emmanuelle Minault-Richomme, Tricia Foley, and Anne E. Peterson for their keen eye and warm support for this project. Thanks to Mathilde Le Corre, Garance Toreilles, and Maeva Lepetit, who were there at the beginning, and to Victoire Fleuriot who helped with drafts. Thanks to Sandrine Tinturier for her scientific advice.

The publications department extends special thanks to André Baldinger and Toan Vu-Huu, for their graphic work on this book, Violaine Aurias, who was the linchpin for it all, and the following people for so generously allowing access to issues of *Harper's Bazaar*:
Antoine & Nicolas, Diktats
Perrine Scherrer, Collection Dior Héritage
Francesco Pastore, Maison Schiaparelli

We are grateful to all those who worked tirelessly on the preparation of the exhibition and this book:
Dorothée Barthélemy Delahaye, Céline Cabrolier, Sylvain Carré, Christophe Dellière, Karin Kato, Alexander Lopez, Daniela Lopez Amezquita, Stephen Mooallem, Lucie Mugnier, Ellen Payne, Victoria Pedersen, Samantha Short, and Jean Tholance.

Finally, at the MAD, our warmest thanks go to the follow departments:
Curator department, particularly Amélie Gastaut and Sébastien Quéquet, who helped define the vision for this project, as well as Raphaële Billé, Denis Bruna, Marie-Sophie Carron de la Carrière, Bénédicte Gady, Audrey Gay-Mazuel, Astrid Grange, Romain Lebel, Sophie Motsch, Évelyne Possémé, Hélène Renaudin, and Marie-Pierre Ribère;
Collections department, particularly Florence Bertin, Ségolène Bonnet, Sylvie Bourrat, Valentine Dubard, Emmanuelle Garcin, Cécile Huguet-Broquet, Alexandra Mérieux, Joséphine Pellas, Dominique Régnier, Myriam Teissier, and Luna Violante;
The library and documentary resources, particularly Emmanuelle Beuvin and Laure Haberschill;
Publications and images department, particularly Iris Aleluia and Marion Servant;
Exhibitions department, particularly Marie Reichmuth;
Public service department, particularly Catherine Collin;
Sponsorship and events department, particularly Juliette Sirinelli, Marion Sordoillet Stéphanie Rolea, and Alice Réau;
Communications department, particularly Isabelle Mendoza and Jennifer Cassamajor.

All covers and layouts are courtesy of *Harper's Bazaar* magazine, published by Hearst Magazine Media. *Harper's Bazaar* is a registered trademark of Hearst Communications, Inc.

PHOTO CREDITS

p. 13: Library of Congress, Washington, D.C. Collection Brady-Handy. • p. 14 (A), 16 (B), 21, 32, 36, 42, 69 (C) 87 (B), 100, 102 (A), 105 (B), 113, 132 (A), 165 (B): MAD, Paris/Jean Tholance. • p. 14 (B), 17 (C), 17 (D), 29 (C), 29 (E), 33 (B2, B4, B5, B8), 45 (B), 50 (A), 50 (D), 51 (G, H, I), 56 (B), 94 (A), 121, 125: 2019 ProQuest LLC • p. 15, 19, 20, 25, 27, 35, 62 (A), 62 (C), 63, 65, 89, 102–103 (B), 126 (A): Hearst Magazine Media/Philip Friedman. • p. 16 (A): Library of Congress Prints and Photographs Division Washington, D.C. 20540 USA. • p. 17 (D), 43, 68: Bibliothèque nationale de France. • p. 22 (A), 22 (3), 52 (B): MAD, Paris. • p. 23: Collection of the New-York Historical Society, USA/Bridgeman Images. • p. 26, 31, 33 (B1, B3, B6, B7, B9), 34, 37, 39, 40–41, 42 (détail), 44, 48–49, 50 (B, C), 50 (E), 51 (L), 52 (A), 51 (F), 51 (J, K), 53, 55, 56 (A), 57, 58–59 (A), 59, 60–61, 62 (B), 67, 70–71, 73–75, 76, 77, 78 (A1, A2, A3), 79, 80, 81, 83–84, 85, 86 (A), 87 (C), 88, 91, 92–93, 94 (B) 97, 98, 99, 104–105 (A), 108–112, 114–117, 120 (B), 122, 123, 126 (B), 127, 128, 129, 132–133, 134–135, 136–137, 142–143, 144–145, 146, 147, 148–149 (A), 149, 151, 152 (A), 153, 155, 156, 157 (C), 159, 160, 161, 162 (B, C, D), 163, 167, 168, 169, 171, 172 (A), 173 (A), 175, 176–177, 179 (B), 184, 187, 188 (A), 189: MAD, Paris/Christophe Dellière. • p. 28: photo : © Pauline Betton/Musée d'arts de Nantes. • p. 29 (B), 29 (D): Library of Congress Prints and Photographs Division Washington, D.C. 20540 USA. • p. 45 (C): © Patrimoine Lanvin. • p. 66, B: © Bibliothèque Forney. • p. 69 (B): © BHVP/Roger-Viollet. • p. 78 (A4), 183 (C): courtesy The Museum at FIT. • p. 94, A: Collection Estate Erwin Blumenfeld. • p. 101: Collection Dior Héritage. • p. 141: Collection Vince Aletti. • p. 154: © 2019. Digital Image Museum Associates/LACMA/Art Resource NY/SCALA, Florence.

COPYRIGHT

p. 31, 33, 37: Erté © Sevenarts Ltd/Adagp, Paris, 2019. • p. 35: © E.O. Hoppé Estate collection/Curatorial Assistance, Inc. • p. 45 (C): © Patrimoine Lanvin • p. 47, 61 (D), 104–105 (A), 107–111, 112–113 (A), 114–117, 134–135, 141, 144–145 (B), 148–149 (A), 160, 161: © The Richard Avedon Foundation • p. 48–49, 55, 92–93: © Estate of Martin Munkácsi, Courtesy Howard Greenberg Gallery, New York • p. 50 (A), 58–59 (A), 85, 88: © Man Ray 2015 Trust/Adagp, Paris 2019. • p. 50 (C): Pierre Pagès/DR. • p. 50 (D), 52 (A): Jean Hugo © Adagp, Paris, 2019 • p. 50 (E): Leonor Fini © Adagp, Paris, 2019. • p. 50 (F): © Adagp/Comité Cocteau, Paris 2019 • p. 51 (G), 57 (D), 60 (D), 61 (C), 97, 126 (A): Copyright © by The Estate of Leslie Gill • p. 51 (I), 91, 94 (A): © The Estate of Erwin Blumenfeld • p. 51 (K): © Fondation Lurçat/Adagp, Paris, 2019 • p. 51 (L), 60 (B), 65, 68, 70–71, 76, 87 (D): © Richard J. Horst. • p. 53 (C), 67, 83–84: TM. & © MOURON. CASSANDRE Lic 2019-14-13-03 www.cassandre.fr • p. 53 (D), 86 (B), 87 (D): © Maison Schiaparelli • p. 56 (A): DR • p. 56 (B), 62 (A), 89: Herbert Matter/DR • p. 57 ©: © Alexey Brodovitch • p. 62 (B, C): Ernst Beadle/DR • p. 63: Herbert Bayer © Adagp, Paris, 2019 • p. 73–75, 78–79, 94 (B, C), 102–103 (B), 120 (B), 122, 125, 128 (B), 188 (C) : © Center for Creative Photography, Arizona Board of Regents • p. 80–81 (A): Marcel Vertès/DR • p. 86 (A): © George Platt Lynes. • p. 101 (B): © Getty images/Pat English. • p. 119: Philippe Jullian/DR • p. 120 (A): © 1954 Universal City Studios. Courtesy of Universal Studios Licensing LLC. • p. 121: © Gettyimages/Berenice Abbott • p. 126 (B): William Burroughs/DR • p. 127 (C): DUGO/DR • p. 127 (D): Image: Sol LeWitt © Adagp, Paris, 2019. Texte: Samuel Beckett's COME AND GO included by kind permission of the Estate of Samuel Beckett, in association with Faber and Faber Limited, London. • p. 128 (A): Image : © David Seymour/Magnum Photos. Texte : © 1956 by The University of the South. Reprinted by permission of New Directions Publishing Corp. • p. 129 (C): © Estate Brassaï–RMN–Grand Palais • p. 129 (D): Image : © Bill Brandt Archive. Texte : © 1963 by Les Editions de Minuit. • p. 131: E. P. Reves-Biro/DR • p. 132–133: Toni Frissell/DR • p. 136–137, 171 (B), 185 (A), 190–191: © Peter Lindbergh. • p. 138–139: © Hearst Magazine Media • p. 142–143: © The Andy Warhol Foundation for the Visual Arts, Inc./Licensed by ADAGP, Paris 2019 • p. 144 (A): Katerina Denzinger/DR • p. 147, 188 (A, B): © Melvin Sokolsky. • p. 151, 152 (A), 153, 155, 156: Hiro/DR • p. 152 (B), 157 (B): © Ministère de la Culture (France), MAP-AAJHL • p. 154: Frank Stella © Adagp, Paris, 2019. • p. 159: © Bill Brandt Archive • p. 162 (A): © Albert Watson • p. 162 (B, C): © Marco Glaviano • p. 162 (D): © Rico Puhlmann. • p. 163: © Bill King/DR • p. 164–165 (A): Courtesy of Liu Bolin/Galerie Paris-Beijing • p. 167, 168 (A), 169, 172 (B), 182 (B), 183 (C): © Hearst Magazine Media • p. 168 (B): © David Sims/Trunk Archive • p. 170: © Fabien Baron. • p. 171 (C): © Michael Thompson/Trunk Archive. • p. 172 (A): Photographed by Raymond Meier, styled by Elissa Santisi. • p. 175: © Mark Seliger. • p. 176–177 (A): © Jean-Paul Goude. • p. 178–179 (A): © Simon Procter. • p. 179 (B): Collection Dior Héritage, Paris. • p. 179 (C): Photo: © Guy Marineau. • p. 180–181: © Txema Yeste/Trunk Archive. • p. 182 (A): © Sebastian Kim. • p. 183 (D): © Richard Burbridge. • p. 184: © Norman Jean Roy. • p. 185 (B): © Alexi Lubomirski. • p. 185 (C): © Mariano Vivanco. • p. 185 (D): © Camilla Akrans. • p. 187: © Georges Tourdjman, Saif, 2019. • p. 189: © 1991 Hans Namuth Estate. Courtesy Center for Creative Photography.

Every effort has been made to identify the authors and copyright holders of the documents used in this book. Any copyright holders we have been unable to reach are invited to contact the Publications Department at the Musée des Arts Décoratifs.

First published in the United States of America in 2020 by Rizzoli International Publications, Inc.
300 Park Avenue South
New York, NY 10010
www.rizzoliusa.com

Originally published in French in 2020 by Les Arts Décoratifs

© 2020 Les Arts Décoratifs

All rights reserved. No part of this publication may be reproduced, stored in a retrieval system, or transmitted in any form or by any means, electronic, mechanical, photocopying, recording, or otherwise, without prior consent of the publishers.

2020 2021 2022 2023 / 10 9 8 7 6 5 4 3 2 1

ISBN: 978-0-8478-6917-6

Library of Congress Control Number: 2019957019

Typeset in EVH Eddi and Didot HTF.

Printed in Belgium.

Visit us online:
Facebook.com/RizzoliNewYork
Twitter: @Rizzoli_Books
Instagram.com/RizzoliBooks
Pinterest.com/RizzoliBooks
Youtube.com/user/RizzoliNY
Issuu.com/Rizzoli